KANDINSKY IN MUNICH: 1896-1914

KANDINSKY IN MUNICH

1896-1914

This exhibition is supported by Philip Morris Incorporated

and the National Endowment for the Humanities, a Federal Agency

The Solomon R. Guggenheim Museum, New York

Published by

The Solomon R. Guggenheim Foundation, New York, 1982

ISBN: 0-89207-030-7

Library of Congress Card Catalog Number: 81-83561

Cover: Kandinsky, *Improvisation VI (African)*. 1911 (cat. no. 261)

FOREWORD

Carl E. Schorske

Kandinsky in Munich: the very title of this exhibition suggests a convergence of a person and a place, an artist and a city. It is a convergence too of two kinds of art exhibit usually held apart. One of these has become almost a dominant form of exhibition in our century: the one-man retrospective, such as the great Picasso show of 1980. This form arose as handmaiden to an important mode of intellectual understanding of art in modern times. Under it, art is viewed as the creation of single developing minds, the achievement of which can best be grasped in the temporal sequence of its products. In the 1970s, however, another form of exhibition kindled the public imagination, one that focuses on the collective artistic production of a single time and place. The Philadelphia Museum's *Art of the Second Empire* was one variant of this refreshed historical approach to visual culture. It compelled the viewer to place his present-day conceptions of artistically valid mid-nineteenth century French art (i.e., an aesthetic derived from the Impressionists and Post-Impressionists) into the historical context of the culture that produced it, a culture with quite different canons of critical judgment, wider stylistic content and long-forgotten modes of displaying—and therefore seeing—works of art. Another variant of this new historical approach to art explores and exploits the city as a cultural unit. The Centre Pompidou has developed the city exhibition to new heights, placing the visual arts of Paris in an international perspective by comparison with other urban cultures: *Paris-New York, Paris-Berlin, Paris-Moscow.* Not only are the plastic arts of France clarified in these exhibitions, but they are illuminated in a context of artistic and intellectual expression in other media, especially literature.

Even as they demonstrate the power of their contrasting perspectives, these two types of exhibition—the individual-textual retrospective and the cultural-contextual or city exhibition—have dwelt far apart and ignored each other's virtues. The concentration on the single painter's oeuvre has tended to detach it from its social and cultural environment. The concentration on a cultural context, on the other hand, has tended to blur the vision of the special, often isolated values of the individual artist's product. Thus we confront, on the one side, text without context; on the other, context without text.

Behind this polarization in exhibiting practice lies a division of view that developed over the last century concerning the nature and function of art and its place in society. As painting ceased to be produced primarily on commission to embellish a church, a public building or a residence, the artist won independence from traditional value systems. It was an ambiguous freedom,

combining imaginative opportunity with cultural rootlessness. On the one hand, the artist became free to devise his own code of meanings, to project his individual vision onto his canvas, independent of any ultimate social use or destination. On the other hand, he became dependent on a public art market to find an anonymous patron who might share his personal vision. France set the tone for nineteenth-century Europe in organizing the art market in the form of the "salon," where the artists adjudged qualified might display their wares collectively for the perusal of potential buyers. The salon was a form of exhibition appropriate to the era of democracy and economic laissez-faire, where the individualistic artist-producer and the connoisseur-consumer could find each other as seller and buyer. Although traditional criteria of judgment of aesthetic worth still exercised a restraining influence on what works the salon accepted for display, two important new principles of modern culture surfaced in the salon in uneasy interaction: "art for art's sake" and "business is business."

It was only logical that the artist who produced no longer on commission but out of his own powers should separate himself from the values, both in subject matter and in form, traditionally assigned to painting by society. But he could do this in two different ways, one individual, the other, social. The "modern" artist who followed the more individual course formulated new and highly personal pictures of the world, devising his own visual language for the purpose. To the degree that his sense of individuation estranged him from society, his art became less concerned with *representation* of the world of nature and inherited culture than with the *presentation* of a personal vision, sometimes of his own feeling, sometimes of the shaping or abstracting powers of art itself.

The retrospective exhibition of a single artist arose as a logical reflection in display practice of this process of artistic individuation, the process by which the very life of art became the expression of a personal vision rather than a shared cultural one. For such an artist as Vasily Kandinsky, who embodied in his own development the passage from "representation" to "presentation," from realism to abstraction, the temporal array of his oeuvre seems a particularly suitable form of exhibition.

But is it enough? To answer the question, one must turn to the other strand of artistic thought and practice that arose in response to the emergence of the autonomy of art in the nineteenth-century world of commerce: the social strand. In Europe's intellectual community there were those who could not accept the separation of the artist from the moral and social functions that by tradition had been his. They criticized the artist from a social point of view while they castigated the society from an aesthetic point of view. Above all, they sought to engage the artist in the task of regenerating society and, in the process, of closing the gap that had opened between culture and society, between art and public life.

Where France led the way in the development of a pluralized and individuated modern art, England and Germany pioneered in the creation of an art endowed with redemptive social functions. In England, under the inspiration of John Ruskin and the leadership of William Morris, the Arts and

ings based on erotic sensations and (imagined) feelings of racial unity. In Wagner's music dramas, reason gave way to mythic and symbolic intuition; Germanic and medieval tales were reformulated to evoke an intensely erotic communal response from the audience. The notion of forging community through theatrical means appealed to Ludwig, who inaugurated his reign by summoning Wagner to Munich. Within little more than a year, though, the composer's extravagant and adulterous personal life led to his expulsion from the Bavarian capital. Embittered by the hostility shown to Wagner, Ludwig turned his back on Munich and reserved his patronage for the Wagnerian festival-house that was erected in Bayreuth (1876), as well as for the fairy-tale palaces, replete with Wagnerian motifs, that he commissioned among the mountains of southern Bavaria (Linderhof, Neuschwanstein).

Ludwig's detestation of his capital city put an end to large-scale monarchical sponsorship of Munich's cultural development. Nevertheless, the traditions established by the Wittelsbach monarchs laid the basis for the cultural innovations that occurred during the reign of Ludwig's uncle, Prince Regent Luitpold (1886–1912), who ruled as a caretaker for Ludwig's fully schizophrenic brother, Otto I (1886–1916). In the 1890s Munich was so receptive to international Art Nouveau—or Jugendstil—because the city had a tradition of middle-class arts and crafts reaching back to the 1850s, as well as a model of vibrant sensualism provided by Wagner. In the early years of Luitpold's reign, this sensuality was embodied not only in Wagnerian music drama (which, despite initial hostility, became standard fare at the Munich opera), but also in the paintings of Franz Stuck. Although Stuck's use of Greek motifs harked back to the classicism of Ludwig I, the Stuckian propensity to portray a mythic demimonde of erotic creatures (nymphs, sphinxes, fauns, satyrs, centaurs) placed him in the sensualist and Symbolist tradition of Wagner. Like the composer, Stuck believed that encouragement of sexual instincts would help break the ascetic and individualist mold of the bourgeoisie. Stuck's sensualism, along with his use of relief-like composition, flat planes of rich color, and ornamental borders, made him an immediate precursor of the Jugendstil movement that burst forth in Munich in 1896.

Although the Jugendstil movement was not formally aligned with any political faction, it can best be understood as the expression of a resurgent nondoctrinaire left-liberalism that occurred when the wider liberal tradition was on its deathbed. By the 1890s, the liberalism that had characterized German bourgeois politics in the mid-nineteenth century was gravely endangered in the Reich at large, as well as in Bavaria in particular. The liberal movement, which had led the revolutions of 1848, collapsed in the course of Germany's unification and domestic consolidation (ca. 1860–80). A left-liberal minority clung to traditional libertarian ideals, namely the unification of Germany under a constitutional monarch with a powerful and democratically elected parliament. The majority of National Liberals, however, acquiesced to the Bismarckian formula: in return for the employment of Prussian arms to forge German unity, the undemocratic constitution of the new Imperial federation gave a commanding political role to Prussia's military and agrarian elites. National Liberal willingness to forgo a democratization of

society was reinforced by the rapid spread of Marxist ideals among Germany's burgeoning proletariat during the 1870s. Fear of Social Democracy encouraged the right-liberal middle classes to continue their cooperation with Prussia's traditional elites long after the military objectives of German unification had been achieved. Thus, except for the brief regime of Bismarck's successor, the liberal chancellor Caprivi (1890–94), liberalism was condemned to play a subordinate role in Imperial politics.

In contrast, liberalism was the predominant ideology of the ruling circles of Bavaria from the time of Maximilian II. The desire to modernize the state and to diminish the influence of the conservative Catholic church induced the Bavarian monarchs of the last half of the nineteenth century to appoint liberal (and usually Protestant) ministers to the royal cabinets. Liberalism was also prevalent in the Bavarian parliament, which was dominated by representatives of Bavaria's urban bourgeoisie. This hegemonic rule of liberal elites was challenged in the 1860s by the political arm of the Catholic church. The signal for the offensive came from Rome: the Syllabus of Errors of 1864 and the proclamation of papal infallibility in 1870 were designed to strengthen the internal discipline of the church and to reverse the secular and modernizing trends of the day. By sponsoring what was, in effect, a massive voter-registration campaign in the staunchly Catholic Bavarian countryside, the Catholic Center Party gained control of the Bavarian parliament in 1869. Except for a period in the 1890s, the Center held an absolute majority of seats in that body until the end of World War I. The Bavarian monarchs continued to appoint liberal cabinets until 1912, but the ministers were increasingly forced to make concessions to the politically hostile parliament, which controlled the governmental budget.

Although the long-term prospects for liberalism looked bleak in the 1890s, there were two major signs of encouragement: Caprivi was able to initiate some liberal reforms during his Imperial chancellorship, and the Center Party lost its majority in the Bavarian parliament between 1893 and 1899, owing to the defection of its radical-populist wing. Within this context, there arose in Munich a politically unaffiliated, but ideologically left-liberal movement that sought to revitalize middle-class self-confidence and support for libertarian ideals. One of the major spokesmen of this trend was Georg Hirth. Hirth had been a liberal publicist during the 1860s and 1870s, but his disappointment with Bismarck's authoritarian regime induced him, by his own admission, to turn from political to cultural concerns. In 1877, he published an influential book on *The German Renaissance Room,* which attacked the stylistic heterogeneity of contemporary interior design, and advocated instead the integral use of Northern Renaissance forms to fashion bourgeois domestic environments. Hirth was drawn back into political journalism in 1881, when he became editor of the *Münchener Neueste Nachrichten,* which his wife had inherited. This publication was Munich's largest-selling daily newspaper, as well as the major organ of Bavarian liberalism.

In 1896, at a time when the liberal era of Caprivi had been followed by a period of intense conservative reaction in Berlin, Hirth decided that conventional political journalism would not suffice for the propagation of liberal

goals. Hence he founded the literary and artistic journal *Jugend*, which combined his expression of political proclivities with his earlier interest in arts and crafts. The goal of *Jugend* was, as its title proclaimed, "youth"—a rejuvenation of the liberal middle classes not just politically, but also psychically and aesthetically. The bourgeoisie was supposed to overcome its subservience to Prussian elites, its creeping accommodation to Catholic majorities and its fear of socialist workers by adopting an exuberant spirit that would allow it to face vigorously and successfully the challenges of the day. The morally ascetic and politically subservient aspects of bourgeois behavior were to be replaced by a more liberated attitude toward religion, culture, sexuality and the state.

Whereas Hirth had earlier viewed the Northern Renaissance as Germany's genuinely bourgeois style, he now became a spokesman for the latest French, Belgian and English trends in the graphic arts. The international Art Nouveau stressed strong linear outline, flat planes of bright color and a wilful stylization of people and objects to achieve either ornamental or comic effects. This style proved perfectly suited to the goals of *Jugend*, which sought to satirize the opponents of liberal values, as well as to encourage an exuberant attitude toward life. The sensuality of Stuckian painting reappeared in the illustrations, provocative for the time, that bedecked the covers and inside pages of the journal. Similar views and a similar style were propagated by *Simplicissimus*, a satirical magazine founded simultaneously with *Jugend*. Indeed, *Simplicissimus* soon outshone *Jugend* in the audacity of its political criticism, so that by 1898 the two competing journals achieved a working accommodation: while *Simplicissimus* specialized in social and political satire, *Jugend* generally restricted itself to graphics and belles-lettres.

Artistic and intellectual rejuvenation was not, of course, confined to the pages of two illustrated magazines; indeed, *Jugend* gave its name to Jugendstil, the broad decorative arts movement that developed throughout Germany in the late 1890s. Within Munich, promising young artists like Peter Behrens and Richard Riemerschmid, who had initially created paintings that were intended to be hung in bourgeois homes in museal fashion, turned now to the applied arts and architecture. Their new goal was to design homes as integrated artistic environments, from exterior facades and internal tapestries to furniture, ceramics and silverware. Since the new artistic movement looked hopefully into the future rather than wistfully into the past, the young craftsmen discarded previous historical styles and employed forms derived from vegetative or crystalline nature, or from a free play of fantasy.

Jugendstil's visual rejuvenation of the bourgeois environment was complemented by a revitalization of the critical liberal spirit in the theater. Frank Wedekind and Ludwig Thoma, the major literary contributors to *Simplicissimus* in its early years, were preeminently playwrights. Whereas Wedekind's dramas (*Spring Awakening, Earth Spirit, Pandora's Box*) criticized the suppression of sexuality and individuality in modern society, the comedies of the left-liberal Thoma satirized both Catholic politicians and weak-kneed National Liberals. The most innovative theatrical expression of the aggressive liberal spirit was the *Elf Scharfrichter* (*Eleven Executioners*, 1901–03),

the most famous cabaret in Wilhelmine Germany. The members of the *Scharfrichter* considered their venture "applied theater," in analogy to applied art: cabaret was to relate to traditional theater in the same manner that the decorative arts related to painting on canvas. In contrast to the "aura" of classical theater or museal art, which seemed to hold spectators at a distance, the informal and intimate format of cabaret encouraged a more direct involvement of the audience with the presentation. Moreover, the lyrics, songs and skits of the cabaret were constantly updated to address the latest topics of the day.

The visual sensuality, verbal satire and theatrical aggression of Munich's resurgent liberal culture were intended to challenge the Catholic moralists in the Bavarian parliament and the reactionary rulers in Berlin. These groups responded with all of the political and legal means at their disposal, most notably the articles in the criminal code that forbade obscenity, blasphemy and lese majesty. In 1895 the Munich playwright Oskar Panizza was imprisoned for a year for publishing his "blasphemous" anti-Catholic play, *The Council of Love*. Four years later, Wedekind spent seven months in jail for ridiculing the Kaiser in the pages of *Simplicissimus*. Ludwig Thoma's attacks on Christian morality-leagues in the pages of the same journal four years later earned him several weeks of incarceration. Even though such imprisonment was infrequent, issues of *Simplicissimus* were regularly confiscated and destroyed on account of excessive blasphemy, obscenity or political satire.

The visual arts were not spared from attack. In the early 1890s, the Munich police, under Catholic pressure, forced a Munich art dealer to remove a reproduction of the Venus de Milo from his display window—an incident that inspired Thomas Mann to compose "Gladius Dei," a story about a confrontation between a dealer in "pornographic" art and an incensed brother of the church. This conflict found its fiercest expression in the notorious Lex Heinze, a legislative proposal that would have broadened the legal definition of obscenity to include potentially all representations of the human nude. This bill was, fortunately, narrowly defeated in 1900, after the Munich artistic community composed a protest that proclaimed: "Under such a law, Munich would soon cease to be a center of artistic and spiritual life—indeed, it would cease to be 'Munich.'" Three years later, though, the Catholic majority in the Bavarian parliament engineered a budgetary crisis that toppled the cabinet of the liberal prime minister Crailsheim (1890–1903). He was succeeded by Podewils (1903–12), a conservative liberal who sought a rapprochement between right-liberals and moderate Catholics. One of his first acts of accommodation was to acquiesce to the demand of Catholic representatives to close the *Scharfrichter* cabaret.

By the time of the liberals' political defeat in 1903, the Jugendstil movement in Munich had passed its prime; the duration of the *Jugend* spirit was as short as that of youth itself. Jugendstil touched only the artistic community and a small portion of the wealthy strata of society; it left little impact on the taste and behavior of the Munich middle classes as a whole. In the 1890s, when the socialists began to win major electoral victories among Munich's laboring population, the liberal middle classes of the Bavarian cap-

ital started to move to the right. This growing political conservatism was complemented by a lingering traditionalism of aesthetic taste. The areas of bourgeois expansion in Munich around 1900—Schwabing, the Prinzregentenstrasse and the land along and beyond the Isar river—all display striking examples of Jugendstil architecture, but the number of buildings designed in the older historicist styles is much greater. Indeed, most so-called Jugendstil facades are actually mixtures of modern decorative designs with Renaissance or Baroque motifs. The unprecedented exterior of the Elvira photographic atelier (1897), bedecked with an immense wave-like ornament, remained unique. In 1901 Hermann Obrist, an outstanding Jugendstil artist, lamented: "If only the Munich bourgeoisie would realize what is happening here, and see that the first act of the drama of the art of the future is being played out here—the art that will lead from applied crafts to sculpture and further to painting. . . . The future of Munich as a city of art will depend on this."

The fact that Munich's bourgeoisie failed to "realize what is happening here" discouraged the Jugendstil movement in the Bavarian capital. By 1903 many of Munich's major Jugendstil artists—Peter Behrens, Bernard Pankok, Otto Eckmann, August Endell—had left the city to continue their careers in more promising and lucrative environments. Indeed, a heated (and indecisive) public debate was touched off on the issue of "Munich's decline as a city of art." By 1909 even Kandinsky complained that the Munich art world had become a "Land of Cockaigne" in which everyone, from painters to public, had fallen into deep sleep. Nevertheless, despite the public somnolence of the visual arts in Munich after 1903, aesthetic innovations were still being engendered in the privacy of exclusive artistic circles.

From its very beginnings, Jugendstil had been a socially ambiguous phenomenon. Whereas the culturally rejuvenating, sensuous and satirical dimensions of the movement had received the most public attention, a minority of its practitioners had transformed the modern style into an intensely personal and spiritual artistic language. Most Jugendstil artists sought to encourage the vitality of modern life. In his essay on *The Beauty of the Modern City* (1908), August Endell proclaimed: "There is only one healthy foundation for all culture, and that is the passionate love for the here and now, for our time, for our country." In contrast, other artists were horrified by the changes in modern life, such as industrial growth, mechanization, urban crowding, and the loosening of social and sexual mores; many artists found these developments psychically disruptive. Significantly, the two outstanding works of prose fiction composed in prewar Munich—Alfred Kubin's *The Other Side* (1909), and Thomas Mann's *Death in Venice* (1912)—both describe near-hallucinatory trips that begin in Munich and end with a total breakdown of self-restraint and social order.

In reaction to the social and psychic flux of modernity, the writers assembled around the poet Stefan George segregated themselves from the public and cultivated ritual and hierarchical relationships among themselves. The same phenomenon of segregation and self-ordering could be seen in certain examples of Jugendstil architecture and decorative art in Munich. The Schauspielhaus, a relatively small, exquisite theater designed by Richard

Riemerschmid in 1901, was concealed in the interior courtyard of an inner-city housing block. The rounded contours, vaguely vegetative forms and deep red color of the auditorium evoked the image of a natural haven—half thicket, half womb—that shut out the public life and commercial traffic of the city. Similarly, Otto Eckmann, an accomplished Munich Jugendstil artist who designed his apartment down to the last detail, considered his abode a private refuge from a disconcerting reality. His sister-in-law wrote of his home: "It was nice at their place, and whoever left there, experienced the world outside as doubly ugly, unharmonious, loud, and heartless. But this environment also emanated a type of paralysis, something that tore one forcefully away from real life." In such cases, Jugendstil was transformed from a public ornament into a defensive casing that excluded the external world.

Whereas most artists used the modern forms to address contemporary issues and to revitalize everyday life, the minority that tended toward aesthetic introversion developed Jugendstil into a means of spiritually transcending material reality. Already before 1900 certain artists in Munich—Hermann Obrist, August Endell and Adolf Hölzel—were coming to the conclusion that the linear and ornamental elements of Jugendstil could be used non-mimetically to evoke strong sensations. The free line in space, much like the immaterial "line" of music, seemed to express feelings more directly than depictions of real objects, which aroused emotional responses only indirectly (through allegory, implied narrative or empathy). Mimesis came to be seen as an unnecessary detour around the direct visual expression of the spirit that could be embodied in pure line, form and color.

The failure of the middle classes to respond on a socially significant scale to the revitalizing tendencies of Jugendstil reinforced the antisocial attitudes of the movement's spiritual and inward-looking practiners. However, introversion was not the only answer to bourgeois neglect. A number of artists looked beyond the culture of their native middle class and turned to the "people," the *Volk*, for inspiration. This development first occurred within the context of the theater. The cabaret movement adopted the format of vaudeville, and it employed many of the genres of popular theater (marionettes, shadow-plays, songs, dances and so forth). These "minor" genres of the performing arts were used not only because they could be composed quickly and adapted to satirical purposes, but also because they offered a greater vitality than the forms of conventional "literary" theater.

Even after the satirical impetus of the cabaret movement was halted by decree in 1903, the vital forms of popular theater were introduced to the "elite" stage. After his participation in the *Scharfrichter* cabaret, Wedekind increasingly employed songs, dances and pantomimes in his dramas. By 1908, when a large exhibition was held to celebrate Munich's commercial and cultural achievements, all three model theaters presented the international public with examples of the imitation and creative appropriation of popular theater. The Schwabinger Schattenspiele produced shadow-plays composed by some of Munich's Symbolist poets; the Marionettentheater Münchener Künstler employed marionettes designed by Munich's best applied artists; and the

Münchener Künstlertheater, for which many of Munich's modern painters and graphic artists designed sets, used styles of acting derived from both popular circus and religious ritual.

The increasing employment of forms of popular theatrics by elite performing artists after 1903 was part of an attempt to reach beyond the liberal and educated middle-class audience. Since the turn of the century (1897 in the Reich, 1903 in Bavaria), the political tendency in Germany was toward *Sammlung*, toward the coalition of all non-socialist parties. This integrative political trend found cultural parallels among those artists who sought to address the *Volk* at large, rather than a specific social class or political group. Georg Fuchs, the organizer of the Münchener Künstlertheater, was a leading spokesman of this *völkisch* movement in Munich. He revived the Wagnerian notion of theater as a communal experience of all members of the Germanic race, and he believed that popular theatrics would enable him to address the widest possible audience. The *Elf Scharfrichter* had employed the popular performing arts for critical and satirical purposes; yet five years later, Fuchs was adapting popular theatrics to nationalist and racist ends. By that time even *Jugend*, which had been founded in a spirit of left-liberalism, had acquired nationalistic and even anti-Semitic overtones. Liberalism had, indeed, fallen upon hard times.

At the end of the nineteenth century the political and social developments in Germany in general, and in Bavaria in particular, fostered varying and contradictory tendencies in Munich's visual and performing arts—aggressive and regenerative Jugendstil, aesthetic introversion and a turn to popular culture. Although these tendencies were components of Kandinsky's evolving art during his years in Munich (1896–1914), his particular genius resided in his ability to employ these developments in novel and non-nationalist ways. Petrov-Vodkin, a compatriot of Kandinsky who likewise came to Munich for artistic training, noted that Russians went to the Bavarian capital to escape the provincialism of their homeland, but tended to fall victim to "another provincialism—blind following of German modernism." Fortunately, Kandinsky took from Munich those innovations which he considered intrinsic to art and man in general, and he discarded those elements which he deemed particularist or ephemeral. The conception of abstraction as a spiritual transcendence of reality; the expressive possibilities of line, form and color in themselves; and the rich potential of the popular arts—these notions were encouraged by Kandinsky's Munich experience. As a foreigner, however, Kandinsky did not involve himself in the social and political conflicts of the Munich artistic community. Indeed, much of what he saw—the Center Party's translation of faith into politics, the Jugendstil use of art for political satire, or the employment of folk theater for racist national ends—confirmed his belief that both art and faith had become degraded in the modern world.

Turn-of-the-century Munich had many artistic spokesmen for community and transcendence, but Kandinsky was unique in that he advocated spir-

itual transcendence in order to reestablish community on a cosmopolitan, trans-national and universalist scale. He employed millenarian themes in his masterpieces of 1909–14 not out of narrow attachment to Christian faith, but rather because he believed that the Christian apocalyptic tradition—which had long been the inspiration for heresy—could be transformed in the faith of the coming "epoch of great spirituality." Likewise, Kandinsky turned to Russian and Bavarian folk art not for reasons of race or nationalism, but rather because he believed that it expressed a fundamental aesthetic urge that could also be encountered in the arts of Asia and Africa, as well as in the works of his modernist colleagues in France, Germany and Russia. The *Blaue Reiter* almanac is perhaps the greatest monument of the universalist urge in art.

Such universalism must always, however, have roots in the concrete particular. In response to the specific political and social nexus of liberalism in Wilhelmine Germany and Catholic Bavaria, Munich's cultural community accentuated certain formal and spiritual dimensions of international Art Nouveau and German popular culture. The particular confluence of politics and culture in Munich threw into relief those dimensions of art that became the building blocks of Kandinsky's prewar style.

Today—after so many years—the spiritual atmosphere in that beautiful and, in spite of everything, nevertheless dear Munich has changed fundamentally. The then so loud and restless Schwabing has become still—not a single sound is heard from there. Too bad about beautiful Munich and still more about the somewhat comical, rather eccentric and self-conscious Schwabing, in whose streets a person—be it a man or woman—("a Weibsbuild")—without a palette, or without a canvas or without at least a portfolio, immediately attracted attention. Like a "stranger" in a "country town." Everyone painted . . . or made poetry, or music, or began to dance. In every house one found at least two ateliers under the roof, where sometimes not so much was painted, but where always much was discussed, disputed, philosophized and diligently drunk (which was more dependent on the state of the pocketbook than on the state of morals).

"What is Schwabing?" a Berliner once asked in Munich.

"It is the northern part of the city," said a München*r.*

"Not a bit," said another, "it is a spiritual state." Which was more correct.

Schwabing was a spiritual island in the great world, in Germany, mostly in Munich itself.

There I lived for many years. There I painted the first abstract picture. There I concerned myself with thoughts about "pure" painting, pure art. I sought to proceed analytically, to discover synthetic connections, dreamed of the coming "great synthesis," felt myself forced to share my ideas not only with the surrounding island but with people beyond this island. . . .

Kandinsky to Paul Westheim, 1930
Bauhaus, Dessau

KANDINSKY IN MUNICH: ENCOUNTERS AND TRANSFORMATIONS

Peg Weiss

I wish to take this opportunity to express my gratitude to my colleague Professor Kenneth C. Lindsay of the State University of Binghamton at Binghamton, New York, for his thorough reading of this manuscript and for his many helpful suggestions.

Due to limitations of space, footnotes are kept to a minimum in the present essay, and are included only where absolutely essential.

Translations from the German are provided by the author, unless otherwise noted.

1. Joseph Campbell, *The Hero with a Thousand Faces*, New York, Meridian Books, 1960, p. 337.

2. In this essay I have tried to provide a general overview of Kandinsky's Munich years. However, for a far more detailed discussion of the Jugendstil experience, the reader is referred to my book *Kandinsky in Munich: The Formative Jugendstil Years*, Princeton, New Jersey, Princeton University Press, 1979, which inspired this exhibition. In the present restricted space, I have discussed at length only subjects about which new information has come to my attention, or areas not covered by the book, in particular Kandinsky's association with the *Neue Künstlervereinigung München* and the *Blaue Reiter*. Other aspects of Kandinsky's early period are discussed by Rose-Carol Washton Long in *Kandinsky: The Development of an Abstract Style*, Oxford, Clarendon Press, 1980, and by Jonathan Fineberg in *Kandinsky in Paris, 1906–07*, Ph.D. dissertation, Harvard University, 1975. These works, as well as the standard biography by Will Grohmann, *Wassily Kandinsky: Life and Work*, New York, Harry N. Abrams, 1958, should be consulted for further information. With the gradual publication of further documentation on this hitherto little-known area of

I Munich: Encounter and Apprenticeship

Kandinsky arrived in Munich to begin the serious study of art in 1896. Between that time and his ultimate departure from the Bavarian capital in 1914 at the outbreak of World War I, he precipitated a vast sea change in the vision and vocabulary of modern art. His historic breakthrough to abstraction may in fact be seen as a modern apotropaic act, a quintessentially twentieth-century exorcism aimed at healing a civilization paralyzed into complacency by the specters of unprecedented social, technological, political and cultural changes. In his art and in his writing Kandinsky thrust a metaphorical coup de grace at the stranglehold of complacency and conservatism; in his image of the Blue Rider, a twentieth-century St. George, he had created an emblem with which to identify himself and his aims.

In *The Hero with a Thousand Faces* Joseph Campbell wrote: "For the mythological hero is the champion not of things become but of things becoming; the dragon to be slain by him is precisely the monster of the status quo: Holdfast, the keeper of the past."[1] No better description could be found of the role Kandinsky was to play in the history of modern art. The conflict between St. George and the dragon became, in fact, a compelling leitmotif in his life's work. In the art of the twentieth century Kandinsky himself was a hero of things becoming, of encounter and transformation; the field of confrontation was primarily Munich in those two decades at the century's turn, before war, undeterred by the conjurations of idealists, tore their dreams asunder.

Kandinsky's encounter with Munich and his transformation of the elements he found there, which fueled his dramatic breakthrough to abstraction, form the subject of this exhibition.[2] The magnitude of that creative leap can, however, only be suggested in what must necessarily be a limited selection. Between the first hesitant works of the student and the brilliant finale of the Campbell murals completed on the eve of World War I, lies a rich vortex of encounter, experience and dream which can merely be adumbrated here. Nevertheless, the suggestion alone must give us pause, and inspire awe at the courage, determination, discipline and inspiration of this artist, whom Franz Marc described as a man "who can move mountains."

The drastic nature of the transmutations wrought by Kandinsky may be briefly but dramatically previewed in a series of comparisons of his works with others by artists well known in Munich before 1900. Hans von Marees, the German Puvis de Chavannes, rediscovered and revered by turn-of-the-

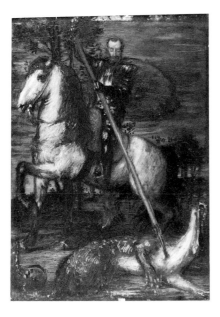

fig. 1
Hans von Marees
St. George. 1881
Oil (on panel?)
Collection Bayerische Staatsgemäldesamm-
lungen, Munich

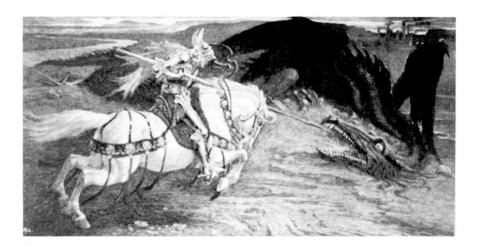

fig. 2
Walter Crane
St. George's Battle with the Dragon or
England's Emblem. ca. 1894
Oil on canvas (?)
Present location unknown

Kandinsky's life, it will be possible to reconstruct a more complete view of his early development. An example of this new material is the Kandinsky-Schönberg correspondence which has recently appeared: Jelena Hahl-Koch, ed., *Arnold Schönberg—Wassily Kandinsky: Briefe, Bilder und Dokumente einer aussergewöhnlichen Begegnung,* Salzburg and Vienna, Residenz Verlag, 1980. Kandinsky's published writings are now available for the first time in English: Kenneth C. Lindsay and Peter Vergo, eds., *Kandinsky: Complete Writings on Art,* Boston, G. K. Hall, 1982. Since the Lindsay-Vergo translations were in press at the time of writing there was not time to coordinate them with this essay. In the case of Kandinsky's *Apollon* letters, Professor Lindsay kindly allowed me to check a previous translation with the new translations from the Russian for the sake of general accuracy. The extremely well-documented edition of the writings of Paul Klee by Christian Geelhaar is also an invaluable source of information about the cultural life, especially the music, of Munich in the early years of this century: *Paul Klee: Schriften, Rezensionen und Aufsätze,* Cologne, DuMont Buchverlag, 1976; Klee's own diary and his recently published correspondence with his family are other valuable sources: Felix Klee, ed., *The Diaries of Paul Klee, 1898–1918,* Berkeley and Los Angeles, University of California Press, 1968, and Felix Klee, ed., *Paul Klee Briefe an die Familie: 1893–1940,* Cologne, DuMont, 1979.

century artists, produced several versions of St. George and the Dragon. One of these (fig. 1), a pendent to his great triptych of saints on horseback (St. George, St. Martin and St. Hubertus), was installed at the Bayerische Königliche Galerie in Schleissheim, a Munich suburb, before 1900. Another von Marees St. George was on view at the Nationalgalerie in Berlin by 1889. *St. George's Battle with the Dragon* or *England's Emblem,* ca. 1894 (fig. 2), was the clou of a retrospective of the work of Walter Crane, the great William Morris disciple; the exhibition toured Germany, including Munich, in 1896–97 and *St. George's Battle* was widely reproduced. It depicted the hero-saint charging the demon-protector of an industrial city, anathema to Crane, the idealist social-reformer.

Between these characteristically nineteenth-century representations of the saint on horseback and the great series of St. George images created by Kandinsky from 1911 to 1913 (for example, cat. nos. 318, 319, 323), we glimpse that sea change, that "thundering collision of worlds," as Kandinsky would

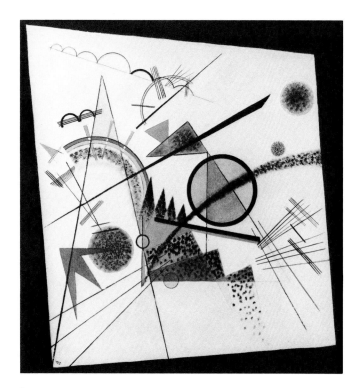

fig. 3
Vasily Kandinsky
In the Black Square. 1923
Oil on canvas
Collection The Solomon R. Guggenheim
Museum, New York

fig. 4
Franz von Stuck
*The Lost Paradise (Expulsion from the
Garden)* (detail). 1897
Oil on canvas
Staatliche Kunstsammlungen, Galerie
Neue Meister, Dresden

define painting in his memoir "Rückblicke" ("Reminiscences"). The momentum of that leap would carry him on to further transformations of the theme as in the 1923 painting *In the Black Square* (fig. 3) and still further to *Tempered Elan* of 1944.

A similarly dramatic transformation is apparent in a series of paintings on the theme of the Guardian of Paradise, beginning with the prize-winning canvas of 1889 of that title by Kandinsky's teacher, Franz von Stuck (cat no. 51), or his *Expulsion from the Garden* of 1897 (fig. 4). Kandinsky's guardian figures in *Paradise* of 1909, and the related *Improvisation 8* of the same year (fig. 5) already inhabit another dimension. The distance traversed from this dimension to the transcendent presence in his 1925 masterpiece *Yellow-Red-Blue* (fig. 6), in which the guardian image is paired with a cosmic St. George and dragon, now transformed into blue circle and whiplash line, represents a leap of yet another magnitude.

fig. 5
Vasily Kandinsky
Improvisation 8. 1910
Oil on canvas
Private Collection, New York

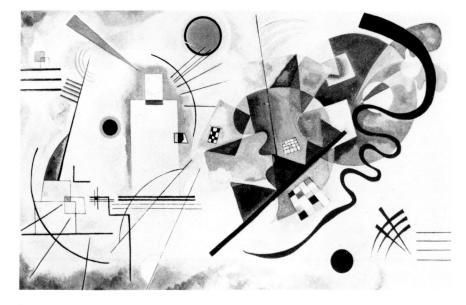

fig. 6
Vasily Kandinsky
Yellow-Red-Blue. 1925
Oil on canvas
Private Collection, Paris

By the time of Kandinsky's arrival in 1896, Munich's golden age had already produced Germany's first secessionist movement with the founding of the Munich *Secession* in 1892 and had witnessed the birth of Germany's version of Art Nouveau, Jugendstil, or "style of youth." These two, then, *Secession* and Jugendstil, carried the banners of the avant-garde in that Isar-Athens during the last uneasy twilit years of the nineteenth century. The *Secession* was composed of a heterogeneous group of artists who had little in common except the need to establish a front against the overwhelming mediocrity of the numbingly vast exhibitions staged annually by the old *Künstlergenossenschaft* (*Artists' Society*) in the mammoth spaces of the Glaspalast (cat. no. 14), Munich's answer to London's Crystal Palace. Among the founders of the *Secession* were some of Germany's strongest and most progressive artists: Peter Behrens, Lovis Corinth, Otto Eckmann, Thomas Theodor Heine, Adolf Hölzel, Max Liebermann, Franz Stuck, Hans Thoma, Wilhelm Trübner and Fritz von Uhde. (Foreign members included Paul Besnard, Emile Blanche, Eugène Carrière and Giovanni Segantini.) Although these artists represented a stylistic mix ranging from academic historicism to naturalism, from Impressionism to Symbolism, and notably lacked programmatic cohesion, the strength of their statement created shock waves which resulted within a few years in the foundation of Secessions in Berlin and in Vienna.

On the other hand, Jugendstil, stepchild of that monumental reform movement in applied arts set in motion by William Morris in mid-century, had not only a cohesive program, but a momentum of then unsuspected power. It harbored within it the seeds of the altogether new: the concept of an art without objects. It was the style of the wavy line, dynamic image of energy, whose own turgid undertow would inevitably bring it down, but on whose crest rode the daring possibilities of an entirely new art, which, indeed, it prophesied. Although an unofficial movement, several members of the *Secession* were spokesmen as well as adherents. The names of Behrens, Eckmann, Heine and Stuck all were to become inextricably associated with Jugendstil. Indeed, both Behrens and Eckmann converted entirely, giving up careers in the fine arts to devote themselves to the Arts and Crafts Movement and to the ultimate dream of the *Gesamtkunstwerk*, the total work of art.

Thomas Mann's description in his story "Gladius Dei" of Munich at the turn of the century as a radiant center of the arts (see p. 12) came close to the truth, though tinged with the irony of his story whose youthful protagonist saw the city rather as a modern Gomorrah. In fact, the Jugendstil cult of line, the "bizarre" architectural ornament, the plethora of publications devoted to art, especially to the applied arts, abounded. The magazine *Jugend* was founded in 1896, just in time to lend its name to the new movement. The young architect August Endell scandalized the city that year with his designs for the Hofatelier Elvira (cat. nos. 15–17, 50) and published an attack on the established art scene in the form of a pamphlet called *On Beauty, a Paraphrase on the Munich Art Exhibitions of 1896* (cat. no. 344) in which he proclaimed: "There is no greater error than the belief that the painstaking imitation of nature is art." The satirical magazine *Simplicissimus*, which was

fig. 7
Bernhard Pankok
Doorway Tapestry with Embroidered Abstract Design (detail). ca. 1899

3. Klaus Lankheit, "Die Frühromantik und die Grundlagen der gegenstandslosen Malerei," *Neue Heidelberger Jahrbücher*, Neue Folge, 1957, pp. 55–90; Otto Stelzer, *Die Vorgeschichte der Abstrakten Kunst, Denkmodelle und Vor-Bilder*, Munich, R. Piper & Co., 1964.

to publish work by the best of Munich's Jugendstil artists and poets, made its debut the same year, and in 1897 the magazine *Dekorative Kunst*, devoted to the international movement in the applied arts, appeared. Endell's mentor, the sculptor Hermann Obrist, who had already attracted attention with an unprecedented exhibition of fanciful and monumental embroideries, was now engaged in organizing the *Vereinigten Werkstätten für Kunst im Handwerk (United Workshops for Art in Craft)*. Walter Crane's retrospective received a warm welcome, as did a competitive exhibition of Art Nouveau posters which included the work of Beardsley, Toulouse-Lautrec and Grasset.

Certain characteristics of Jugendstil—its arbitrary play with line, color and form at the expense of historical or naturalistic reference; its tendency to two-dimensionality, its messianic, reforming spirit; and, above all, its striving for the ideal of an aesthetically determined environment—were to have significant ramifications for the art of the twentieth century. Yet these characteristics were born of a long development out of the art of the previous century. Jugendstil found much of its theoretical justification and inspiration in German Romanticism, as the English Arts and Crafts Movement had found precedent and inspiration in the work of Blake, Palmer and even Turner. Philipp Otto Runge's yearning for a great synthesis of the arts in the ideal *Gesamtkunstwerk*, Caspar David Friedrich's inward-turning eye and his identification of the creative act with cosmic creation were fundamental assumptions of turn-of-the-century Symbolist art and theory. Impressionist indifference to subject matter and emphasis on technique at the expense of clarity, Symbolist emphasis on essence and idea as opposed to narrative and description, Post-Impressionist separation of the formal elements of color and line, and its particular concern with the psychological effects of these elements —all these were shared and extended by Jugendstil art.[3] But it was primarily in the vision of an aesthetically determined environment that the adherents of Jugendstil sought a solution to the crisis which had existed in the arts from the middle of the nineteenth century. Detoured into meaningless historicism and empty academicism, art was perceived as having become estranged from life. The arts and crafts movement proposed to bridge the gap by returning aesthetic values to everyday life through universal reform in applied arts, architecture and urban planning. Its ambitions were utopian and messianic; its aim was to raise the fundamental quality of modern life by means of an aesthetic language which would transcend social and national boundaries.

In Munich the acknowledged leaders of the Jugendstil revolution in applied arts were Obrist and Endell. Among other prominent artists engaged in the movement in Munich were Richard Riemerschmid, Bernhard Pankok and Bruno Paul as well as Behrens and Eckmann (for example, figs. 7, 8, cat. nos. 18–29). Obrist exemplified the ideal Morrisean artist-craftsman. Brilliant, highly educated, widely traveled, he had brought the new style with him to Munich in 1894. Filled with the energy of the zealous reformer and overflowing with ideas and talent, he soon acted to present his message to the public in lectures, publications and exhibitions, in the foundation of the aforementioned *Vereinigten Werkstätten für Kunst im Handwerk* and, somewhat later, in an extremely influential school. The environmental revolution

fig. 8
August Endell
Tapestry with Arrow Design. ca. 1897
Executed by Ninni Gulbranson. Exhibited
at Glaspalast, Munich, 1897

he envisioned would be based on radically new concepts in art which involved the application of psychological theories of perception to the problems of design. He went far beyond Morris in terms of inventing a visual vocabulary capable of moving into the twentieth century.[4] Even today, in their radical abstraction, Obrist's drawings (cat. nos. 58–67) convey an eerie sense of his visionary power. Perhaps no other artist of his generation moved closer to abstraction before the turn of the century. Obrist's conscious exploitation of abstract form, line and color for expressive purposes was to have a significant and direct effect on Kandinsky who, within a short time, was to become his close friend and admirer.

Within months of Kandinsky's arrival in Munich, Obrist's young disciple Endell published in the pages of *Dekorative Kunst* his stunning prophecy of a "totally new art," an art "with forms that mean nothing and represent nothing and recall nothing," yet which will excite the human spirit as only music had previously been able to do. Shortly thereafter he elaborated on his prophecy, naming the new art "*Formkunst*," or "form-art," and stating that the time was soon approaching when monuments erected on public plazas would represent neither men nor animals, but rather "fantasy forms" to delight and intoxicate the human heart.[5] Undoubtedly Endell's words had been inspired by Obrist's latest work, the two astonishing abstract plaster models for monuments standing ready in his studio by that time, vainly awaiting public commissions: the *Arch Pillar*, of which only a photograph survives today, and *Motion Study*, both about 1895 (cat. nos. 68, 70).

Kandinsky's encounter with the idea of an art form which would "move the human spirit" without reference to "anything known," but only by means of a manipulation of its fundamental elements (line, color, form), came at a crucial and formative time in his life. Even before leaving Russia, however, he had become aware of the incredible power of pure color in the discovery of a painting of a haystack by Monet (fig. 9) at an exhibition in Moscow. As Kandinsky was later to recall in his memoir, he had at first not recognized the subject of the painting. He felt embarrassed, even irritated by such deliberate obfuscation. But, when the painting persisted in his consciousness, he

4. Cf. Weiss, pp. 23–34 and passim, in which the influence of the psychologist Theodor Lipps on Obrist, Endell and other artists in Kandinsky's circle is noted. The enormous influence of Lipps, who lectured at the University in Munich from 1894 to 1913, should be the subject of more detailed study in the future.

5. Endell's letters to his cousin Kurt Breysig (now in the Handschriftenabteilung of the Staatsbibliothek Preussischer Kulturbesitz, Berlin) reveal not only his indebtedness to Lipps, but the fact that his ideas on the possibility of a totally abstract art which is not derived from nature were, already by 1897, even more radically advanced than those of Obrist: "Pure form-art is my

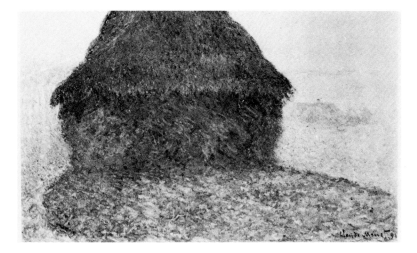

suddenly realized the "hidden power of the palette," and in that moment, at a subconscious level, it was borne in on him that "the object as an inevitable element of a picture" had been "discredited."[6]

As Kandinsky now subjected himself for the first time to the discipline of learning the fundamentals of painting, this awareness of new possibilities in artistic expression was reinforced by his encounters with prophecies of abstraction in Munich Jugendstil. Soon he was assembling notes on a new "*Farbensprache*" ("color-language"), and in letters to his friend Gabriele Münter would before long refer to his own paintings as "color-compositions." By the spring of 1904 he was ready to state that he had come far with his "color- language," and that ". . . the way lies quite clear before me. Without exaggerating, I can maintain that if I solve this problem, I will show painting a new, beautiful way capable of infinite development. I have a new route, which various masters have only guessed at here and there, and which will be recognized sooner or later . . . I already had a premonition of this whole story long ago. . . ."[7]

The idea of an aesthetically determined environment was also to remain a determining force in Kandinsky's life, leading eventually to his association with the Bauhaus, which indeed can be seen as the twentieth-century culmination of the concepts of William Morris. From his encounter with Jugendstil principles of interior design, which he acknowledged in several of the exhibitions he organized in Munich, to his own designs for applied arts and the decoration of furniture for his house in Murnau, and ultimately to the wall panels he painted for the Campbell foyer in 1914, he demonstrated the significance he attached to the value of the *Gesamtkunstwerk* ideal. This ideal informed as well Kandinsky's concept of a synthesis of all the arts in theater. As he had come from Moscow already aware of the potential of abstraction, so too the dream of an environment integrated by art was one Kandinsky had brought with him from Russia, and for which he found confirmation in Munich's Jugendstil movement. In "Rückblicke" he described his excitement when, during an anthropological expedition to the remote Vologda region of Russia, he stepped into the "magic" houses of the peasants and felt himself

goal. Away with every association."
See also the essay by Tilmann Buddensieg, "Zur Frühzeit von August Endell
—seine Münchener Briefe an Kurt Breysig," *Festschrift für Eduard Trier*, Berlin, Gebr. Mann Verlag, 1981.

6. Wassily Kandinsky, "Rückblicke," *Kandinsky, 1901–1913*, Berlin, Der Sturm, 1913, p. IX. Henceforth, references to this work will be noted by page number directly in the text.

7. Kandinsky, Letter to Gabriele Münter, 25.5.04, typescript by Johannes Eichner in the collection of Kenneth C. Lindsay, Binghamton, New York. Henceforth the Kandinsky-Münter correspondence in the Lindsay collection will be referred to as Lindsay K/M letters, followed by their dates.

surrounded on all sides by the brightly decorated furniture, votive pictures and candles. "It taught me," he wrote, "to move in the painting, to live in the picture." He compared the force of this experience to the impact of the great cathedrals of the Kremlin and of the Rococo Catholic churches of Bavaria and Tyrol (p. XIV). By the turn of the century he was already deeply involved in the applied-arts movement, forming professional associations with Obrist and Behrens, and joining Munich's *Vereinigung für angewandte Kunst (Society for Applied Arts)*.

At the age of thirty Kandinsky came late to the discipline of art. He had already successfully terminated a university education in law and economics, passing his examinations in 1892. He had, he recalled in "Rückblicke," consciously subordinated his inner wishes to the strictures of society, accepting the responsibility he felt imposed upon him to become a self-supporting member of the family and of society (p. VIII). Yet, clearly, he had always been attracted to art, and as a child had shown unusual talent. Now, in 1896, although married and at the threshold of a promising career with the offer of a teaching position at the University of Dorpat, events conspired to change his life once and for all. By his own account, he had worked the previous year as a director in a prominent Moscow art-printing firm. Although his ostensible purpose had been to put his economic theories to practical test as a worker, the actual result was to confirm his yearning to become an artist himself. The overwhelming experience of the Monet haystack painting may also have had its catalytic effect at about this time, for the only Monet haystack documented as having been exhibited in Moscow during this period was included in an exhibition of French art which toured to St. Petersburg and Moscow in 1896 and 1897.[8] It is tempting, although pure speculation, to wonder whether the premiere of Chekhov's *The Sea Gull* at St. Petersburg in October of 1896 may also have influenced Kandinsky's momentous decision. Certainly its depiction of tragically stifled artistic creativity would have provided another catalyst had one been needed. In any case, as Kandinsky later recalled, at the age of thirty the compelling thought "overtook" him: "now or never."[9]

In looking back to his years as a student, Kandinsky particularly noted the encouragement and freedom offered by his two teachers, Anton Ažbe and Franz von Stuck. At the same time he remembered the inner turmoil and conflict which accompanied those years of apprenticeship. Ažbe and Stuck represented the dualism inherent in the art of the turn of the century. Ažbe, despite his bohemian demeanor and liberal pedagogical approach, exemplified the traditions of naturalism that had evolved by then into an Impressionist apprehension of reality. Stuck, paradoxically, a master of the otherwise conservative Munich Academy, was actually much closer to Jugendstil. He represented that peculiarly Germanic hybrid of "naturalistic Symbolism" or "Symbolist naturalism" of which both Böcklin and Klinger were superior exponents. This dualism, encompassing the poles of naturalistic Impressionism and a lyric Symbolism, was to be reflected in Kandinsky's own development. It was a source of deep inner conflict and, at the same time, helped to spur his progression toward abstraction.

8. Daniel Wildenstein, *Claude Monet: Biographie et catalogue raisonné, Tome III: 1887–1898 Peintures*, Lausanne-Paris, La Bibliothèque des Arts, 1979, no. 1288, *Meule au Soleil*. John Bowlt suggests that Kandinsky may have seen a Monet painting in Moscow in 1891, citing a report written in 1931 by the poet Belyi (John E. Bowlt and Rose-Carol Washton Long, *The Life of Vasilii Kandinsky in Russian Art: A Study of "On the Spiritual in Art,"* Newtonville, Massachusetts, Oriental Research Partners, 1980, p. 36, n. 28). However, no catalogue evidence is cited to support this report.

9. Kandinsky, untitled introduction to catalogue *Kandinsky Kollektiv-Ausstellung 1902–1912*, Munich, Verlag "Neue Kunst" Hans Goltz, 1912, pp. 1–2.

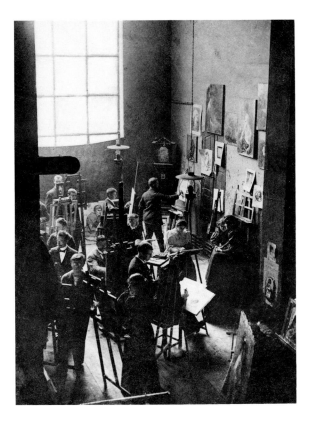

fig. 11
Class in the Anton Ažbe School. ca.
1895
Ažbe center, with top hat and cigar, hand
on shoulder of Richard Jacopic; Igor
Grabar top row, second from right
Courtesy Narodna Galerija, Ljubljana

fig. 10
Studio of Anton Ažbe. ca. 1890
Courtesy Narodna Galerija, Ljubljana

10. Kandinsky, "Betrachtungen über die
 abstrakte Kunst," in *Essays über Kunst
 und Künstler*, ed. Max Bill, Bern,
 Benteli-Verlag, 1963, p. 150. Kandinsky
 also enrolled twice in Academy courses
 on anatomy with Professor Molliet;
 he later claimed that the teaching was
 of poor quality. See also Johannes
 Eichner, *Kandinsky und Gabriele
 Münter, von Ursprüngen moderner
 Kunst*, Munich, Verlag Bruckmann,
 1957, p. 58.

Ažbe, although not associated with the Academy, was highly respected
for his virtuoso technique and beloved as a teacher. Tiny in physical stature,
yet he was already in the nineties a monumental legendary figure within
Munich's bohemian quarter, Schwabing. Stuck, on the other hand, a frequent
gold medal winner at the annual Glaspalast exhibitions and a founding mem-
ber of the Munich *Secession*, was already professor at the Academy by 1895,
at the age of thirty-two. In contrast to the almost comical Ažbe, Stuck was a
fine figure of a man (as he made sure to dramatize in his numerous self-
portraits, for example, cat. no. 86), and he had assured himself social posi-
tion to match his artistic stature by marrying a wealthy American widow
and building himself a palatial villa on a commanding site above the banks
of the Isar River. While Ažbe died at the age of forty-five, worn out by the
conflicting demands of his talent and the restrictions of his existence as an
outsider, as well as by his addiction to alcohol, Stuck outlived his own fame,
still honored in the 1920s, but by a somewhat bemused public uncertain as
to why he had once been so sought after and admired.

From Ažbe, Kandinsky learned the basics of anatomical drawing and
easel painting; yet his most distinct memory of Ažbe's pedagogy was: "you
must learn anatomy, but before the easel, you must forget it."[10] Typically,
Kandinsky subjected himself to this discipline with a patient determination,
even though he found the crowded atelier and the insensitivity he felt
amongst the younger students irksome (figs. 10, 11). In his early wash studies
from the nude (cat. nos. 76–78), we can observe what he called the "play

of lines" which fascinated him more than the scrupulous imitation of nature (p. xx). As was often to be the case in Kandinsky's career, his progress was a process of encounter and transformation. In conflict with what he termed the stifling air of the atelier, Kandinsky often skipped school, escaping instead to the English Garden or the rural environs of Munich to make his first oil studies from nature, using the palette knife recommended by Ažbe (cat. nos. 80, 81). In these studies he could experiment with the color theories taught by Ažbe, who encouraged his students to employ the divisionist technique developed by the Impressionists, whereby pure colors influence each other on the canvas. Ažbe himself practiced a modified Impressionism, but his works display as well a sensitivity to Symbolist form and color. The technical virtuosity that made him a minor master on the Munich scene is apparent in paintings such as *Self-Portrait*, 1886, *Half-Nude Woman*, 1888, and *Portrait of a Negress*, 1895 (cat. nos. 73–75).

Kandinsky observed in "Rückblicke" that in Munich in the nineties, Stuck was considered Germany's "first draftsman" (p. XXII). Therefore, as the next step in his self-imposed program of art education, after two years of study with Ažbe, Kandinsky conscientiously presented himself to Stuck. As he ruefully acknowledged in his memoir, Stuck turned him away with the suggestion that he spend a year in a drawing class at the Academy. However, he failed the Academy's entrance exam. Despite what to a sensitive though determined spirit must have seemed a bitter blow, Kandinsky resolved to work out his problems alone. On his next application to Stuck, this time with examples of sketches for paintings and a few landscape studies, he was accepted with the compliment that his drawing had become "expressive." But the master objected strenuously to what he called Kandinsky's "extravagances" with color, and admonished him to work for a time in black and white; this advice may well have caused Kandinsky to begin his nearly obsessive study of positive and negative space, resulting eventually in his first color drawings on black ground and his first woodcuts.

Kandinsky was struck by two characteristic attitudes of Stuck, which he found extremely beneficial. One was what he perceived as Stuck's instinctive sensitivity to form and the "flowing into one another" of forms; the other was a deep feeling of responsibility and obligation to the artistic muse which he communicated to his students. According to Kandinsky, Stuck cured him of a helpless sense of insecurity and enabled him for the first time to bring a compositional concept to a satisfying conclusion (p. XXII). Stuck's commitment to the ideal of the aesthetically determined environment was also of significance for Kandinsky. His own villa (cat. no. 88), constructed during Kandinsky's first years in Munich, was a remarkable example of the *Gesamtkunstwerk*. Stuck had taken immense delight in designing every element of the house, from its basic architectural plan to the murals, prize-winning furniture, silverware, lighting and other details (fig. 12). Many of his pictures were as much objects of applied art as they were paintings. His famous and extremely popular portrait of *Sin* (fig. 13) was adorned with a specially designed architectural frame, and eventually became the centerpiece of an altar in the artist's atelier.

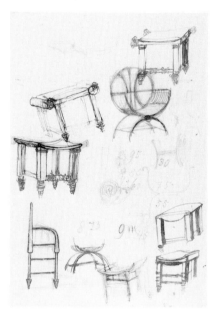

fig. 12
Franz von Stuck
Sketches for Furniture for the Stuck Villa.
ca. 1898
Pencil, pen and tusche on yellowish paper
Private Collection

Stuck's eclecticism and freedom, indeed the very ambiguity at the root of his art, contributed to his popularity amongst students and public alike. While Kandinsky was a member of Stuck's atelier, Paul Klee, Ernst Stern, Alexander von Salzmann, Albert Weisgerber and Hans Purrmann were also students there. (Klee depicted a student approaching the famous Stuck villa in a humorously disrespectful drawing [fig. 14]). Eugen Kahler, who was later to become associated with Kandinsky, and Hermann Haller, a friend of Klee, studied with Stuck just after the turn of the century. Although the limitations of Stuck's turgid personal style were clear to Kandinsky, many of his teacher's striking images, Jugendstil transformations of traditional symbols, were to make a lasting impression upon him. Not only the guardian of paradise, but also the serpent-symbol of evil, the mysterious horseman and the Grecian warrior who symbolized the avant-garde were to figure in Kandinsky's own work (cat. nos. 82, 83, 93, 94).

After a year at Stuck's atelier, however, Kandinsky realized that the time had come to liberate himself from apprenticeship. By the late fall of 1900 Kandinsky was approaching his thirty-fourth birthday. Once again he must have felt a sense of urgency; time was passing and he recognized that his dream was still far away. Courageously now he struck out on his own.

fig. 13
Franz von Stuck
Sin. ca. 1893
Oil on canvas
Bayerische Staatsgemaldesammlungen,
Munich

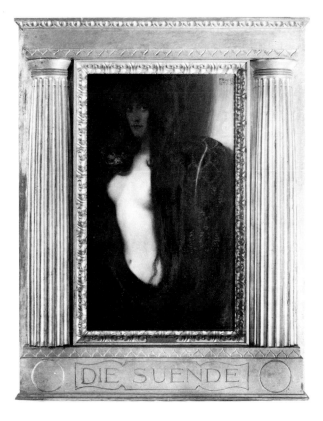

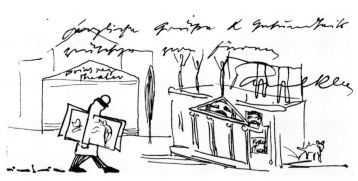

fig. 14
Paul Klee
Drawing of the Stuck Villa, Munich, from
letter dated April 20, 1900
India ink on paper
Collection Felix Klee, Bern

II Phalanx: Encounter with Avant-Garde

Kandinsky was not without friends during those early years of struggle. In addition to the Russians he had met at Ažbe's studio (Marianne von Werefkin and Alexej Jawlensky), he also knew Ernst Stern, Stuck's atelier assistant, who shared an apartment with another of Kandinsky's Russian friends, Alexander von Salzmann. Perhaps through Stern he had already met Waldemar Hecker, the puppeteer, and Wilhelm Hüsgen, the sculptor, with whom Hecker shared a studio.[11] At about the time Kandinsky left Stuck's studio, Hecker, Hüsgen and Stern were participating in the organization of what was to become Germany's most famous literary and artistic cabaret, the *Elf Scharfrichter (Eleven Executioners)*. During the same period they also became involved with Kandinsky in plans to organize a new artists' society, one which would provide exhibition opportunities not available to younger artists or to those outsiders not acceptable to the *Künstlerverein* or the *Secession*. The group was to be called the *Phalanx*, symbolizing the avant-garde ideals it shared with the *Elf Scharfrichter*, whose own name was intended, as Stern aptly explained, "to suggest that judgement was sharp and execution summary in the battle against reaction and obscurantism."[12]

The first performance of the *Elf Scharfrichter* took place in April of 1901, and by the end of May arrangements had been made to announce the founding of the *Phalanx* society. In August the first *Phalanx* exhibition opened with works by Kandinsky, von Salzmann and three participants in the *Elf Scharfrichter*: Hecker, Hüsgen and Stern. Kandinsky had designed the poster which announced the exhibition, adapting the Jugendstil imagery and style of Stuck's famous poster for the Munich *Secession* to produce a work of decidedly more refinement and subtlety (cat. nos. 93, 94).

The conjunction of the founding of the *Phalanx* with the beginnings of the *Elf Scharfrichter* and the personal ties among the participants in the two enterprises are significant. They indicate that from the very outset of his public career Kandinsky not only stood with the avant-garde, but that he was deeply conscious of the social responsibility of art, and much interested in the lyric and performing arts as vehicles for expression of that high obligation. He was never to shirk encounter and conflict, recognizing in them the potential for social reform and transformation.

The avant-garde quality of the first *Phalanx* exhibition was instantly attacked by a local reviewer in the pages of *Kunst für Alle*: "The whole [exhibition] stands much too much under the sign of caricature and the hypermodern." Indeed, in consideration of the radical combination of the genres represented, even today we are struck with the daring of the conception. Included were masks by Hüsgen and marionettes by Hecker for the *Elf Scharfrichter*, graphics by the first *Phalanx* president, Rolf Niczky, decorative work by von Salzmann and Stern (cat. nos. 99, 96a-g, 98, 100), both of whom were to become distinguished theater designers. Unidentified works by Kandinsky and paintings by artists who had exhibited previously with the *Secession* and the splinter group known as the *Luitpoldgruppe* were also shown.

11. Another Kandinsky associate, Gustav Freytag, later recalled that it was Hecker who introduced him to Kandinsky sometime during the winter of 1900–01; therefore, Kandinsky obviously knew Hecker prior to that. See "Erinnerungen von Gustav Freytag" in Hans Konrad Röthel, *Kandinsky: Das graphische Werk*, Cologne, DuMont Schauberg, 1970, p. 429.

12. Ernest Stern, *My Life, My Stage*, London, Victor Gollancz Ltd., 1951, p. 28.

The inclusion of the *Elf Scharfrichter* material in the first *Phalanx* exhibition is another indication of the liberal nature of Kandinsky's intellectual character and of his abiding belief in the possibility of social reform through art. As Peter Jelavich has pointed out, the intellectuals' espousal at this time of the cabaret medium as an appropriate, indeed preferred, form and forum for the expression of ideas was to have significant ramifications for twentieth-century culture. The appearance of the political cabaret in Germany was the direct result of the Lex Heinze, a repressive censorship bill that had been introduced in the Prussian legislature in 1900. The furious debate it engendered precipitated the founding of Ernst von Wolzogen's *Überbrettl* cabaret and Max Reinhardt's *Schall und Rauch* in Berlin and the *Elf Scharfrichter* in Munich, all within weeks of each other.[13] It is interesting to note, as Jelavich has also remarked, that this concern with the variété form paralleled the movement in the visual arts to integrate artistic expression with life. At the turn of the century, the writer Julius Otto Bierbaum had already identified the cabaret with the Arts and Crafts Movement, calling for an "*angewandte Lyrik*," an "applied lyric."

The leading members of the *Elf Scharfrichter* were Marc Henry, a Frenchman concerned with promoting the cause of international cultural exchange and friendship, and Marya Delvard, whose exotic beauty was captured by the *Simplicissimus* caricaturist Thomas Theodor Heine in his famous poster for the *Elf Scharfrichter* (cat. no. 95). A decade later her features were to be memorialized in *The Green Dress*, 1913 (cat. no. 97), a painting by the American artist Albert Bloch, whose works were included in Kandinsky's *Blaue Reiter* (*Blue Rider*) exhibitions. One of the most famous members of the *Elf Scharfrichter* was the Munich dramatist Frank Wedekind. Hüsgen fashioned masks for all of the *Elf Scharfrichter*, including one for Wedekind which was shown in the second *Phalanx* exhibition the following winter (cat. no. 99). At about the same time, *Phalanx* president Niczky designed a poster to advertise the Lyrisches Theater (cat. no. 98), which had been founded by an early member of the *Elf Scharfrichter*.

Stern's contribution to the *Elf Scharfrichter* must have been of acute interest to Kandinsky. According to Stern's own memoir, he was hired by the cabaret to do what he called "rhythmical drawing." He recalled: "I was provided with charcoal and a huge sheet of paper six foot by four, and as the music played so I sketched whatever the music suggested to me. Not only that, but my lines moved in time with the music: to a waltz they moved gracefully; to a polka they moved jerkily; to a march they went smartly, and so on. As soon as one sketch was completed the sheet was torn away and another one was ready beneath it for the next attempt."[14] Kandinsky, who was already deeply concerned with the idea of placing the effects of synaesthesia at the service of the new way he foresaw in art, must have been greatly impressed by this cabaret act. He would eventually devote a whole chapter to "color-language" in his treatise *Über das Geistige in der Kunst* (*Concerning the Spiritual in Art*), discussing at length the relationships between colors and musical instruments, rhythms and tones. He subsequently noted in "Rückblicke" how music had always called forth colorful visual imagery in his

13. See the excellent discussion of this development by Peter Jelavich, "Die Elf Scharfrichter: The Political and Sociocultural Dimensions of Cabaret in Wilhelmine Germany," *The Turn of the Century: German Literature and Art 1890–1914*, eds. Gerald Chapple and Hans Schulte, Bonn, 1980; also see Jelavich, *Theater in Munich 1890–1924: A Study of the Social Origins of Modernist Culture*, Ph.D. dissertation, Princeton University, 1981.

14. Stern, p. 27.

mind. Later in Russia he would develop an experimental workshop devoted to the study of synaesthesia and the psychology of perception.

During those same months in which he took part in the establishment of the *Phalanx*, Kandinsky had been at work on his first art review for publication. This review appeared in the Russian periodical *Novosti dnia* on April 17, 1901.[15] In the first year of the new century, then, his own thirty-fifth year, Kandinsky had clearly made the conscious decision to take an active role in public life. His activity at this time was manifestly representative of a behavior pattern that was always to distinguish his career: painting and publication, art and activism were to proceed hand in hand.

Over the next three and a half years a dozen exhibitions under the aegis of the *Phalanx* took place, and soon after the group was formed, a school of the same name was founded (here Kandinsky taught painting and Hecker and Hüsgen taught sculpture). A review of the participants in these exhibitions reveals not only the avant-garde attitude of the leader of the *Phalanx*, but also the two artistic strains which were in conflict in his mind and work during this period: naturalistic Impressionism and lyric Symbolism (Jugendstil). Kandinsky would search for a rapprochement between these two tendencies for the next several years. Both directions were represented in exhibitions of the *Phalanx* but, more often than not, the lyric Symbolist or Jugendstil works outnumbered the others. This preponderance was mirrored in Kandinsky's own work, as he exhibited more and more of his decorative designs and woodcuts, becoming ever more preoccupied with this form.

If integration of everyday life and dramatic expression in the form of the cabaret was the major subject of the first *Phalanx* exhibition, the idea of transforming life itself into the ideal *Gesamtkunstwerk* was the theme of the second. This extraordinarily large exhibition (it included 131 works) was almost entirely devoted to the Jugendstil Arts and Crafts Movement, with additional works by one of Germany's leading Symbolist painters, Ludwig von Hoffman. On the occasion of this exhibition, Kandinsky, now president of *Phalanx*, associated himself once again with an avant-garde event. This was the opening, in the summer of 1901, of the Darmstadt *Künstlerkolonie (Artists' Colony)*, the most important Jugendstil exhibition of its time. Within months of the opening, Kandinsky had invited its major artists to exhibit examples of their applied arts with *Phalanx*. Furthermore, he included crafts by members of the *Vereinigten Werkstätten für Kunst im Handwerk* and by a number of independent craftsmen, such as Emmy von Egidy, an Obrist student (cat. nos. 128, 129). Kandinsky himself exhibited four decorative designs, including *Twilight*, 1901 (cat. no. 184), significantly, one of his first fully developed crusader-horseman images.

The direct relationship between the possibilities of abstraction in painting and the exploitation of abstract ornament in Jugendstil was especially evident in the work of two of the most productive and significant artists of the *Künstlerkolonie*, Peter Behrens and Hans Christiansen. Behrens, a founding member of the Munich *Secession,* had by 1900 given up painting to devote himself entirely to architecture and the applied arts. His woodcuts of the 1890s, such as *The Kiss* (cat. no. 126), had already indicated his facility

15. Translated in Lindsay and Vergo. It is important to remember that, although Kandinsky's Munich experience is emphasized here, he always maintained close ties with Russia, through visits, exhibitions and publications. (Compare Eichner, Lindsay, Bowlt and Washton Long, and Donald E. Gordon, *Modern Art Exhibitions 1900–1916*, Munich, Prestel Verlag, 1974.)

fig. 15
Hans Christiansen
Landscape with Trees. 1899
Stained-glass window
Collection Hessisches Landesmuseum,
Darmstadt

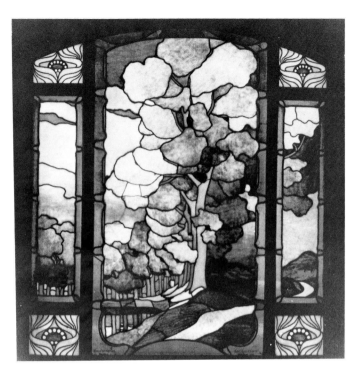

with decorative design. But in the monumental banners Behrens devised for the home he designed for himself at the *Künstlerkolonie* (cat. no. 10a-b) this abstract lyric mode, significantly expressed in paint on canvas, implied far more serious intentions.

In the case of Christiansen, an ambiguity of artistic intention persisted in his lifelong loyalty to both applied arts and painting; this ambiguity is perhaps most poignantly conveyed in his beautiful designs for stained-glass windows (fig. 15). In fact, the saturated color and opportunities for formal abstraction offered by the stained-glass medium were irresistible to many artists of Christiansen's generation. To what degree the example of stained glass influenced Kandinsky's development perhaps cannot be accurately assessed at present, but even at that time critics compared the color effects of his woodcuts to those of stained glass. (The implications of stained glass for the development of abstract art in general require further study, but are clearly evident, for example, in the work of Adolf Hölzel, who eventually devoted himself entirely to that medium in his search for what he called an "absolute" painting.)

In the second *Phalanx* exhibition, Christiansen showed ten tapestries, thirteen ceramic vases, three large carpets, six embroidered cushions and a number of table linens and curtains (cat. nos. 138, 111, 114, 116). The vases, especially the so-called *Prunkvase*, or presentation vase, perhaps affected Kandinsky most immediately. Its design of circles and wavy lines evidently made an indelible impression on Kandinsky, whose sketchbooks of this period contain drawings of the same motif and even a vase of the same shape (cat. nos. 113, 118). Eventually circles and wavy lines were to become sym-

bols imbued with poetic significance in Kandinsky's work of the Bauhaus period. *Several Circles*, 1926 (fig. 16), in the Guggenheim Museum collection, is an important example of his development of this motif.

Clearly, at this point in his career Kandinsky was enormously interested in the potential of the Arts and Crafts Movement. His notebooks are full of designs for appliqué, jewelry, ceramics and furniture (cat. nos. 118, 148, 113, 110). In addition to the four drawings he showed at the *Phalanx* and specifically designated as "decorative sketches" in the catalogue, he exhibited his painting *Bright Air*, 1902, which, in its studied formal relationships and stylization, may be characterized as a thoroughly Jugendstil work. Kandinsky also produced designs for embroidery and for clothing at this time (cat. nos. 157, 159). The dresses he designed for Münter (cat. nos. 145–147a-b) indicate not only sensitivity but also mastery of the Jugendstil vocabulary. Designs for locks and keys appear in the notebooks as well (cat. no. 149), and these reveal the typical Jugendstil exploitation of the abstract-expressive forms of nature for ornamental purposes. They may be compared with similar designs by Endell for the Hofatelier Elvira (fig. 17).

By 1904 Kandinsky's letters to Münter often allude to his enthusiastic involvement with decorative design. In February of that year he wrote: "Suddenly I am again in tune, in a mood in which I see a thousand thoughts, plans, compositions, color combinations, linear movements before me. . . ." In July he described a woodcut he had done and from which he had made a drawing and then a painting (the sequence is significant): "But I do like the Russian city with many figures. And [I've made] a similar drawing and then painted it in oil decoratively." A few days later he noted: "Suddenly I [have] in my

44

fig. 17
August Endell
Designs for Locks and Keys, Probably for Hofatelier Elvira. ca. 1895–96

head pictures, decorative paintings, embroideries, whole rooms and I'm thinking again in color. Will it last long?"[16] He had joined the *Vereinigung für angewandte Kunst*, attended its meetings, and wrote that he was working "like crazy" to prepare drawings for the society's exhibition. As the summer of 1904 progressed, his tempo of work increased and he made woodcuts for the new publishing firm established by Reinhard Piper and for exhibitions in Germany, France and Russia. In August he wrote to Münter an impassioned defense of his preoccupation with the craft of the woodcut (see p. 83). The woodcut provided an outlet for his inner need to cut through to the essence of things, and satisfied the yearning to reduce forms to abstractions while at the same time conveying symbolic meaning.

Undoubtedly, it was in the propensity of Jugendstil craft design for abstraction that Kandinsky found its greatest attraction. His close contact at this time with Obrist, the leader of the Munich Jugendstil movement, has already been noted. Indeed, in his letters to Münter between 1902 and 1904 Kandinsky often mentioned his discussions with this man whom many called a seer. Clearly Obrist was then feeling his way towards a new art form. Furthermore, the work of Obrist's students also displayed an astonishingly prophetic tendency to abstraction. Paintings by his pupils Hans Schmithals and B. Tölken reproduced in the March 1904 issue of *Dekorative Kunst* are particularly remarkable. Schmithals executed a series of paintings during this period (cat. nos. 53–56) which offer striking proof that tendencies to abstraction were not only evident in Munich by this time, but that they were producing results within Kandinsky's direct circle of acquaintances.

In fact, Kandinsky's *Phalanx* school was situated in the immediate vicinity of Obrist's newly founded arts and crafts school, known as the Obrist-Debschitz School. Münter, one of Kandinsky's students and soon to become his closest friend and companion, lived in the building occupied by Obrist's school, and Obrist attended meetings of the *Phalanx* society. Doubtless it was Obrist who arranged for the generous representation of Munich's *Vereinigten Werkstätten* in the second *Phalanx* exhibition.[17]

16. Lindsay K/M letters: 23.2.04, 1.7.04 and 13.7.04.

17. Cf. Kristian Bäthe, *Wer wohnte wo in Schwabing?*, Munich, Süddeutscher Verlag, 1965. The flyer advertising the *Phalanx* school gives its address as Hohenzollernstr. 6. Documentation on Obrist gives the address of the Obrist-Debschitz school as Hohenzollernstr. 7a. At present writing it is unclear whether the two occupied the same building, as Bäthe suggests. An interesting pendent to this is a letter from Obrist which is partially reproduced in Sylvie Lampe-von Bennigsen, *Hermann Obrist Erinnerungen*, Munich, Verlag Herbert Post Presse, 1970, giving Obrist's address as Finkenstrasse 3b; the first exhibition rooms of the *Phalanx* society were also in Finkenstrasse.

Many of Kandinsky's later associates of the *Blaue Reiter* years also devoted their energies to applied-arts designs at various times in their careers. August Macke designed for a variety of media, eventually producing interior decorations, among them murals and furniture for the Worringer Tee-Salon in Cologne (cat. no. 162). Some of his exquisite craft designs (cat. nos. 150, 163, 164) are included in this exhibition.[18] Paul Klee, too, at least once tried his hand at applied art, executing a group of designs for endpapers (cat. no. 171). That Franz Marc shared the widespread hope for social regeneration through the applied-arts movement is documented in his work and also in his correspondence and other writings. Among his craft designs is a pamphlet of patterns for a home weaving-loom (cat. no. 355). Both his original design for a tapestry of *Orpheus with the Animals* and the tapestry itself have been lost, but a cartoon which was probably carried out by another hand is extant (cat. no. 172). Marc also designed ex libris, posters (cat. nos. 173–177, 289) and embroideries, including one executed by Ada Campendonck (cat. no. 40).[19]

Despite his growing interest in decorative design, Kandinsky dutifully pursued the discipline of traditional landscape painting during this period. In the summers of 1902 and 1903 he took his *Phalanx* students into the countryside where they could paint from nature in a setting remote from the distractions of the city. We see him seated stiffly on the grass in a portrait painted by Münter at Kallmünz in the summer of 1903 (cat. no. 193). And Kandinsky painted Münter the same summer standing before her easel in the shade of the trees (cat. no. 194). Like this portrait, most of his plein-air oil studies remained small in format, and we know that Kandinsky spent a good deal of time in Kallmünz experimenting with woodcuts, decorative designs and pottery.[20] While the oil studies exhibit a certain freedom of paint application (with palette knife), and often display a sensitive orchestration of color, they clearly lack the lyric conviction of his woodcuts of the same period (cat. nos. 215, 219). The most successful of Kandinsky's early outdoor studies, the small *Beach Baskets in Holland* (cat. no. 196), were executed a year later during an excursion with Münter to Holland. Here dabs of color were applied in a free pointillist manner, leaving large areas of untouched canvas. But this was an isolated experiment. The dabs of colors closed up again to create the jewel-like mosaic surface, quite different from Impressionist pointillism, of such other-directed paintings as *Sunday, Old Russian,* 1904, and *Riding Couple,* 1907 (cat. nos. 195, 258).

The work of established Impressionist artists was presented in only two documented *Phalanx* exhibitions. These were the third *Phalanx* exhibition in the early summer of 1902, which featured Lovis Corinth and Wilhelm Trübner, and the seventh, held almost exactly a year later, which brought a group of sixteen paintings by Claude Monet to Munich.[21] Both Corinth and Trübner represented the continuation and development of German naturalism. Corinth had studied in Paris, where he was directly exposed to French Impressionism, while Trübner was inspired by the Courbet-influenced style of the Munich artist Wilhelm Leibl, with whom he was associated for a while. Both had been founding members of the Munich *Secession,* but by the time their work was shown at *Phalanx,* Corinth was in Berlin (where he had be-

18. See also Dominik Bartmann, *August Macke Kunsthandwerk,* foreword by Leopold Reidemeister, Berlin, Gebr. Mann Verlag, 1979.

19. Cf. Klaus Lankheit, *Franz Marc: Katalog der Werke,* Cologne, Verlag M. DuMont Schauberg, 1970; *Orpheus with the Animals,* no. 884, was probably painted by Marc's friend Annette von Eckhardt or Michael Pfeiffer after Marc's design. On Marc's designs for applied arts, see also Rosel Gollek, *Franz Marc 1880–1916,* exh. cat., Munich, Städtische Galerie im Lenbachhaus, 1980, p. 28 and passim. See also Lankheit, ed., *Franz Marc Schriften,* Cologne, DuMont Buchverlag, 1978, pp. 126–128.

20. Cf. Weiss, p. 123, and Lindsay K/M letters, 27.8.03.

21. Cf. Weiss, Chapter VI, which includes a more detailed analysis of the documented *Phalanx* exhibitions. The eighth exhibition included a portfolio of prints by Impressionist, Neo-Impressionist and Symbolist artists, ibid., p. 69. Neo-Impressionist works were also included in the tenth exhibition, but records of the exact titles or media have not yet come to light.

fig. 18
Akseli Gallen-Kallela
Symposium. 1894
Oil on canvas
Depicts the artist, far left, with musicians
Robert Kajanus and Jean Sibelius. Exhibited at *Phalanx IV*
Collection Gallen-Kallela Family

22. See Salme Sarajas-Korte, *Suomen var-*
haissymbolismi ja sen lähteet, Hel-
sinki, Otava, 1966. In her article
"Kandinsky et la Finlande I. 1906–
1914," *Ateneumin Taidemuseo*
Museojulkaisu, 15 Vuosikerta 1970,
pp. 42–45, Dr. Sarajas-Korte points out
that the Finnish painter Axel Haart-
man had studied with Kandinsky in
Munich in 1902, and that Kandinsky's
work was first exhibited in Finland by
the *Society of Art of Finland* in spring
1906. (At the time of writing she was
not aware of Kandinsky's connection
with Gallen-Kallela.)

come an influential member of the Berlin *Secession*) and Trübner was in
Frankfurt. Interestingly, the Monet exhibition included not a single haystack
painting. But it was advertised with a poster designed by Kandinsky, in typi-
cal Jugendstil manner, with a Viking ship on a sinuously meandering river
(cat. no. 191). It seems to have consisted of a Monet collection then touring
Europe, since works shown at both Cassirer's gallery in Berlin and at the
Viennese *Secession* earlier that year were included. (Kandinsky would have
seen these paintings during a trip to Vienna in April, since he wrote to Münter
that he had visited the *Secession*.)

The most immediate effect of both exhibitions was more political than
aesthetic, for they established Kandinsky and *Phalanx* as entities with which
to reckon. The Corinth-Trübner show elicited a respectful review in *Kunst*
für Alle, which, however, ignored the Monet exhibition. Nonetheless, Kan-
dinsky's associate Gustav Freytag recalled that the most memorable event
connected with the Monet exhibition was the visit of the Prince Regent Luit-
pold himself, and that Kandinsky escorted him personally through the show.
But, memorable or not, no record of Kandinsky's own reaction to this event
appears to have survived. These two exhibitions seem to have been dutiful
homages, on the one hand, to established secessionist taste, and, on the other,
to Kandinsky's memory of that crucial confrontation with a Monet haystack
in Moscow. His correspondence with Münter during the period of the Monet
exhibition indicates that he was in a depressed frame of mind; the dream
engendered by that earlier encounter still eluded him and, although he made
no direct reference to it, the exhibition must have been a poignant reminder.

Akseli Gallen-Kallela was the star of the fourth *Phalanx* exhibition in
1902, where he was represented by thirty-six works. A close friend of the
composer Sibelius (fig. 18) and the architect Eliel Saarinen, Gallen-Kallela
was Finland's greatest Symbolist artist.[22] He had already attracted interna-
tional attention with the exhibition he shared with his friend Edvard Munch

in Berlin in 1895, his illustrations for *Pan* the same year and with his frescoes for the Finnish Pavilion and decorations for the Iris Room at the Paris World's Fair in 1900. Kandinsky's letter of invitation to Gallen-Kallela on March 29, 1902, provides evidence of his diplomatic acumen, and also sheds light on the operation of the *Phalanx* as an organization:

> *Until now here in Munich there has been only very little possibility available for an artist to bring his talent and individuality fully before the public, that is, in an extensive way.*
>
> *Our young society has adopted primarily two goals, first, to offer to known artists the opportunity to exhibit numerous works collectively in the rooms of the Phalanx; secondly also to give unknown young artists the opportunity to step before the public.*
>
> *In accordance with our first goal then, we humbly allow ourselves to invite you to exhibit a collection of your works if possible already in the May exhibition.*
>
> *It is scarcely necessary to note that artists who are personally invited are jury-free. In the case of sales, we take 10% commission. We offer fire insurance and free transportation. The duration of the exhibitions are usually 4 to 6 weeks.*
>
> *In the pleasant hope of receiving a positive answer soon, very respectfully yours*
> *W. Kandinsky*
> *1st Chairman*
> *on behalf of "Phalanx"*

The selection submitted by Gallen included examples of both his decorative Symbolist and more naturalistic work. *Landscape Under Snow* of 1902 (cat. no. 180) exhibits a formal abstractness wavering ambiguously between the real and the symbolic. But Gallen was especially noted for his illustrations of the great Finnish folk saga the *Kalevala*, which had been rediscovered in the nineteenth century and had become an inspiration for many of the country's poets, musicians and artists (as the Nibelungen saga and the Ossian legends had inspired Wagner and Yeats). *Kullervo Goes to War*, 1901 (fig. 19), was one of the episodes from the *Kalevala* saga exhibited at Phalanx. The hero on horseback, blowing his trumpet to summon the forces of good in the world, made a lasting impression on Kandinsky. The prevalence and importance of the horse-and-rider motif in Kandinsky's work has already been noted: now trumpet-blowing horsemen would appear in a notebook, in a linocut of 1907 and in a tusche study of about 1908–09 (cat. nos. 185–187). However, Gallen-Kallela's greatest significance for Kandinsky lay not so much in his imagery, gripping as it was, but rather in his reliance on universal folk legend as the basis of a symbolism expressed in monumental decorative paintings, such as *Kullervo* and *Defense of the Sampo*, 1900 (cat. no. 179); in the brilliant saturation of his bold colors, employed with the naive directness of folk art; and in the degree of abstraction attained in many of his applied-art designs, for example, *Seaflower*, 1900–02, and the monumental rug *Flame* (cat. nos. 182, 57).[23]

23. There are seven letters to Gallen-Kallela concerning this *Phalanx* exhibition preserved in the archive of the Akseli Gallen-Kallela Museum, Espoo, Finland. Hitherto unpublished, they are exhibited here for the first time (cat. nos. 189, 190). Six are from Kandinsky, one from Freytag, the group's business advisor. Kandinsky wrote his first and last two letters to Gallen in German and the third and fourth in French. (Freytag also wrote in French.) The last two are written out in a fine calligraphic hand by an unknown secretary and signed by Kandinsky. At the time my book *Kandinsky in Munich* went to press, the catalogue of the fourth *Phalanx* exhibition had not yet come to light. Nevertheless, on the basis of the comments of the reviewer in *Kunst für Alle*, it had been possible to identify certain works that were included in the exhibition, and to conjecture that certain others might have been included (for example, *Defense of the Sampo* and *Lemminkäinen's Mother*). In the spring of 1981 I was fortunate to discover a copy of the catalogue (which is included in the present exhibition [cat. no. 356]) at the Gallen-Kallela Museum in Espoo, as well as additional reviews of the show and the letters cited above. Although in some instances the catalogue itself is vague, listing untitled prints, illustrations, designs, etc., as well as precisely titled works, we can now deduce the actual contents of the show with greater accuracy. Several important works and sketches from the *Kalevala* saga were shown, including *Kullervo—An Episode from His Youth*, a watercolor version of *Kullervo Goes to War* (also known in the literature as *Kullervo's Return from War*, *Kullervo on the Warpath* and *Kullervo's Departure for War* [fig. 19]), *Kullervo* (identified only as a "Kalevala gouache"), *Fratricide (Old Folksong)* and *Sketches for the Paris World Exhibition 1900* (which probably included *Defense of the Sampo* on exhibition here [cat. no.

fig. 19
Akseli Gallen-Kallela
Kullervo Goes to War. 1901
Tempera on canvas
A watercolor of the same motif was exhibited at *Phalanx IV*
Collection The Art Museum of The Ateneum, Helsinki

179]). Among the other paintings were several with titles indicating that they were winter landscapes, such as cat. no. 180 in the present exhibition. There were also prints and works in stained glass. Further, the letters inform us that at least two important paintings not listed in the catalogue were added during the course of the show (10 June 1902); one of them was *Symposium* (fig. 18), which was described in detail in several reviews. (Apparently, however, *Lemminkaïnen's Mother* was not shown.) The popularity of Gallen-Kallela's work is indicated by Kandinsky's request for more copies of the prints in a letter written on the day of the opening: "For these things there are already buyers here." (13 June 1902) It is clear from the reviews that the show traveled to Schulte's gallery in Berlin after closing at the *Phalanx* at the end of July.

Yet another decorative Symbolist artist Kandinsky invited to exhibit collectively with *Phalanx* was the unique Munich painter-craftsman Carl Strathmann. Strathmann is particularly interesting from today's perspective because his own contemporaries thought his work bridged the gap between the decorative and the fine arts. August Endell had expressed serious interest in Strathmann's work in 1897 in his pamphlet *On Beauty, a Paraphrase*, and Corinth published a major article on him in the Berlin art journal *Kunst und Künstler* in March of 1903, calling him "an original of our time." The following autumn Kandinsky invited Strathmann to show thirty-one works at the eighth *Phalanx* exhibition.

Strathmann's originality, like that of Jan Toorop and Gustav Klimt, derived from his capacity to subvert naturalistic traditions entirely to the abstract-expressive power of ornament. His vocabulary of abstract-expressive imagery tugged constantly at the bonds of possibility. Strathmann's two-dimensional picture plane comes alive with energy conveyed by convoluted linear devices. These devices swirl in layered veils over stylized forms which vaguely suggest remembered objects, thus rendering them ambiguous or, as in the borders of *Satan*, 1902, and *Decorative Painting with Frame*, ca. 1897, entirely illegible (cat. nos. 201, 202). Often the tangled web of ornament overflows onto the frame, a characteristic usage of Art Nouveau and Jugendstil which makes it an inextricable element of the *Gesamtkunstwerk*, transforming the painting itself into an objet d'art. But in his exploration of the world-serpent theme, to which he frequently returned, Strathmann demonstrated the seriousness of his intentions. While *Satan* remains in the realm of amusing decorative illustration, *The World Serpent*, before 1900, and *Small Serpent*, 1897–98 (cat. nos. 200, 203), despite their small format, assume a significance beyond mere decoration. The traditional symbols of serpent, tree of life, sun-moon and bird-flight used in conjunction carry a message of

49

regeneration through artistic inspiration. Strathmann's two-dimensional surface, filled with energetic allover calligraphic design and charged with symbolic significance, provided Kandinsky with an additional example of the potential of abstract design. The whiplash serpent image was to persist as well in Kandinsky's memory.

In the next *Phalanx* exhibition, the ninth, in January of 1904, Kandinsky presented the work of the young Alfred Kubin, yet another artist who consciously exploited the powerful potential of compressed surfaces energized by overall calligraphy and demonic imagery. Kubin's pictures departed, however, from the strict two-dimensionality of ornamental art; he created instead an eerily ambiguous space in which his figures often seemed to float in an obscuring primal haze. The transformation of the ordinary into the bizarre and exotic, effected by artists such as Max Klinger and Fernand Khnopff, was carried to a new level by Kubin, whose novel of 1908, *The Other Side* (cat. no. 359), a poetic allegory of the artist's own journey to the other side, into his innermost self, achieved a proto-Surrealist fusion of visual and poetic imagery. Already a friend of the Symbolist poets Stefan George and Karl Wolfskehl, Kubin now became a close associate of Kandinsky and remained so throughout the Munich period.

If Kandinsky's selection of participants for the *Phalanx* (which included Félix Vallotton, Theo van Rysselberghe, Paul Signac and Toulouse-Lautrec in the tenth exhibition in the spring of 1904) indicates a clear bias toward a lyric Symbolist mode of expression, a similar bias may also be discerned in his own work of this period. This is particularly evident in his enthusiasm for romantic Symbolist imagery expressed in the techniques of woodcut and tempera painting. By the time the *Phalanx* society exhibitions drew to a close in December of 1904, it was clear that the conflict between the lure of the decorative and the demands of more traditional naturalism was sharper than ever in Kandinsky's mind and work. But the contest leaned heavily to the side of the decorative.[24] During 1903 and 1904 he had achieved a remarkable mastery of the woodcut and had begun to enjoy his first critical success with that demanding medium. He had been approached by Peter Behrens, now head of the Kunstgewerbeschule in Düsseldorf, with an offer to take charge of the school's decorative painting section. Kandinsky refused the invitation, but threw himself with renewed enthusiasm into his woodcut production. He had found his métier in a lyric medium which brought him closer than ever to the Symbolist Jugendstil tide of the times.

III The Lyric Mode: Encounters with Woodcut, Poetry, Calligraphy, Theater

In Kandinsky's mind, the woodcut was immediately identified with lyric poetry. He had confided to Münter his frustration at being unable to compose poetry for her in German, but soon he would substitute a lyric visual image for the verse that eluded him. By 1904 Kandinsky had completed a set of such visual poems, which he published under the title *Verses Without Words* (also known as *Poems Without Words* [cat. nos. 210, 211]).

24. In February of 1904 he had exhibited fifteen works at the *Moscow Association of Artists* of which fourteen were specifically identified in the catalogue as "decorative drawings." See Gordon, vol. II, p. 85.

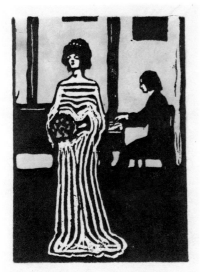

fig. 20
Vasily Kandinsky
Singer. 1903
Color woodcut
Collection, The Solomon R. Guggenheim
Museum, New York

Once again his encounter with Munich had yielded a transformation, one that marked a major turning point in his career. Munich was in fact the meeting place of Germany's most important group of Symbolist poets, whose leaders were the Mallarmé disciple Stefan George and his friend Karl Wolfskehl, known as the Zeus of Schwabing because of his prodigious intellect. Since 1892 George had been publishing an elitest Symbolist journal, *Blätter für die Kunst,* which called for reform and renewal in all the arts. It was a typically Jugendstil-Art Nouveau publication combining poetry, criticism, art reproductions and even musical scores. George's commitment to the *Gesamtkunstwerk* extended to a concern with the appearance of his poems on the page, so that he even designed a typeface resembling his own fine hand and introduced drastic reforms in the use of punctuation and capitalization.

In emulation of Mallarmé, George strove to express essence and music at the expense of discursive content in his poems, which are laden with Symbolist imagery and ambiguities. Several of the artists in his circle, including Behrens and Schlittgen as well as Kubin, were also associated with Kandinsky. Eventually Kandinsky himself became acquainted with Wolfskehl, who was among the first in Munich to purchase his work. Already by 1904 Kandinsky had paid George a silent tribute by portraying him in one of his *Verses Without Words* as a knight (St. George) in armor.

The woodcut, like the lyric poem, requires an ability on the part of the artist to reduce the means of expression to the minimum while retaining the essence of his vision or dream. In poetry such reductions are achieved by means of verbal compression and abbreviation which often result in startling fusions of verbal images, highly structured rhythm and rhyme and an emphasis on sound above discursive meaning. In the woodcut these fusions and abbreviations are achieved by compressing forms to flat planes delineated by the outline of opposing planes and reducing colors to clear contrasts or subtle harmonies. The woodcut allows, in fact demands, an abstraction from nature far more drastic than does the more plastic medium of oil paint and encourages the Symbolist preference for images of memory, dream and fantasy. The remarkable series of woodcuts Kandinsky produced between 1903 and 1907–08 exhibit an ever more soaring lyricism and an ever greater degree of abstraction as his mastery of the medium grew.

From the beginning, the woodcut was associated by Kandinsky with music as well as with poetry, quite in keeping with the Symbolist quest for a synthesis of the arts: for him the woodcut would be not only a poem but a song. Among his earliest efforts in woodcut is *Singer,* 1903 (fig. 20), in which the image makes a direct reference to music: someone is about to sing, the pianist is poised, about to strike the first chord. In this restrained print the studied geometrical composition and the subtle color harmony convey the effect of a musical chord or *Klang,* a word Kandinsky used to characterize the effect by which the successful work of art communicates its inner meaning.[25] The work of art, he said, must *klingen,* or resonate, so that the soul of the viewer vibrates with the same resonance. This thought, already expressed in his correspondence with Münter as early as 1904, recurs throughout Kandinsky's work and writings.

25. Lindsay K/M letters: 31.1.04, 25.4.04.

fig. 21
Vasily Kandinsky
Motley Life. 1907
Tempera on canvas
Collection Städtische Galerie im Lenbach-
haus, Munich

In *Über das Geistige in der Kunst* he was to call again upon the image of the artist-pianist, drawing an analogy between the artist and the hand of the pianist: the hand (artist) strikes the key (color) which moves the hammer (the eye of the viewer), which strikes the strings (the soul of the viewer). The image had already been encountered and articulated in *Singer*. In 1909 Kandinsky published a second portfolio of prints; these he called *Xylographies* (cat. no. 212), a play on words constituting a hidden reference to his musical analogy. (Xylography, an unusual word for woodcut, calls to mind the word xylophone.) The transformation was complete when, in 1913, he published his graphic masterpiece, *Klänge (Resonances* or *Sounds)*, a book of poems and woodcuts (cat. no. 360).

Singer is one of scarcely more than a dozen or so of Kandinsky's prints which make use of imagery drawn from everyday life. From the start, in his woodcuts he preferred invented imagery derived either from romantic historicism (figures in medieval or Biedermeier-style dress and settings), from folk legend or myth or from pure fancy. Kandinsky later recalled that at this early stage of his development he had needed some justification, some "excuse" to allow the freer use of colors and forms he envisioned. He had discovered that motifs from the past, real but "no longer extant," provided that justification.[26] In effect, as Klaus Brisch has pointed out, such images allowed Kandinsky to distance himself from reality.[27] *Night (Large Version), The Golden Sail, Farewell*, all 1903, and *The Mirror*, 1907 (cat. nos. 215, 216, 218, 219) and other prints demonstrate this principle. Furthermore, their easy grace, which belies the extremely demanding discipline of the woodcut tech-

26. Kandinsky as quoted in Eichner, p. 111, from notes for a lecture he prepared for the *Kreis der Kunst* in Cologne in 1914; the lecture was never delivered.

27. Klaus Brisch, *Wassily Kandinsky: Untersuchung zur Entstehung der gegenstandlosen Malerei*, Ph.D. dissertation, University of Bonn, 1955, pp. 136 ff.

nique, indicates that the artist had indeed found his métier. The same lyric quality and easy grace is apparent in such romantic tempera paintings as *Riding Couple, Motley Life*, both 1907 (cat. no. 258, fig. 21), and *Early Hour*, ca. 1906. In all these works, reality is left behind and the mind is invited to the fairy tale or dream. The various areas of color are given equal weight, diminishing any sense of real perspective and creating a mosaic-like surface on which the almost cloisonné-like figures float as if under some enchantment.

Related to the reductive techniques of both woodcut and lyric poetry, calligraphy or calligraphic design appears to have been yet another source of inspiration in the development of abstract art around the turn of the century. Adolf Hölzel, leader of the *Neu-Dachau* school, may have been the first to experiment seriously with the abstract potential of calligraphy in graphic experiments which he called "abstract ornaments" (cat. nos. 234, 235). These small abstractions were discussed in artistic circles and known to his students before 1900. (Emil Nolde, who studied with Hölzel in 1899 recalled trying to imitate his teacher's inventions.) They were also analyzed and reproduced in at least two major articles on Hölzel by the noted critic Arthur Rössler, first in 1903 and again in 1905.

By the 1890s Hölzel had already developed a stylized form of lyric-expressive landscape painting. Works such as *Birches on the Moor*, 1902 (fig. 22), were visions based less on observed reality than on a complex of inner formal relationships. Although he apparently was not personally acquainted with Hölzel in the first years of the century, Kandinsky would have been aware of his teachings and his work, which was exhibited regularly at the Munich *Secession*. Hölzel lectured widely and published as well, expressing himself in terms that in many ways anticipated the theoretical approach manifested in Kandinsky's later writings. His article "On Forms and the Distribution of Masses in Painting," published in 1901 in the prominent Jugend-

fig. 22 (cat. no. 144)
Adolf Hölzel
Birches on the Moor. 1902
Oil on canvas
Collection Mittelrheinisches Landes-museum, Mainz

ständig. Unser Auge ruht auf keinem bestimmten Punkte, sondern gleitet über die ganze Fläche.

⊙ Bringen wir an einer Stelle derselben einen dunkleren Punkt oder Flecken an, so wird unser Auge ständig auf diese Stelle hingezogen. Unser Blick wird also stets dort gefesselt werden, wo eine sichtbare Dunkelheit einer Helligkeit und umgekehrt gegenübergestellt wird.

⊙ Diesem Beispiele entsprechend können wir folgenden Satz aufstellen und ihn so erweitern:

⊙ JE MEHR UND JE STÄRKERE GEGENSÄTZE AN EINER STELLE CONCENTRIERT WERDEN, DESTO MEHR WIRD DER BLICK DES BESCHAUERS DORTHIN GELENKT.

⊙ Damit sind wir imstande, Wichtigeres vor anderem besonders zu betonen, oder bei Bildern, welche direct vor der Natur entstehen, jene Gegenstände, die die stärkeren Gegensätze enthalten, von vornherein als die wichtigeren zu erkennen und demgemäss auf die gegebenen Fläche zu placieren. Auch haben wir hiedurch alle Mittel in der Hand, Hauptsächliches und Untergeordnetes genügend zu differenzieren.

⊙ Als Gegensätze sind zu nennen: die Linearen, die Formalen, hell und dunkel, kalt und warm, horizontal und vertical auch als Flächenbewegung, viel und wenig, hart und weich, gross und klein, Ruhe und Unruhe etc.

⊙ Bringen wir auf einer Fläche zwei Punkte von annähernd gleicher Grösse und Tonstärke

248

an, so können wir, von jedem gleich stark angezogen, keinen fest in die Augen fassen. Wir werden zum Schielen gezwungen, oder unsere Augen irren im einen Punkte zum andern, ohne Ruhe zu finden. Das hierdurch im Auge des Beschauers erzeugte Missbehagen wirkt störend:

⊙ GLEICHMÄSSIGKEITEN IM BILDE SIND ZU VERMEIDEN.

⊙ Dies ist einer der wichtigsten Grundsätze, welcher sich auf verschiedene Weise als wertvoll ergeben wird. Die meisten begangenen Fehler lassen sich auf diesen Satz zurückführen; er ist daher stets im Auge zu behalten und bildet die Grundlage für die meisten folgenden Sätze und Beispiele.

⊙ Vergrössern wir einen der zwei Punkte ein wenig, so wird das Auge mehr auf den grösseren Flecken hingeleitet werden, ohne dass aber dadurch das Missbehagen vollständig aufgehoben wird.

⊙ Erst wenn wir einen der zwei Punkte derart vergrössern, dass wir ihn nach oben und den nächsten Seiten der Umgrenzungslinien hin mit diesen in Verbindung bringen, wird die erwähnte Unruhe für das Auge aufgehoben. Unser Auge wird nun vornehmlich auf den kleineren Punkt hingezogen und nicht so sehr auf die, wenn auch bedeutend grössere seitliche dunkle Masse. Diese wird, da sie sich mit der Unrahmung verbindet, nur mit einzelnen Theilen an den Gegensatz grenzen, während der kleinere Fleck von demselben fast allseitig umgeben ist. Wir folgern daraus:

249

⊙ JENER GEGENSTAND ODER FLECK, DER GRÖSSTENTHEILS VON EINEM AUFFALLENDEN GEGENSATZE UMGEBEN IST, WIRD DEN BLICK BESONDERS AUF SICH ZIEHEN.

⊙ Zeigt dieser und der vorvorhergehende Satz, wie nothwendig für einen harmonischen Eindruck das stärkere Betonen des Wichtigeren, wie das gleichzeitige Unterordnen des Nebensächlichen ist, so ist uns dadurch ein Mittel an die Hand gegeben, bei mehreren Gegenständen auch kleinere als Hauptsachen zur Geltung zu bringen.

⊙ Viele vereinzelte Flecken und Punkte auf einer Fläche erzeugen gleichfalls Unruhe.

⊙ Erst wenn dieselben zu einer grösseren Masse zusammengezogen werden, tritt das Gefühl von Ruhe ein.

⊙ Hieraus ersehen wir, dass einfachere und ruhigere Wirkungen durch Gegeneinanderstellen von Massen erzielt werden, während man durch viele kleine Flecken die angestrebte Wirkung zerreisst oder kleinlich wirkt. Bei der Wahl der Gegenstände aus der Natur wird hierauf Rücksicht zu nehmen sein, wie auch auf den Standpunkt, von welchem aus sich eine Anzahl Gegenstände zu Gruppen oder Massen vereinigt. Oder wir werden, um eine ruhigere Wirkung des aus der Natur Entnommenen zu erzielen, die vereinzelten Flecken zu Massen zusammenziehen müssen.

⊙ Als Ausdrucksmittel für eine auf die Fläche zu übertragende grössere oder kleinere Masse oder einen Flecken

250

besitzen wir aber nichts anderes als eine gleichartige, dem Gegenstande oder der Situation entsprechend geformte ebene Figur.

⊙ Diesen auf die Fläche aus der Natur wiedergegebenen, oder für das harmonische Ganze entsprechend geformten ebenen Figuren, kürzer ausgedrückt „Formen", müssen wir deshalb eine erhöhte Bedeutung zuwenden, und beim Studium der Natur für ihre malerische Verwertung werden wir auf das Sehen und Empfinden dieser Formen ein ganz besonderes Augenmerk zu richten haben.

⊙ Ist so dieses wichtige Ausdrucksmittel festgestellt und gefunden, dass damit Ruhe und Grösse im Bilde erzeugt und kleinlichen Wirkungen begegnet werden kann, so ist eine künstlerische Darstellung von Gegenständen und Ideen für den Maler mit der Erkenntnis dieses Formbegriffs überhaupt aufs Innigste verknüpft. Seine verschiedenartige Verwertung im Bilde soll uns darum eingehender beschäftigen.

⊙ Wenn wir in den zwei diagonal gegenüberliegenden Ecken der gegebenen Fläche je eine dunkle Formfigur anbringen, so bildet der helle Zwischenraum gleichfalls eine sichtbar ausgestaltete Form. Wir haben mit den zwei dargestellten dunkleren Formfiguren drei Formen gebildet, wobei die Form der helleren Zwischenfigur durch die Formgestaltung der beiden anderen bedingt ist.

⊙ Einige auf der Fläche angebrachte Formen können also bestimmend für alle anderen sein, und es erhellt daraus, dass gewisse gegebene oder erfundene Grundformen in formaler Beziehung massgebend für die Ausgestaltung und das Ge-

251

stil journal *Ver Sacrum*, was accompanied by illustrations remarkably similar to those used much later by Kandinsky in his treatise on pictorial composition *Punkt und Linie zu Fläche (Point and Line to Plane)*, begun in 1914 but not published until 1926 (figs. 23, 24). Furthermore, the reproductions of Old Master paintings Hölzel included in his article to demonstrate the fundamentally geometric bases of composition in the art of all ages anticipated Kandinsky's use of comparable works for a similar purpose in *Über das Geistige in der Kunst*. Yet Hölzel, too, wavered uncertainly between naturalism and abstraction. It was many years before he achieved a nearly total abstraction, and then it was in the medium of stained glass, rather than paint. Nonetheless, as early as 1905 his *Composition in Red I* (cat. no. 262) attained a degree of abstraction not evident in Kandinsky's work until three or four years later (cat. no. 261).

In 1908 a prominent Munich publisher, Ferdinand Avenarius, brought out a portfolio of drawings by the Dresden artist Katharine Schäffner. Schäffner attempted to capture, in this series of abstract graphic images, various psychological moods or states. In a prophetic introductory essay, Avenarius remarked on the abstract character of Schäffner's inventions and spoke of a

fig. 25
Vasily Kandinsky
Thirty. 1937
Oil on canvas
Private Collection, Paris

"new language" of forms that would lead to an art no longer representational of nature, but existing somewhere between visual imagery and music.

However, it was Kandinsky's friend Kubin who perhaps most fully exploited the potential of the linear hieroglyph for abstract expressive power. In his aforementioned book, *The Other Side,* the artist-hero "attempted to create new form-images directly according to secret rhythms of which I had become conscious; they writhed, coiled and burst upon one another. I went even further. I gave up everything but line and developed . . . a peculiar line system. A fragmentary style, more written than drawn, which expressed, like some sensitive meteorological instrument, the slightest vibration of my life's mood. 'Psychographics' I called it. . . ."[28] In Kubin's own work, the calligraphic hand nervously covered the entire surface, creating a dense allover network of expressive linear elements while at the same time eschewing any ornamental imperative (cat. no. 257).

As Kandinsky copied Moorish decorations and hieroglyphic inscriptions in his sketchbooks (cat. no. 245) during a trip to Tunis in 1905, so too August Macke exhibited a fascination with the mysteriously evocative effects of calligraphy (cat. nos. 246, 247). Works by Klee, Kahler and Bloch (cat. nos. 254–256) also provide evidence of a similar interest in the expressive potential of line exploited calligraphically in an allover network of evocative "scribblings."

In a graphic of 1913 (cat. no. 243), Kandinsky made use of a genre similar to that developed by Hölzel (cat. nos. 234, 235, 242), combining abstract hieroglyphs with text: "Drawing," he wrote under the design, "which in the strict sense is only a line, can express everything." By that time he was already employing an abstract calligraphy in such paintings as *Black Lines* (cat. no. 332). Much later, at the Bauhaus and in Paris, hieroglyphic imagery would return in his paintings, for example *Variegated Signs,* 1928, and *Thirty,* 1937 (fig. 25), recalling such Hölzel works as *Composition. Picture and Text Pen Drawing* (cat. no. 244).

28. Alfred Kubin, *Die andere Seite,* Munich, Nymphenburger Verlagshandlung, 1968, p. 140 (originally published 1909).

Kandinsky's interest in the lyric mode encompassed a concern with the theater, which he considered the ideal vehicle for the true *Gesamtkunstwerk* synthesis of the arts of which he dreamed. He was eventually to compose several "color operas" and to devote a long essay to the theater in the *Blaue Reiter* almanac. His ideas on theater represented another transformation of material he encountered on the Munich scene.

Munich theater at the turn of the century manifested an unusual degree of activity in the direction of Symbolism and general reform which cannot have failed to draw Kandinsky's attention. His interest in the *Elf Scharfrichter* cabaret has already been discussed, and he was attracted as well to the revivals of puppet and shadow-play theater taking place in the city. However, the most important manifestation of the new movement in Munich theater was the creation of the Münchner Künstlertheater (Munich Artists' Theater) by Behrens's earlier associate, Georg Fuchs. Fuchs envisioned the Künstlertheater as a Symbolist stage par excellence and the paradigmatic *Gesamtkunstwerk*. Its major innovation was the so-called relief stage which was another attempt to achieve enhanced effect through reduction to two-dimensionality. The deep perspectival stage of naturalistic theater was abandoned in favor of a drastically narrowed stage on which the effect of the dramatic silhouette could be emphasized (fig. 26). Further, Fuchs conceived of the theater as a thoroughly artistic enterprise in that all sets, costumes and music would be provided by the best artists and musicians in the community. The theater opened to great acclaim in 1908. (Edward Gordon Craig hurried to Munich to see it and reported enthusiastically about it in his magazine, *The Mask*.) But the dream-theater was never to truly fulfill its promise.

Many of Kandinsky's earliest associates in Munich were already involved in theater or later became so: Behrens's pamphlet *Feste des Lebens und der*

fig. 26
Max Littmann
Munich Künstlertheater. Summer 1908
Curtain embroidered by Margarete von Brauchitsch

Kunst (*Celebrations of Life and Art*), published at the Darmstadt Künstler-kolonie, was his manifesto calling for reform in the theater; Stern became the chief set designer for Max Reinhardt; and von Salzmann in collaboration with Adolphe Appia designed the spectacular light theater at the Jaques-Dalcroze School at Hellerau which undoubtedly had a direct influence on Kandinsky's plans for *Der gelbe Klang* (*The Yellow Sound*).[29]

Indeed, the lyric mode was to hold a strong appeal for Kandinsky throughout his lifetime. Now, as he entered a new period of activity between 1905 and 1908, traveling widely throughout Europe (returning intermittently, to be sure, to the Munich area and to his native Russia), the lyric muse accompanied him. It came to dominate his associations, his vision and his work for a time, leading him onward in his search for that new way he foresaw.

IV Departures and Returns: Transition and Self-Realization

When I was young, I was often sad. I searched for something, something was lacking, I absolutely wanted to have something. And it seemed to me that it is impossible to find this lacking thing. "The feeling of the lost paradise" I used to call this state of mind. Only much later did I get eyes, which can sometimes peer through the keyhole in the gate of paradise. I am still searching too much on earth. And he who looks down naturally sees nothing up above.[30]

When Kandinsky and Münter discovered Murnau in the spring of 1908, after a year in Paris and some months of restless wandering, it must have seemed to him that he had at last found his paradise. From the end of 1905 until the summer of 1907 they had been away from Germany, spending some months in Italy, a year in Paris. After a brief return to the Munich area, they had spent the winter months of 1907–08 in Berlin. And this rootless time had been filled with psychological stress.

With the collapse of *Phalanx* in 1904, Kandinsky had recognized his need to immerse himself in his own work and to strive vigorously toward his goal. But this inward turning had brought him face to face with his inner self, with doubts and questions and temptations. It was in Paris in December of 1906 that Kandinsky had attained his fortieth year, depressed and temporarily estranged from Münter. He was forty and still his dream of a new way in art had not been realized; it must have seemed to him that his dream eluded him fiendishly. The differential between his actual production at the time—lyrical and pleasing as it was—and the true breaking away of which he dreamed, when he measured his work against that of Matisse, Picasso, Braque, Derain, Rouault and others whose works he saw there, must have seemed to him as a vast chasm. It would have been simple for him to adapt the styles and techniques he encountered in Paris, such as the radical Pointillism or bold color combinations of the Fauves, but he could not on principle adopt such easy solutions. Kandinsky had already made this clear in a letter to Münter of April 1905, in which he had criticized Jawlensky's *Tupfenmalen* (literally,

29. See Weiss, chapter IX, for a detailed analysis of the influence of the Münchner Künstlertheater and the work of Georg Fuchs on Kandinsky's thoughts on theater and on his conception of the color operas. I am grateful to Professor Joseph Henry, director of orchestras at Ohio University, Athens, Ohio, whose long interest in the music of Thomas de Hartmann and personal acquaintance with Mme de Hartmann led to my discovery of the fragments of the score of *Der gelbe Klang*, now in the archive of the Music Library, Yale University, New Haven (cat. no. 337). Professor Henry introduced me to Mme de Hartmann, with whom I discussed my hopes for a historically authentic production of the color opera in 1976, three years before her death. I am also extremely grateful to Professor Louis Krasner of the Boston Conservatory for encouraging me to approach composer Gunther Schuller with the idea of re-creating the score on the basis of the Yale fragments. Schuller's enthusiastic response led eventually to my collaboration with producer-director Ian Strasfogel and thence to the first real attempt to stage the opera within its historical context. Professor John Stevenson of Ithaca College and Professor Selma Odom of York University, Ontario, provided much helpful information about the Jaques-Dalcroze method of dance. This production of *Der gelbe Klang* will be staged at the Marymount Theater, New York, in February 1982. The scenarios for all of Kandinsky's documented color operas are to be published in an edition by Jelena Hahl-Koch, *Kandinsky, Die gesammelten Schriften: Stücke für die Bühne*, forthcoming.

30. Lindsay K/M letters: 11.10.03.

"dot-painting") as "not quite right," and implied that it was for him a technique devoid of meaning.[31] Obrist had chided him for devoting himself to his "black" studies (the color drawings on dark ground), Münter had criticized his absorption with woodcuts. But deep within himself, he knew that it would be necessary to push this decorative or lyric style of his to its extreme.

In fact, Kandinsky's success with his graphic work had led to his involvement during the Paris year with an enthusiastic circle of admirers centered around the Symbolist journal *Tendances Nouvelles*.[32] He produced a flood of lyrical woodcuts, many of which were published in *Tendances Nouvelles*, and continued to develop the thematic ideas enunciated in such earlier Munich works as *Sunday*, *Old Russian* and *Verses Without Words* of the 1903–04 period (cat. nos. 195, 210, 211).

At last the mood and thematic content of these Munich works reached a culmination in the monumental tempera *Motley Life* (fig. 21). Completed in Paris early in 1907, it was apparently the largest painting (145 by 160 centimeters) Kandinsky had yet brought to conclusion. (Although in a letter to Münter in the summer of 1904 he had described a painting that was to measure 120 by 240 centimeters.[33]) Monumental for reasons beyond its sheer size, the painting presents in a single unified expression the universal themes of life in its multiplicity and death in its mystery, themes which were to persist long afterwards in Kandinsky's oeuvre. Stylistically, it brought to a brilliant climax the technique of disposing mosaic color dots against a dark ground to create a rich tapestry effect. Other temperas from the same year based on similar lyric themes, such as *Early Hour*, *Panic* and *Storm Bell* were also of fairly large format. The latter paintings, with their disturbed subject matter and titles evoke feelings which contrast markedly with the harmonious and confident mood of *Motley Life*. Indeed, they suggest that a new period of doubt followed the completion of *Motley Life*, particularly in view of their position in Kandinsky's house catalogue, which indicates that they were painted after *Motley Life*. This deduction is further substantiated by Kandinsky's retreat in June of 1907 to the mountain resort of Bad Reichenhall for a "rest cure" and his continuation in Berlin of the tempera paintings.[34] His work during the Paris interlude still reflected a deep schism between the lure of the decorative and the demands of naturalism, for he had continued to produce oil studies from nature in this period. Gradually his oil color was becoming more brilliant and beginning to approach the glowing quality of the color in the woodcuts. However, Kandinsky's recurrent depressions indicate that he recognized he had not yet found a satisfactory solution to this stylistic conflict.

In the late spring of 1908 Kandinsky and Münter returned again to the mountains of Bavaria—always a favorite area of theirs for painting and recreational excursions—visiting Murnau in June and again in August, then taking an apartment together in Ainmillerstrasse in Schwabing with a grateful sense of returning home. Consciously Kandinsky put the tempera paintings and woodcuts behind him and stood resolutely before the Bavarian landscape.

Nestled scenically between the shore of Lake Staffel and the broad Murnau moor, the old market town of Murnau lay in almost pristine beauty at

31. Letter from Kandinsky to Münter, 26.4.05, partially quoted in Eichner, p. 88.

32. The richness of Kandinsky's involvement with the interesting personalities of the *Tendances Nouvelles* group is well documented in Fineberg, op. cit.

33. Lindsay K/M letters: 13.7.04.

34. Eichner, p. 53.

the foot of the Wetterstein and Karwendel Alps, beneath Garmisch-Parten-kirchen and only a few miles below Oberammergau. The wooded *Kögeln*, or hills, that were once islands in an Ice Age sea added a picturesque note to an otherwise almost too dramatic view. Clean air and the brilliant light characteristic of the subalpine climate appeared to diminish perspective, so that the hills and mountains seemed to share, at an indeterminate distance, a narrow crystalline plane. Far from the competitive distractions of the city, Murnau offered a tranquil retreat.

As if a gate had suddenly opened onto a new vista, Kandinsky now experienced a liberation in style that represented a drastic break with the recent past. All at once, there seemed to be a way to resolve the dichotomy between his impressionist landscapes and the lyric works that had held his heart in thrall for so long. In several later statements Kandinsky explained that his transition to abstraction had been effected by means of three major steps: the overcoming of perspective through the achievement of two-dimensionality; a new application of graphic elements to oil painting; the creation of a new "floating" space by the separation of color from line.[35] In fact, numerous changes began to take place at this point in his career. Now for the first time he began to transfer to the oil medium the elements he had so successfully learned to manipulate in his woodcuts and lyric tempera paintings, namely line, flat planes of saturated color and the "noncolors" of drawing, black and white.

This transfer was so successful that some paintings exhibited the characteristics of woodcuts. The graphic qualities of flattened perspective, an ambivalent equality of positive and negative forms, and a clear definition of forms can be observed in comparing his painting *Landscape near Murnau with Locomotive*, 1909 (cat. no. 260), with a woodcut on a similar theme by Martha Cunz (cat. no. 259)—a print with which Kandinsky would have been familiar.[36] So intense was Kandinsky's preoccupation during 1908 with the transference of this lyric manner to landscape painting that he abandoned woodcut and tempera almost entirely and instead devoted himself to landscape painting in oil. For the first time since the earliest student years, the landscape genre outweighed the decorative. Only two woodcuts may have been executed that year: these are *Archer* and the abduction motif for the *Neue Künstlervereinigung* membership card (cat. nos. 269, 276), both of which were also the subjects of oil paintings. In fact, the successful transference of the graphic to the painterly resulted in an interchangeability of media such that the same subject was often to appear in both idioms. For example, *White Sound* and *Lyrical*, both 1908, as well as *Archer* and the abduction motif, appear as both oil paintings and as woodcuts (cat. nos. 265–268).[37] This represented a significant breakthrough, since the techniques of woodcut and tempera had with few exceptions previously been reserved for lyric or fantasy subjects. The only interchange between media had occurred in the transferring of a decorative "color drawing" (tempera on colored cardboard or paper) to woodcut. Landscapes were formerly executed almost exclusively in oil, and in a more or less impressionist manner. Now, however, the thoughtful, constructive, graphic method (what Eichner called the "applied arts"

35. Kandinsky, *Über das Geistige in der Kunst*, Bern, Benteli-Verlag, 1965, pp. 110–112 (originally published by Piper & Co., Munich, 1912); Eichner, pp. 111–113; Karl Gutbrod, ed., *"Lieber Freund ..." Künstler schreiben an Will Grohmann*, Cologne, DuMont Schauberg, 1968, pp. 60–61 (letter of 23.11.32); Kandinsky, "Mes gravures sur bois," *XXe Siècle*, no. 27, December 1966, p. 17 (originally published in *XXe Siècle*, no. 3, 1938).

36. On the relationship of the Cunz woodcut to Kandinsky's work, see Weiss, p. 128.

37. See the photograph of the lost oil painting based on the abduction motif reproduced in Röthel, p. 471 (no. 19).

method) of the woodcuts and decorative tempera paintings, with their mosaic or cloisonné-like paint application, is carried over into the oils painted from nature. For the first time the two genres share an equally colorful yet structured confidence of execution, as demonstrated in *Before the City* and *White Sound*, both 1908 (cat. nos. 299, 265).

By 1909, when the lyric pictures based on fantasy themes returned to take their place side by side with the landscapes, line as contour was emphasized equally in both genres, and the medium employed for both was oil, as exemplified in *Winter I* (fig. 27) and *Blue Mountain* (cat. no. 296), both 1909. Soon linear schemata replaced more representational forms. And with the resolution of stylistic conflict, Kandinsky began once more to produce woodcuts. In 1909 the portfolio *Xylographies* was published in Paris, albeit with woodcuts of the 1907 period; and he had begun to think about executing an album of music and woodcuts, and perhaps another with text and woodcuts.[38] By 1910 he was once again making woodcuts with his old gusto.

Kandinsky now felt confident enough of the new development in his style to accord the old dichotomy a kind of official recognition by assigning verbal categories to the different modes. Those paintings derived directly from observations of nature he would now designate as "Impressions"; those lyric works which derived from fantasy or, as he was to say, "impressions of inner nature," he would call "Improvisations"; and on the major canvases which required slow and thoughtful preparation (in reality extensions of the second category), he would bestow the selective title "Compositions." Although the explanation of these categories did not appear in print until publication of *Über das Geistige in der Kunst* in 1911, the first Improvisation title was used by 1909. While all of his works were not differentiated in their titles by these designations, their categories can, in fact, easily be discerned. Significantly, the "impressions of inner nature" were still almost invariably larger than the nature studies.

38. Compare Erika Hanfstaengl, ed., *Wassily Kandinsky-Zeichnungen und Aquarelle im Lenbachhaus München*, Munich, Prestel Verlag, 1974, no. 121, p. 54, and Röthel, p. 445.

Previously, the landscapes from nature had been restricted to very small format, and only the lyric paintings had achieved monumental proportions. Gradually, however, during the 1908-09 period the sizes of the oil landscapes began to increase. Still, it was not until 1910 that they approached the scale of paintings with fantasy themes. In 1911 the designation "Impression" was first used, and the largest of them, *Impression II (Moscow)* (120 by 140 centimeters), was still not as large as the lyric painting of 1907, *Motley Life.* Nevertheless, there was now a real consonance of style and execution between the two categories, the Impressions and the Improvisations sharing the technical breakthrough of emancipated color and line used schematically to suggest the barest outline of objective content: compare, for example, *Impression V (Park)* and *Improvisation 20* (fig. 28), both of 1911.

Kandinsky's new confidence spilled over into all aspects of his life. As in the early days of his emancipation from apprenticeship, now too he moved to take an active role in the artistic life around him. He participated in the founding of an exhibition society, the *Neue Künstlervereinigung München (NKVM; New Artists' Society of Munich)*; he began to organize the notes he had kept over the years for a book and for his color operas; and he resumed reporting on the Munich art scene for Russian journals. A new confidence was evident in his personal relationships as well. He now lived openly with Münter and introduced her as "my wife—Gabriele Münter." Together they furnished the apartment at Ainmillerstrasse and looked for a house in Murnau. When Münter purchased one the following year, Kandinsky joined enthusiastically in its decoration, creating a stenciled design of leaping horses and riders for the stairway (cat. nos. 33, 34), and painting furniture in the bright, raw colors of peasant tradition (cat. nos. 30–32). Once more, the decorative became an integrated part of his life, and he joined Münter in

fig. 28
Vasily Kandinsky
Improvisation 20. 1911
Oil on canvas
Collection Puschkin-Museum, Moscow

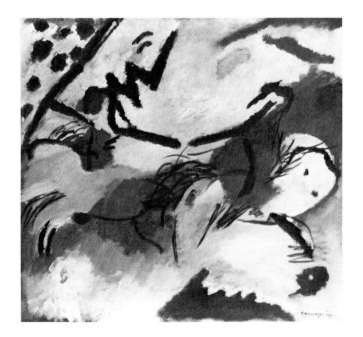

collecting and imitating examples of peasant art such as the indigenous *Hinterglasmalereien* (glass paintings) and wood carvings of the area (cat. nos. 318, 320, 35–37, 39).

With the foundation of the *NKVM* in January of 1909, Kandinsky again established himself as an active force on the Munich scene. He had renewed his acquaintance with his compatriots Alexej Jawlensky and Marianne von Werefkin, whom he had known since his days at the Ažbe school, and with Alfred Kubin. In addition to these friends and Münter, the *NKVM* included Adolf Erbslöh, Alexander Kanoldt, Paul Baum, Vladimir von Bechtejeff, Erma Bossi, Karl Hofer, Moissey Kogan and the dancer Alexander Sacharoff. Pierre Girieud, Emmi Dresler and others were to participate in the first exhibition of the group, which took place the following December. It was a sizeable organization with an international membership at a time when there was a growing isolationism in the arts in Germany. The membership circular (cat. no. 282) articulated Kandinsky's concept of an artistic "synthesis" which unites all artists and by means of which, dispensing with all that is extraneous, only the "necessary" is brought to expression. Kandinsky designed the signet and poster of the *NKVM* (cat. nos. 272–274, 271), as he had done for the *Phalanx*.

At the first *NKVM* exhibition Kandinsky showed five paintings, a sketch, two studies and five woodcuts. The two largest and most expensive works were *Picture with Crinolined Ladies* and *Picture with Boat*, both 1909 and both paintings of the lyric or improvisational mode. *Group in Crinolines* (cat. no. 284), in the Guggenheim Museum collection, is a painting of the same theme and year as *Crinolined Ladies* (it was not, however, included in the *NKVM* show). Among other works exhibited were Pierre Girieud's *Judas*, ca. 1909, and Bechtejeff's *Battle of the Amazons*, ca. 1910 (cat. nos. 286, 297).

But it was the second exhibition of the *NKVM* in the autumn of 1910, which, as Peter Selz has said, was the first exhibition anywhere "in which the international scope of the modern movement could be estimated. . . ."[39] Georges Braque, David and Vladimir Burliuk, André Derain, Kees van Dongen, Henri Le Fauconnier, Pablo Picasso, Georges Rouault and Maurice Vlaminck were among the new exhibitors. Ironically, Munich, which, in the years since the demise of *Phalanx*, had lost its position as Germany's first art city to Berlin and had grown increasingly conservative, again became the center of an avant-garde of international scope. Moreover, Kandinsky himself had become an international figure.

Kandinsky exhibited four paintings and six woodcuts at the second *NKVM* show, demonstrating his continuing conviction regarding the value of that lyric medium. Of the paintings, only one was a landscape; the others were of the improvisational lyric mode: *Composition II*, *Improvisation 10* and *Boatride*, all 1910. *Composition II* was the largest painting he had yet produced (200 by 275 centimeters, that is, almost exactly twice the size of the Guggenheim's *Study* for the canvas [cat. no. 285], which was lost in World War II). Significantly, the three major paintings Kandinsky selected for inclusion in this exhibition represented three major breakthroughs in his progress toward an art entirely divested of reference to the external world, three steps

39. Peter Selz, *German Expressionist Painting*, Berkeley and Los Angeles, University of California Press, 1957, p. 193, and Gordon.

to abstraction which he himself later identified as such: freedom from perspective (*Composition II*), use of line as a painterly element (*Composition II* and *Improvisation 10*) and the painterly use of the "graphic" colors black and white (*Boatride*).

The flat, tapestry-like quality of *Composition II* was immediately singled out as an object of scorn by Munich critics who castigated the entire exhibition as the work of madmen or "morphine drunks." *Composition II*, wrote one wag, was like nothing so much as a sketch for a tapestry, and the title a mere excuse by an artist who could think of nothing better.

The catalogue of the second *NKVM* exhibition contained the most extensive programmatic statements yet made on the occasion of a group show organized by Kandinsky. In addition to a lyrical, almost messianic, proclamation by Kandinsky, there were essays by Le Fauconnier, the two Burliuk brothers and Odilon Redon, as well as a reprint of an unsigned introduction to a catalogue for a Georges Rouault exhibition. The intermingling of a multiplicity of themes and ideas, the unity in diversity represented by the conjunction of these essays was characteristic of Kandinsky's approach. It was a literary parallel both to the exhibition of heterogeneous works of art and to the all-embracing thematic content of his own *Composition II*. Le Fauconnier wrote of the structural basis of art, articulating an essentially Cubist point of view; the Burliuks drew an analogy between the traditional Russian arts of the *lubki* (or folk print), the icon and church frescoes and the best of modern French art from van Gogh to Matisse and Picasso; Redon spoke as a Symbolist of the "suggestive art" which can call forth dreams, and of a younger generation which would be more receptive to this idealistic art. The essay on Rouault particularly took note of his role as both artist and craftsman (painter and ceramist) as exemplifying an ideal union between art and life comparable to that of medieval times. Kandinsky's hymn to the creative act gave expression to the mystery and pain through which the artist creates a work out of conflicting elements, and of art as the "language" through which humans speak to one another of the "suprahuman."

The confidence Kandinsky displayed in his artistic production and in his activism was reflected as well in the critical judgements he expressed in his reviews for the Russian journal *Apollon*, five of which were published in 1910–11. He tore into the complacency and conservatism into which Munich had declined, and reported with obvious relish the intensity of the reactions provoked by the *NKVM* exhibitions. But more importantly the reviews document his observations and opinions on major artistic events that were still taking place in Munich. For example, the reviews particularly reveal the great impact exerted on Kandinsky by the major Munich exhibition of Japanese and East Asian Art (in the summer of 1909) and the monumental exhibition of Mohammedan Art in the summer of 1910. In the Japanese exhibition Kandinsky was particularly impressed by the outstanding group of woodcuts which, he wrote, displayed an "inner sound" that unites them in their very diversity. In commenting on the Mohammedan exhibition, Kandinsky noted that he had already become familiar with Persian miniatures in the Kaiser Friedrich-Museum in Berlin but was completely enchanted by them again in

the Mohammedan show. He remarked especially on their technical virtuosity, their extreme beauty, their total freedom from reality, the "sometimes insidious beauty of the line," the "primitiveness" of color, the "seething abundance" of details which nevertheless reveals an "inner realm." He marvelled at the way the tiny figures seemed to be "modeled," yet at the same time appeared to "remain in the plane" of the picture, the magical way perspective was overcome by simple devices such as turning the heads of horses in a team so that they are visible although one runs in a row next to the other. In short, he admired the artistic freedom of these virtuosos.

In his third *Apollon* review, published in April of 1910, Kandinsky commented on two exhibitions brought by Thannhauser to his Moderne Galerie in Munich (where the *NKVM* had shown): one by the Swiss artists Cuno Amiet and Giovanni Giacometti, the other by a group of Fauvist painters. His warmest remarks were reserved for Matisse, but most interesting was his attack on the Fauvist method in general. Although it is often said that Kandinsky was much influenced by the Fauves during his year in Paris, there is little real evidence to support such a view except possibly the brightening of his palette after his return, and in this review he raised questions which clearly indicate his distance from them. While he found the Fauve's *peinture* itself beautiful, he criticized their attachment to the fortuitous details of reality. He observed that their arbitrary use of color achieved little more than the presentation of nature "colored in various ways, just as one may paint a house, a chair or a cabinet in various manners." But these differently colored objects remain objects and have not been "transformed" into art. He perceived that the "linear element" had not been emancipated, except in the work of Matisse. These artists, he wrote, have not yet developed a language necessary for the creation of a truly painterly composition.

If Munich's own art scene had grown stale, nevertheless the city was still, perhaps more than ever before, a center of international culture, as the presence of these exhibitions abundantly indicated. The Far and Near Eastern exhibitions excited international interest and visitors flocked to Munich to see them. Matisse made a special trip to Munich for the Mohammedan show, and Roger Fry reviewed it enthusiastically for *The Burlington Magazine*.

While these selections from Kandinsky's reviews indicate to some degree the breadth of his experience and the thoughtfulness with which he approached a wide variety of artistic phenomena, they barely begin to suggest the true spectrum of his interests during this period. For example, at this time Kandinsky and his colleagues were also discovering the attractions of Bavarian folk art (figs. 29, 30), especially the *Hinterglasmalereien* and wood carvings that were a cottage industry in the Murnau area. The naiveté with which the universal religious motifs were rendered and the freshness of color in the glass paintings held immense appeal for Kandinsky and the artists of his circle, who themselves began to experiment with the medium. Not only were the formal simplifications, the bright colors, the crude uninhibited drawing appealing, but also the universal religious myth retold in this simple way carried its own impact. Kandinsky was later to state that eventually he turned to more universal subjects after leaving his purely Russian folk themes be-

fig. 29
Votive Painting from Parish Church of
St. Nikolaus, Murnau
Paint on panel

fig. 30
St. Luke. Upper Bavaria, ca. 1800
Glass painting

hind.[40] Indeed, the universal roots of the Christian myths so naively reported in the artifacts of the peasants held a special appeal for Kandinsky, who recognized here the potential value of such a symbolic vehicle for communicating his own message.

As he was to remark in *Über das Geistige in der Kunst*, objects have their own inner sounds and to do away with them all at once in an effort to arrive at pure abstraction would simply diminish the store of devices with which the artist communicates fundamental truths.[41] He had already found it possible to suggest this inner sound of objects with the barest minimum of linear means. And now he discovered another device within the vast "arsenal" at the artist's disposal: the peasant depictions of the myths of creation, confrontation, passage or death, regeneration and salvation. Kandinsky noticed that in the naively executed *Hinterglasbilder* these universal myths were transmitted instantaneously, without the excess baggage of culture and learning. Such immediate transmission of eternal truth was what Kandinsky hoped to achieve by shedding the dross of accumulated pictorial tradition.

During this period, a propitious result of the second *NKVM* exhibition was the meeting with Franz Marc, whose enthusiastic comment on the show in a letter to Thannhauser led to an immediate friendship with Kandinsky, who was greatly impressed by the younger artist's sensitivity to his own work and ideas. Indeed, at the same time that Kandinsky was composing his ec-

40. Letter to Will Grohmann, 12.10.24, in Gutbrod, ed., pp. 46–47.
41. Kandinsky, *Über das Geistige in der Kunst*, pp. 70–71, 117, and also Eichner, p. 112.

static lines on the Mohammedan exhibition for *Apollon*, unbeknownst to him, Marc was writing:

> It is a shame that one cannot hang Kandinsky's great Composition [II] and others next to the Mohammedan tapestries at the Exhibition Park. A comparison would be unavoidable and how educational for us all! Wherein lies our amazed admiration of this oriental art? Does it not mockingly show us the one-sided limitation of our European concepts of paintings? Its thousand times deeper art of color and composition makes a shambles of our conventional theories. We have in Germany scarcely a decorative work, let alone a tapestry, that we could hang next to these. Let us try it with Kandinsky's Compositions—they will stand this dangerous test, and not as tapestry, rather as "Pictures." What artistic insight hides in this unique painter! The grand consequence of his colors holds the balance of his graphic freedom—is that not at the same time a definition of painting?[42]

By this time Kandinsky and his colleagues were preparing for the third exhibition of the *NKVM*, which was scheduled to take place in December of 1911. But tensions were brewing, and Kandinsky had already stepped down as president when Marc formally joined the group in February of that year. This was to be the year of the infamous *Protest deutscher Künstler*, published in spiteful chauvinistic fury by the Worpswede artist Carl Vinnen, with a long list of supporters from Germany's artistic establishment. The protesters attacked the importation of foreign art into Germany by dealers and museum directors, a situation which they claimed was stunting the growth of pure German art. The pamphlet appeared in the spring, and was immediately met with a counterattack inspired by Marc, edited by Alfred Heymel (publisher of the beautiful but short-lived Jugendstil journal *Insel*) and published by Piper of Munich in *Kampf um die Kunst*. This counterattack included the signatures of the most prominent non-establishment artists in Germany, among them Max Liebermann, Corinth, Max Pechstein, Emil Orlik, Rudolf Bosselt, Henry van de Velde and, of course, Marc and Kandinsky. Critics and dealers who signed included Wilhelm Worringer, Hans Tietze, Paul Cassirer and Wilhelm Hausenstein. Kandinsky's lyrical panegyric began: "Like the world and the cosmos equally, man consists of two elements: the inner and the outer. . . ." Today, he wrote, artists need the external element which provides structure, but in future, painting will achieve the state of pure art already attained by music.

The more conservative artists of the *NKVM*, led by Erbslöh and Kanoldt, began to look askance at their colleagues. Perhaps this talk of "pure painting" was serious. Besides, Kandinsky was a foreigner. By August, Marc and Kandinsky were aware that the *NKVM* could not be held together, and Marc predicted in a letter to his friend Macke that a split would follow the next jury meeting in late fall. In fact, when the *NKVM* jury did convene in early December, a quarrel developed over the question of whether or not Kandinsky's *Composition V* of 1911 would be allowed in the show. Members were supposed to be permitted two jury-free paintings in each exhibition, so

42. Lankheit, *Franz Marc Schriften*, pp. 126–127. It is interesting to note that Marc's comments were written in September, while the critical attack comparing *Composition II* to a sketch for a modern carpet or tapestry appeared in *Kunst für Alle* in November.

fig. 31
Vasily Kandinsky
The Blue Rider. 1903
Oil on canvas
Bührle Collection, Zürich

long as they were not over four square meters in surface. Since the majority of the jury opposed the painting, and since it exceeded the acceptable size by a few centimeters, it was to be refused. Marc tried to convince the members to change the rules, which in any case had never been strictly observed, but to no avail. Whereupon Kandinsky, Marc, Münter and Kubin resigned at once.

In 1904 Kandinsky had written to Münter: "Art is conflict and victory and happiness."[43] It seemed to him now that victory was in the offing; the battle was engaged.

V The Blue Rider: Exorcism and Transformation

The horse-and-rider motif had become a dominant one in Kandinsky's work during the year 1911. This most consistent of his images became his personal emblem.[44] Before the year was out, it was to be assigned an awesome burden: as the Blue Rider it would carry a message of exorcism, healing and salvation to the world.

From its earliest appearance around 1901 in such works as *Twilight* (cat. no. 184) as a charging knight and as the mysterious blue-coated messenger in *The Rider* (now known as *The Blue Rider*) of 1903 (fig. 31) to the many riders of the woodcuts—trumpeting messengers, flying crusaders—to the horsemen of the Impressions, Improvisations and early Compositions, the motif had symbolized encounter, battle and quest. Now leaping, lyrical, victorious, the horse and rider became a veritable symbol of encounter, breakthrough and transformation. In *Lyrical* of 1911 (cat. no. 267), he was transformed into a heroic figure of monumental proportions, dwarfing the landscape; and in *Ro-*

43. Lindsay K/M letters: 18.7.04.

44. In a letter to Marc written on 1.9.11, Macke praised Kandinsky's work in lyrical terms and said: "His storming riders are his coat of arms. . . ." (Wolfgang Macke, ed., *August Macke-Franz Marc: Briefwechsel*, Cologne, DuMont Schauberg, 1964, p. 70.) In his article on "The Genesis and Meaning of the Cover Design for the First Blaue Reiter Exhibition Catalog," *Art Bulletin*, vol. XXXV, 1953, p. 49, Kenneth Lindsay called the horse-and-rider motif Kandinsky's "symbol of poetic inspiration."

fig. 32
Vasily Kandinsky
Romantic Landscape. 1911
Oil on canvas
Collection Städtische Galerie im Lenbach-
haus, Munich

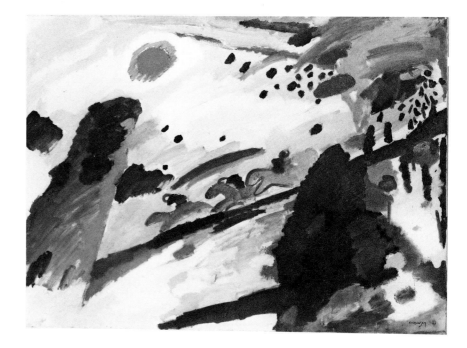

mantic Landscape, joined by two others, he plunged down a rocky precipice
(fig. 32). Then in rapid succession that same year, the horse and rider became
St. George slaying the dragon, a St. George almost recklessly cavalier, in
three major paintings and several glass paintings, watercolors, woodcuts and
sketches (for example, cat. nos. 318, 319 and fig. 33). The horseback saint
appeared in other works as well: in two entitled *All Saints* (one on glass)
and in the glass painting *Composition with Saints.* But his most enduring
and significant embodiment was to appear on the cover of the *Blaue Reiter*
almanac (cat. nos. 311–317, 365).

In June of 1911 Kandinsky had written to Marc about his idea of found-
ing a new art journal, a yearly almanac, that would represent, in his words,
"a link with the past and a ray into the future. . . ." It would be both "mirror"
and complex synthesis: "a Chinese [work] next to a Rousseau, a folk print
next to a Picasso . . . [we will include] writers and musicians. . . ."[45] Klaus
Lankheit has described in detail the mounting excitement through the sum-
mer and autumn as plans for the almanac moved forward. By September they
were ready to make a public announcement, and Marc revealed their plans
for the first time to August Macke in a veritable ecstasy, writing that the
publication had become "our whole dream." Describing their concept of
presenting illustrations of folk and ethnic art together with examples of
modern art, he added: "We have hopes for so much [that is] healing and
inspirational from it."[46] In fact, the concept of the book as an agent of heal-
ing, even of exorcism and salvation, was to be reflected not only in its title,
but in the selection and arrangement of the illustrations. The title was also
chosen sometime in September and because, as Kandinsky was later to ex-
plain, "we both loved blue, Marc—horses, I—riders."[47] By that time, Kan-
dinsky had already defined blue in his manuscript for *Über das Geistige in*

45. Kandinsky to Marc, 19.6.11, quoted in
Klaus Lankheit, ed., *The Blaue Reiter
Almanac* edited by Kandinsky and
Marc, documentary edition, New York,
The Viking Press, 1974, pp. 15–16.

46. Marc to Macke, 8.9.11, quoted in
Wolfgang Macke, pp. 72–74. Instead
of Sindelsdorf, Marc wrote his address
at the top of the letter as *"Symbolds-
dingen,"* a playful comment on this
symbolic enterprise.

47. Kandinsky, letter to Paul Westheim in
Das Kunstblatt, XIV, 1930, pp. 57–60.

fig. 33
Vasily Kandinsky
St. George I. 1911
Glass painting
Collection Städtische Galerie im Lenbachhaus, Munich

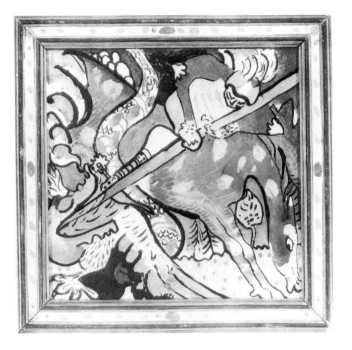

der Kunst as "the typical heavenly color," and St. George had become a dominant figure in his painting. The Blue Rider's symbolic function was not in doubt. Thus, when faced with the pressing need for a title for their "secessionist" exhibition, they were ready: it became the *Erste Ausstellung der Redaktion der Blaue Reiter* (*First Exhibition of the Editorial Board of the Blaue Reiter*).

Not only Marc but other catalysts entered Kandinsky's magnetic field in 1911. The auspicious meeting with Marc was soon followed by encounters with other figures in the arts. On the day after New Year's 1911, Kandinsky and Marc, together with other members of the *NKVM*, attended a concert of music by the Viennese composer Arnold Schönberg, which precipitated another stimulating contact. By autumn Kandinsky had met Marc's friend Macke, and his uncle and patron Bernhard Koehler, as well as Klee, who had been his neighbor for some time. For the first time Kandinsky felt himself surrounded by a circle of admiring colleagues capable of understanding his intellectual and aesthetic message. Buoyed by their moral support, he was ready to take the reins of artistic leadership.

The stupendous momentum now engendered was discharged in Kandinsky's production of some forty or more major paintings, many glass pictures, watercolors, sketches and woodcuts. At the same time he worked on the final details of the manuscripts for *Über das Geistige* and also produced the woodcuts for the book's vignettes and cover, where the horse and rider would assume a place of honor. He served as the rallying point for Marc's drive to publish the counterattack to Vinnen's *Protest* and contributed an essay to it.[48] Together with Marc, he forged plans for the almanac, maintaining a prodigious correspondence and actively seeking ways to fund the project. He worked on two major essays for the almanac and revised his color

48. Marc to Macke, 12.4.11, quoted in Wolfgang Macke, pp. 52–53. For more detailed information on the meeting of Kandinsky and Klee, see Christian Geelhaar, "Paul Klee: Biographische Chronologie," and Charles W. Haxthausen, "Klees künstlerisches Verhältnis zu Kandinsky während der Münchner Jahre," in Armin Zweite, ed., *Paul Klee: Das Frühwerk 1883–1922*, Munich, Städtische Galerie im Lenbachhaus, 1979, pp. 27, 98, 127.

opera notes to produce the scenario for *Der gelbe Klang,* which would conclude the publication. Concurrently, he exhibited in Paris, Cologne, Berlin, Weimar and Odessa and wrote reviews for *Apollon.*

Thus the schism with the *NKVM* that occurred on December 2, 1911, must be seen within the context of this frenetic period as just another, not unexpected hurdle in the race. Within a scant two weeks the Editorial Board of the *Blaue Reiter* was prepared to mount a modest exhibition of forty-three works by diverse artists—an exhibition that was to become a legend.[49] The catalogue (cat. no. 366) was equally modest in extent—five small pages that incorporated Kandinsky's brief statement of purpose: "In this small exhibition we seek to propagate not *one* precise and special form, rather we propose to show in the *diversity* of the represented forms how the *inner wish* of the artist is variously shaped." Announcement of the coming publication of the *Blaue Reiter* almanac was included, and Kandinsky's manifesto *Über das Geistige in der Kunst* appeared in time for the exhibition.

Kandinsky was represented with one example of each of his three categories of paintings: *Composition V, Improvisation 22* and *Impression—Moscow.* The other exhibitors were: Marc, Macke, Münter, Schönberg, Henri Rousseau, the Burliuk brothers, Heinrich Campendonk, Robert Delaunay, Kahler, Elizabeth Epstein, Jean Bloe Niestlé and Albert Bloch. (All but Niestlé, an animal painter and friend of Marc, and Epstein, a student of Kahler, would be represented by illustrations in the pages of the *Blaue Reiter* almanac.) Both the exhibition and the almanac were intentionally shocking. Next to Niestlé's ultra-realistic and tenderly rendered paintings of birds, in which even the most unsophisticated viewer could read a message and observe the high technical virtuosity of the artist, hung the crude otherwordly visions of Schönberg, the non-artist (cat. no. 340); and next to Schönberg, the naive renderings of Rousseau, whose work Kandinsky had already compared to Schönberg's as exemplifying what he called "the great realism" in painting. Near Kahler's small, finely drawn *Garden of Love,* hung Delaunay's large *Eiffel Tower,* its subject depicted in an alarming state of explosive dissolution, and his *City* with its obscuring veil of spots daring the viewer to find the tipped roofs of barely identifiable buildings. Marc's monumental painting of an unlikely yellow cow kicking up her heels in unbovine rhapsody (cat. no. 303) provided a dazzling contrast to Kandinsky's even larger *Composition V* (cat. no. 300), with its muted color and seemingly impenetrable hieroglyphics.

This year of incredible creativity and activity culminated, then, in the tandem events of the exhibition that once and for all proclaimed Kandinsky the leader of the new movement toward pure painting and the publication of his manifesto *Über das Geistige in der Kunst*: the public pronouncement both in practice and in theory of his ultimate transformation, of his leap to abstract art.

But even friendly critics such as Wilhelm Michel, with whom Kandinsky had corresponded (and who was also a personal friend of Klee), found it difficult to respond to what Michel termed Kandinsky's "hieroglyphic" art.[50] For Kandinsky this reaction was grist for the mill; he had already diagnosed

49. Indeed, the secession from the *NKVM* may well have been intentionally forced, as is suggested between the lines of Marc's correspondence with Macke during the months from August to December 1911. Even as early as February of that year, Marc had reported that Erbslöh and Kanoldt were in opposition to Kandinsky (letter to Maria Franck, 13.2.11, partially quoted in Gollek, *Franz Marc 1880–1916,* Munich, Prestel Verlag, 1980, p. 34). As has been noted, by August he reported that it was clear to both of them a break was in the offing. In fact, the artificial quarrel over the size of *Composition V* might have been breached had Kandinsky been willing to substitute another painting. The equally important *Composition IV* would have fit the required measure and could therefore have been hung without jury approval. Obviously, breaching the argument was not the point; both parties must have felt that the schism was inevitable. In fact, Kandinsky later recalled that he and Marc had prepared for this eventuality and thus were ready immediately to provide Thannhauser with an alternate selection for a separate exhibition.

50. Wilhelm Michel, "Kandinsky, W. *Ueber das Geistige in der Kunst,*" in *Kunst für Alle,* September 15, 1912, p. 580.

the problem as a rift within the soul of contemporary society. At the beginning of *Über das Geistige* he had written: "In our soul there is a crack and it rings, when and if one is even able to touch it, like a precious vase long hidden in the depths of the earth which has been found again and which has in it a crack."[51] This inner fracture, caused by the nightmare of our materialistic epoch, makes it impossible for the modern soul to ring when touched by the subtle vibrations the artist seeks to evoke by means of his work. But there is an art, an art dependent not on styles and timely modes, which follows only the impulse of "inner necessity" and has an inspiring, prophetic power and is capable of healing the crack in the inner soul of mankind. This new art of "inner necessity," which has for its content not the trappings of the materialistic world view but pure "artistic content," would rescue art from the false emphasis on technique characteristic of the present time, and would restore to it a "full healthy life" without which neither art, nor man, nor a people can live.[52]

The artist is obliged, if he is honest and sincere, to attempt to fill the cracks in the soul, which effectively separate him from his public; he must dedicate himself, Kandinsky maintained, to "higher purposes" which are "precise, great and sanctified."[53] He must educate himself in his craft, and develop his own soul so that his external talent has "something to put on." He must "have something to say," because his obligation is not the mastery of form, but rather the suiting of form (and Kandinsky meant *any* form) to that content, which must arise freely out of the artist's innermost soul. The artist is no "Sunday child," he is not free in life, only in art.

With remarkable concision Kandinsky traced the recent history of art, citing those artists who, he felt, had done most to reach out and bring the cracked vase back to "ringing," noting that the Pre-Raphaelites and the Symbolists had mirrored this flawed condition of the modern soul. Of contemporary artists, he suggested that Matisse with color and Picasso with form were pointing the way to the future. He discussed the technical problems of contemporary art, suggesting that the path to restoration would be through a monumental synthesis of all the arts (the *Gesamtkunstwerk*), on the one hand, and, on the other, through a more complete and precise study of the singular effects of the fundamental elements of each independent art. As an example of such a study he included a bold chapter on the psychological effects of color, in which he took particular note of recent experiments in the therapeutic effects of color, or "chromotherapy." The art of the future, he predicted, would produce two equally effective modes, "pure abstraction" and "pure realism" (by which he meant the kind of naive realism of Rousseau).[54] Kandinsky later stated that the purpose of his two books, *Über das Geistige in der Kunst* and the almanac, was to "call forth the capacity of humanity to experience the spiritual in material things, in abstract things."[55] This, in effect, was to be a healing act, an act intended to repair that rift in the cracked vase of the modern soul.

The creation of the *Blaue Reiter* almanac may in fact be seen as an apotropaic act, an act at once of exorcism and magical healing, a "medicine book," prescribed to restore a society diseased with the multiple ills of mate-

51. Kandinsky, *Über das Geistige in der Kunst*, p. 22.
52. Ibid., p. 34.
53. Ibid., p. 135.
54. Kandinsky, "Über die Formfrage," in *Der Blaue Reiter*, Munich, R. Piper & Co., 1912, p. 94.
55. Kandinsky, "Rückblicke," p. XXVII.

56. At almost the same moment Thomas Mann was developing the idea of his great metaphorical novel of disease and health, *The Magic Mountain*, begun in 1912 in Munich. See Mann, "On the Spirit of Medicine," quoted in Joseph Campbell, *The Masks of God: Creative Mythology*, New York, Penguin Books, 1968, pp. 322–325.

57. As Lankheit and Lindsay have both noted, the editors had taken great pains with the number, size and placement of the illustrations (cf. Lankheit, ed., *The Blaue Reiter Almanac*, p. 38). In fact, they had undertaken this task with such zeal that their publisher, Reinhard Piper, was forced to reprimand them and to point out that their "independent" actions particularly in respect to number and size of the plates had increased the costs of the book (cf. Reinhard Piper, *Briefwechsel mit Autoren und Künstlern 1903–1953*, Munich, R. Piper & Co., 1979, p. 128).

58. This aim is documented in Piper's letter, ibid., in which he also complained that the editors had set the price too low out of the "quite correct presumption" that a "propaganda sheet" should not be too expensive.

59. W. H. Roscher, *Ausführliches Lexikon Griechischen und Römischen Mythologie*, Leipzig, Verlag B. G. Teubner, 1884–86, pp. 435–442, 421–426; Joseph Campbell, *The Masks of God, Occidental Mythology*, New York, Penguin Books, 1964, pp. 24, 296; Edith Hamilton, *Mythology*, New York, Mentor Books, 1957, pp. 30–31.

60. Lankheit's documentary edition of the almanac includes the inscriptions under the votive pictures which were omitted in the almanac; these document the specific cures effected by the prayers of the faithful.

rialism. From St. George, the "Blue Rider" on the cover, to the literary contents, to one after another of the illustrations, the book was clearly intended by its editors to have a curative effect.[56] A great many of the illustrations selected for the almanac by Kandinsky and Marc represent art and artifacts expressly related to exorcism, healing, regeneration, salvation, miraculous occurrences or personages, and the like.[57] St. George appears not only on the cover, where he is accompanied by his serpent and bound maiden (representing materialism and society respectively), but in three other illustrations: Münter's painting *Still Life with St. George* (cat. no. 38), a German lithograph and a Russian folk sculpture in which he is slaying a seven-headed hydra. The heroic, leaping horseman of Kandinsky's *Lyrical* (cat. no. 267) appears as well, as does his trumpet-blowing horseman on the back cover.

The first illustration in the book is a Bavarian mirror painting, handsomely reproduced and hand-colored, depicting another saint on horseback, St. Martin, sharing his coat with the beggar (fig. 34). The reference here is unmistakably to the announced aims of the manifesto: to share what Marc called in his opening essay "the spiritual treasures" of art with a wide public.[58] Kandinsky's color woodcut *Archer* was included as an additional frontispiece in the deluxe edition of the almanac. Recalling Kandinsky's promise of the restorative power of art and Marc's expressed hope for "so much healing," we might identify this rider as Apollo, the Archer-God, who first taught men the art of healing. Also known in mythology as Phoebus, god of light and truth, he is said to have killed a monstrous serpent with his silver bow and arrow, and his arrows were often likened to rays of light.[59] Thus, Apollo would be a fitting companion to the Blue Rider.

A major reference to the magical healing the editors hoped to effect through art appears in the early pages of the almanac: this is the full-page reproduction of a mosaic from the Cathedral of San Marco in Venice, depicting the miraculous apparition of St. Mark's body. Since St. Mark's gospel is the primary source of the tales of Christ's miraculous exorcisms, healings and raisings from the dead, the selection of this particular work as an illustration for a book with similar aims can hardly be considered coincidental. References to miraculous healing powers are particularly remarkable in the illustrations selected to accompany Kandinsky's major essay "Über die Formfrage" ("On the Question of Form"). These include five Bavarian votive pictures, each given a full page. All five pictures are from the parish church of St. Nikolaus in Murnau (which is further distinguished by a sculpture of St. George and the dragon). And all five represent scenes of exorcism, healing or salvation (fig. 29). In each case, the naive artist has painted a representation of Mary as Queen of Heaven floating in the upper center of the panel above the scene documenting the miraculous occurrence.[60] Two other miracle pictures grace the essay, one a Bavarian glass painting depicting Mary and the Descent of the Holy Ghost (as tongues of fire) and the other (of unidentified origin) representing the dormition of a saint, perhaps Mary. Opposite the conclusion of the essay is a full-page reproduction of Münter's *Still Life with St. George*.

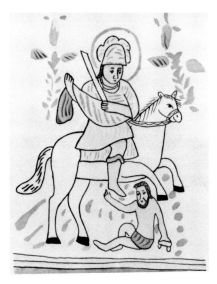

fig. 34
St. Martin and the Beggar
Hand-colored tracing of Bavarian mirror painting, frontispiece *Blaue Reiter* almanac
Collection Städtische Galerie im Lenbachhaus, Munich

But perhaps the most startling juxtaposition of healing motifs is the appearance back to back of Kandinsky's *Composition V* and van Gogh's 1890 *Portrait of Dr. Gachet* (fig. 35). The sequence is introduced just a page earlier by a Bavarian glass painting depicting St. Luke (fig. 30), and is directly followed by a Japanese woodcut (fig. 36). Van Gogh's portrait of Dr. Paul Gachet, the eccentric physician who attended him during his last weeks at Auvers, includes in the foreground the symbol of the doctor's craft, the foxglove flower, wilting but still the source of the medicinal digitalis (stimulant, by the way, to the heart). In his essay for the almanac, "The Masks," Macke had commented on the portrait of Dr. Gachet, comparing it to the Japanese woodcut which appears directly opposite it: "Does not the portrait of Dr. Gachet by van Gogh derive from a similar spiritual life as that of the astonished caricature of the Japanese magician cut into the wood block?" The comparison of the act of healing with an act of artistic conjuration (for a *Gaukler*, as Macke calls the Japanese figure, is an artist of conjuration, of legerdemain) is further demonstration of the message of the book. The name digitalis, of course, is derived from the German name for foxglove, *Fingerhut* or "finger-hat," that is, "digit-hat." The reference to digits is particularly apt here in the context of the Japanese *Gaukler* with his fingers spread, the finger-artist or prestidigitator. The physician, like the painter and the sleight-of-hand artist, employs large doses of illusion in effecting his cure or trick. And all three offer a tonic for the heart or soul of mankind.

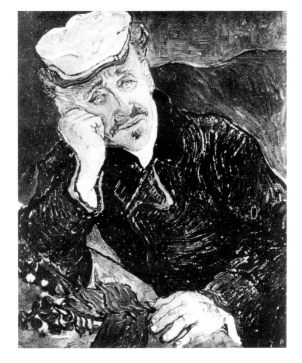

fig. 35
Vincent van Gogh
Portrait of Dr. Gachet. Auvers, June 1890
Oil on canvas
Collection Musée du Louvre, Paris

fig. 36
Utagawa Kuniyoshi
Two Chinese Warriors of the Han Dynasty. 19th century
Japanese woodcut
Estate of Franz Marc, Courtesy Galerie Stangl, Munich

fig. 37
Pongwe Mask. Gabon
Collection Bernisches Historisches Museum, Ethnographische Abteilung, Bern

61. It is possible that the editors were unaware of this particular mask's purpose since, although correctly identified as "Pongwe," its characteristically oriental features apparently misled them to also label it as "Chinese?" in the list of illustrations.

62. Recent scholarship has indicated rather precise relationships between the text of the scenario for *Der gelbe Klang* and the accompanying illustrations (see the revealing study by Susan Stein, "The Ultimate Synthesis: An Interpretation of the Meaning and Significance of Wassily Kandinsky's *The Yellow Sound*," Master's thesis, State University of New York at Binghamton, 1980).

63. Kandinsky, *Über das Geistige in der Kunst*, pp. 120–121.

In the same paragraph Macke states that: "What the wilting flowers are for the portrait of the European physician, the wilting corpses are to the *Mask of the Conjurer of Disease*." He was referring to the Ceylonese *Dance Mask* (cat. no. 306) which was reproduced full-page between the first and second "pictures" or scenes of Kandinsky's color opera *Der gelbe Klang*. This mask was used specifically for exorcising the demons of disease. Through the efficacy of the medicinal flower, life is stimulated; through death, true spiritual life and resurrection. Another illustration for Macke's essay is a small ceramic figure of the Mexican god Xipe Totec, known as *The Flayed God* (cat. no. 304). In Aztec mythology Xipe Totec is associated with the miracle of spring, of regeneration and rebirth. His figure appears just under Macke's assertion of the relationship between van Gogh's portrait of Dr. Gachet and the Ceylonese *Dance Mask*.

The introduction of the *Composition V*—Dr. Gachet—conjurer sequence by St. Luke, the saint who was himself both physician and painter, and who became the patron saint of both physicians and painters, was particularly apt. In the glass painting he is shown together with his attributes, the palette and paint brushes, the ox of sacrifice and the book of his gospel. The implication is clear, indeed overwhelming, that the editors considered Kandinsky's *Composition V* appropriately placed between St. Luke, the physician-painter, and Dr. Gachet, the physician to painters. The painting's curative mission was thus revealed. In the context of the almanac as "medicine book," then, the resurrection theme of *Composition V* becomes intelligible as an expression of faith in the restorative and transforming powers of art as spiritual "medicine" prescribed by the physician-artist.

This remarkable series of illustrations and allusions occurs within the pages of the almanac devoted to Kandinsky's second major essay "Über Bühnenkomposition" ("On Stage Composition"), in which he discusses his vision of theater as the appropriate arena for a great synthesis of the arts, for that great healing of the fractured vase. His prescription for this act of synthesis is a return to the source of "inner necessity." Music, dance and color, stripped of their references to externals are to be joined "on the ground of inner being." The essay is introduced with an illustration of a Pongwe mask (fig. 37) from the Ogawe River area in Gabon, a mask worn by stilt dancers of the Mashango to personify the individual who returns from the dead.[61] And indeed, the almanac culminates in the scenario for Kandinsky's modern miracle play, the color opera *Der gelbe Klang*, which itself climaxes in an unmistakable symbolic vision of resurrection.[62]

The dominant and most striking visual element of *Composition V* is the great black linear device, which, like a whiplash, sweeps out across the upper portion of the canvas, widening from right to left and curving back toward the center of the picture where it ends abruptly in a welter of indistinct flower-like forms. In *Über das Geistige in der Kunst* Kandinsky admonished the viewer who, trained by his materialistic background, would search for remnants of reality, clues to a discursive description of content, in his paintings. Such a viewer, he warned, would miss the "inner life" of the painting.[63] Yet in the case of *Composition V*, the artist himself committed the "error" of pro-

fig. 38
Vasily Kandinsky
All Saints' Day I. 1911
Glass painting
Collection Städtische Galerie im Lenbachhaus, Munich

64. Eichner, p. 115.

65. Washton Long has provided a thorough analysis of many of these literal thematic images in her publications (cf. Washton Long, op. cit.). It may be suggested here that, in the context of the present interpretation, the two brotherly saints, with their arms about each other (identified by Washton Long as "entwined couple") in several paintings of All Saints' Day (e.g., GMS 71, 107 [fig. 38], 122) were intended to represent Cosmas and Damian; these were the physician saints who practiced miraculous healing and were eventually martyred by decapitation after other attempts to kill them, by drowning, for example, had failed. However, none of Kandinsky's themes should be exclusively associated with a single Biblical myth, since, despite his awareness of Christian beliefs and traditions and of the theosophist writings of Mme Blavatsky and Rudolf Steiner, the artist was undoubtedly far more interested in the universality of such ideas. In any case, the universal character of the myths was confirmed in the churches and the folk art of Bavaria which Kandinsky encountered every day. His interest in the universality of the mythic imagination was documented in a letter to his biographer, Will Grohmann, in which he described his evolution from a personal "yearning for Russia" (expressed in such early works as *Motley Life*) to the universal experience of humanity (the *Allgemeinmenschlichem*). See Kandinsky letter to Grohmann of 12.10.24, in Gutbrod, ed., pp. 46–47. The variety of mythic sources represented in the illustrations selected for the almanac attests to this search for universal content which was characteristic of the period (James G. Frazer's *The Golden Bough* was first published in 1890, for example).

viding a literal clue. In notes for a lecture planned for presentation in Cologne in 1914 but never delivered, he stated emphatically that only two of his Compositions were based on specific themes. The theme for *Composition V,* he wrote, was taken from the *Auferstehung* (Resurrection), and that for *Composition VI* from the *Sintflut* (Deluge). "There was a certain boldness," he admitted, "in taking such used up themes as a starting point to pure painting. It was for me a test of strength, which in my opinion, came out well."[64] In other words, the thematic content was there, but to be overcome, to be transformed.

In any case, the impact of the dominant black painterly line in *Composition V* is compelling. It has the effect of a sudden loud noise; its form suggests a trumpet. As we have seen, the artist himself has revealed the derivation of the painting from the Resurrection theme, and with this loud visual noise he seems to bring us to the contemplation of a mystery:

> *Behold I shew you a mystery: We shall not all sleep, but shall all be changed.*
> *In a moment, in the twinkling of an eye at the last trump: for the trumpet shall sound, and the dead shall be raised incorruptible, and we shall be changed.*
> > *Corinthians 15:51-52*

While the theme of Resurrection appears throughout the Bible (in both the Old and New Testaments, in the Gospels as well as in the Revelations to St. John), this particular image from St. Paul's first letter to the Corinthians, in which the writer discourses on the mystery of the Resurrection, is strikingly suggestive of the great trumpet call signified by the dramatic central motif of *Composition V.*

Nevertheless, and despite the fact that we now know the artist incorporated into the composition a plethora of images from several other works with more or less related themes, such as All Saints' Day and the Last Judgement (fig. 38), the painting as a whole must be taken as Kandinsky intended —that is, as a statement about the universal theme of resurrection within the context of an ailing society in need of the medicine of the soul offered by art.[65]

66. These two works also exhibit a symbolic similarity. The Persian miniature represents the story of Iskandar (Alexander the Great) who, while on a journey with the prophets Elias and Khizr, loses his way in the "land of darkness," where he is called by Israfil, the Angel of Death (counterpart of the Archangel Michael), blowing on his trumpet. The two prophets, however, discover the Fountain of Life. Israfil's trumpet is a typical Persian instrument, but its seven "bells" are imaginary and intended to symbolize its sounds. I am indebted to Marie Swietochowski of the Islamic Department and to Kenneth Moore of the Musical Instruments Department of The Metropolitan Museum of Art, New York, for their expert help in interpreting this work, which confirmed my original suppositions.

67. Richard Ettinghausen, "Early Shadow Figures," *Bulletin of the American Institute for Persian Art and Archaeology*, no. 6, June 1934. A more recent study is by Metin And, *Karagöz: Turkish Shadow Theatre*, Ankara, Dost Yayinlari, 1975. Many of the ethnic artifacts included in the almanac were on display in Munich at the Völkerkundemuseum. Undoubtedly both Marc and Kandinsky visited the museum and saw the objects themselves. Marc, in fact, described one such visit in a letter to Macke in January of 1911 (at just about the same time he was becoming friendly with Kandinsky). See the Macke-Marc *Briefwechsel*, p. 39. They also knew the Egyptian shadow-play puppets at firsthand: through his brother Paul, a Byzantine specialist, Marc met the Islamic historian Professor Paul Kahle and examined his private collection. Because of their fragility (they were made of leather), not many of the puppets have survived intact. According to one source, Marc reassembled one for color reproduction in the almanac, although in actuality, the puppets were generally blackened from the smoke of the lamps used to illuminate them. (Cf. Clara B. Wilpert, *Schattentheater*, Hamburg, Hamburgisches Museum für Völkerkunde, 1973, p. 75.)

68. Interest in shadow-play theater was widespread among Symbolist artists and writers at the turn of the century (cf. Weiss, p. 99 and passim).

69. See Jelena Hahl-Koch, "Kandinsky's Role in the Russian Avant-Garde," *The Avant-Garde in Russia 1910–1930*, Los Angeles County Museum of Art, 1980, pp. 84–90.

From a strictly compositional, structural point of view, the graphic device of the extended "trumpet-motif" may well have been suggested by images Kandinsky had observed in the Persian illuminations at the Mohammedan exhibition in 1910—for example in the painting illustrated the same year in *Münchner Jahrbuch der bildenden Kunst* (fig. 39). Here the dominant motif is the long trumpet of an angel, with its sound rendered quite graphically, serving much the same compositional purpose as the trumpet in Kandinsky's *Composition V*.[66] Further, the many disparate events crowding the picture plane in this illumination recall Kandinsky's method not only in *Composition V*, but in *Composition II* and earlier in *Motley Life* (fig. 21). Kandinsky had particularly remarked on the Persian representation of teeming detail in his review of the Mohammedan exhibition for *Apollon*.

Throughout the pages of the almanac, reproductions of Egyptian shadow-play figures proliferate. Based on Islamic shadow-theater precedents, the filigreed puppets reflected the ancient doctrinal prescriptions on the belief that worldly phenomena are "merely the illusory medium through which the soul acts in the world."[67] They were particularly appealing to the editors of the *Blaue Reiter* because of their obvious symbolism: shadow figures come to life only when illuminated by the divine fire of the artist. Like Kandinsky's color opera *Der gelbe Klang*, they depend for life on light. Metaphorically art must be illuminated by the light of "inner necessity" which springs from the innermost being of the artist.[68]

There are many more indications in the almanac of the editors' symbolic intentions, but it is clear even from this necessarily condensed discussion that the *Blaue Reiter* carried a rich complex of messages to the world, with an emphasis on art as a universal medicine for the human soul.

VI Conclusion: To the Edge of Abstraction

With the *Blaue Reiter* almanac and exhibitions and the publication of *Über das Geistige in der Kunst*, Kandinsky's activities in 1911–12 as organizer and leader of the new movement had reached their apex. Now the Blue Rider—and there is no doubt that, as Eichner has suggested, Kandinsky identified himself with the crusader on horseback—turned to the practical pursuit of his vision. For he saw that the transformation he sought had not yet been entirely achieved. Although the almanac itself exemplified in the best sense the kind of synthesis, or *Gesamtkunstwerk*, its editors had intended, still Kandinsky hoped for more radical realizations of his goals.

During the following two years he continued to exhibit at Der Sturm in Berlin and elsewhere, and he traveled to Russia where he kept up a lively, though not always happy, dialogue with the younger generation of avant-garde artists represented by the Burliuks, Natalia Goncharova, Mikhail Larionov and others.[69] And within his own oeuvre, he now intensified his efforts in four directions: toward a further emancipation from reality in his painting; toward completion of another *Gesamtkunstwerk* publication, this

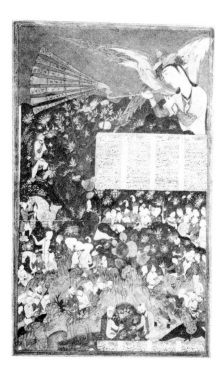

fig. 39
Persian Miniature. 17th century
Shown at Exhibition of Mohammedan Art, Munich, 1910, reproduced in *Münchner Jahrbuch der bildenden Kunst,* 1910, Bd. I

combining woodcuts and poems; toward the realization of his dream of a "theater of the future"; and toward his vision of an aesthetically determined environment within the context of architecture ("my old dream" he called it much later in a letter to Will Grohmann[70]).

In *Painting with White Border,* 1913 (cat. no. 323), Kandinsky once more associated the rider on horseback with his personal battle to wrest painting from traditional modes and transform it into pure abstraction.[71] Once more St. George, the eternal Blue Rider, was to stand for his own need to move forward to conflict and victory. In a letter written to Münter on his way to Odessa and Moscow in October of 1912, Kandinsky again gave expression to the self-doubt that had plagued him in the early years: his feelings were, he said, even "more mixed now when new paintings by me are purchased. For a long while I sat on a high, lonely tower. Now I am no longer alone. Is the tower still so high?"[72] It was St. George on horseback who had stood on the high tower in the square in Rothenburg so many years ago (fig. 40), in that medieval town Kandinsky and Münter had visited together in 1903. And after that earlier encounter, Kandinsky had written to Münter: "for those things that are theoretically ready . . . one must yet find an appropriate form. . . ."[73]

70. Kandinsky letter to Will Grohmann, quoted in Gutbrod, ed., p. 45 (July 1924).

71. Kandinsky called the painting *Bild mit weissem Rand,* literally *Picture with White Edge.* While the traditional translation of the word "*Rand*" has been "Border," the word "Edge" is both more accurate and more appropriate. In his description of the painting in *Rückblicke* (p. xxxxi), Kandinsky spoke of the white strip as a wave breaking, that is as at the "edge" of the sea. Further, the white strip only edges along two sides and part of another; it does not surround the picture as would a border.

72. Kandinsky to Münter, quoted in Eichner, p. 105 (14.10.12).

73. Lindsay K/M letters: 22.11.03.

fig. 40
Main Square in Rothenburg ob der Tauber with *Herterichbrunnen* and *St. George,* 1446
Kandinsky and Münter painted here in November 1903

fig. 41
Vasily Kandinsky
Untitled (Knight and Dragon).
ca. 1903–04
Pencil on paper
Collection Städtische Galerie im Len-
bachhaus, Munich

Immediately on his return from the trip to Russia just before Christmas of 1912, Kandinsky began sketches for *Painting with White Border.* Now he again reached back in memory to one of his earliest depictions of St. George's conflict with the dragon, a tiny drawing in a notebook of about 1903–04 (fig. 41). This early drawing resembles the prototype created by Walter Crane in his famous painting *St. George's Battle with the Dragon* or *England's Emblem* (fig. 2), which had been exhibited in Munich in the 1890s. The direction of the action is the same (the knight moves from left to right), and in the background Kandinsky suggests Crane's city polluted by materialism. But what a difference in the relative sizes of the protagonists! Kandinsky's dragon is a colossus, the charging knight utterly dwarfed by his gigantic opponent. A zinc plate of the same subject by Kandinsky exists in which the serpent has become even more threatening by virtue of its raised position on a hilltop. This was no doubt expressive, if subconsciously so, of the situation Kandinsky felt himself to be in at the time—both in his illicit relationship to Münter and in his inner striving to discover a new form in art. But by the triumphant years of 1911–12 and his great series of St. George paintings, relative sizes and positions were reversed: the saint had achieved his proper proportions and place, and the much-diminished dragon was sometimes even made to look foolish (cat. no. 319). Now, in harking back to the compositional structure of the earlier picture, Kandinsky directs the action as it would have appeared in an etching from the zinc plate: the crusader charges from right to left and is placed in the raised position, while the dragon is lower.

The early sketches for *Painting with White Border* demonstrate his painstaking efforts to develop a viable hieroglyph for the crusader-St. George motif (cat. no. 324). The conflict between knight and dragon may also be seen as a metaphor for Kandinsky's battle to liberate the graphic line from its traditional role in drawing and transform it into a painterly element. He had already developed a prototype for such a hieroglyph in the watercolor *With Three Riders* of 1911 (cat. no. 322). Now he modified it, evolving both a "troika" motif and the St. George motif.[74] For the first time Kandinsky found himself able to make a truly daring leap toward total abstraction. In one of the preparatory sketches for *Painting with White Border* (cat. no. 325), the

74. A thorough discussion of the development of the sketches and painting is to be found in Angelica Rudenstine, *The Guggenheim Museum Collection: Paintings 1880–1945*, New York. The Solomon R. Guggenheim Foundation, 1976, vol. I, pp. 256–263.

fig. 42
Walter Crane
The Horses of Neptune. 1892
Oil on canvas
Bayerische Staatsgemäldesammlungen,
Munich

horse and rider are enveloped entirely by the circle into which they ultimately would be transformed in the postwar years. In the transformation of graphic sketch to painting, the circle became a circular blue wash.[75]

In an essay he wrote for the album which accompanied his exhibition at the gallery of Der Sturm in 1913, Kandinsky identified the action in this painting only as "*Kampf in Weiss und Schwarz*" (battle in white and black). He did not specifically identify the rider-crusader-St. George in those terms, but he had no need to do so. To him it seemed perfectly obvious: "the middle is thus very simple and completely unveiled and clear," he wrote. He had, in fact, used this kind of abstract descriptive language to refer to his symbols for years. In a letter to Münter of April 1904, he had described a painting he was working on, and for which he said he had great expectations, as a "*Kampf in Grün und Rot*" (battle in green and red). He had described it further as a scene of one crusader charging another on a plain before a Russian city, and he expressed some concern that perhaps the "color language" might be too obvious.[76] Certainly, then, we need not hesitate to read this *Kampf in Weiss und Schwarz* as St. George with his white lance bearing down on the black-outlined dragon. And indeed, Kandinsky was no longer concerned at this point that the color language might be too obvious.

The white edge of the painting was the final solution to the composition evolved after almost five months of gestation (as Kandinsky recounted in the *Sturm* album essay). When the solution came at last, it came in a form he described as a "wave," cresting and "falling suddenly" and then, "flowing in sinuously lazy form" around to the right side of the picture to appear once more in jagged scallops in the upper left corner. Here again, remembrances of forms encountered earlier may have called to Kandinsky's mind another Crane painting, *The Horses of Neptune* (fig. 42), in which the power of the cresting wave was associated with that of the horse. In any case, in this painting with its white edge, Kandinsky's Blue Rider had carried him quite literally to the edge of abstraction.

Completed a month after *Painting with White Border*, in June of 1913, *Small Pleasures* (cat. no. 321) set the horseman in motion again, united here once more with his two companions from such paintings as *Composition I*,

75. For a more detailed discussion of the transformation of the horse and rider motif into a circle, see Weiss, pp. 128–132 and passim.
76. Lindsay K/M letters: 3.4.04.

Romantic Landscape and *With Three Riders*. Now they storm the citadel on their leaping steeds, defying gravity and the threatening clouds of the other side. They, too, begin a flirtation with the circle, as can be seen in many related sketches and studies.[77]

In addition to these two works from the first half of the year, Kandinsky produced two major Compositions, numbers *VI* and *VII,* during 1913. As already noted, *Composition VI* was one of the two compositions Kandinsky identified as having a specific theme. Like the theme of *Composition V,* its subject, the Deluge, was, by his own account, ultimately transformed into a universal symbol of regeneration. The largest of all his compositions and preceded by a great many preparatory studies, *Composition VII* was his major statement in this year of "breakthrough." In scale, ambition and power it represented a significant step toward the formal emancipation he had sought.

The autumn of 1913 saw the publication of Kandinsky's long-planned volume of woodcuts and poems which, in true lyric-synthetic style he called *Klänge* (*Resonances* or *Sounds*) (cat. no. 360).[78] It harked back to his earlier efforts, the *Verses Without Words* of 1904 and the *Xylographies* of 1909, to produce a work of art that was at once visual and musical, graphic and lyric. *Klänge,* however, provided the additional dimension of Kandinsky's own remarkable prose poems, as well as woodcuts dating back to 1907.

In the spring of 1914, hope flared up for the realization of a production of *Der gelbe Klang.* The Münchner Künstlertheater was by that time close to collapse, but a heterogeneous group of Munich artists attempted to bring about a second "revolution in the theater" by proposing to take it over for themselves. This group included Erich Mendelsohn, Hugo Ball, Marc, Kubin and others who were to have provided set and costume designs for the revised program (cat. nos. 335, 336). *Der gelbe Klang* was among the productions they scheduled for performance. For a short but intense time Kandinsky, Marc, Macke and the others were involved, but their efforts proved ultimately futile and the idea was never realized.[79]

Kandinsky now undertook his last attempt in this prewar period to fulfill one of the dreams engendered by the first Munich experiences: the dream of the aesthetically determined environment. The occasion was provided by a commission offered by an American, Edwin R. Campbell, to design four wall panels (cat. nos. 43–46) to decorate the foyer of his apartment at 635 Park Avenue in New York. Campbell was a friend of Arthur J. Eddy, the Chicago lawyer, who had discovered Kandinsky at the 1913 Armory Show and had already purchased his work for his own collection. A letter Eddy wrote to Münter in June of 1914 clearly indicates that the plan was to integrate the paintings architecturally into the designated space so that they would look "exactly as if originally intended as part of the hall."[80] Thus, by the summer of 1914, even as Europe rumbled with the ominous signs of war, Kandinsky stood on the brink of realizing his great dream of integrating lyrical abstraction and architectural environment into a grand synthesis.

The extreme degree of abstraction attained in the Campbell panels had already been adumbrated in two other paintings, *Light Picture* and *Black*

77. Cf. Weiss, pp. 131–132, and Rudenstine, pp. 264–271.

78. Unfortunately, the usual translation of *Klänge* into English as *Sounds* does not do the German word justice, for it has an association both in meaning and in tone with the sound of bells ringing or choirs singing. The work of art, Kandinsky was wont to say, must "*klingen*"; it must ring like a bell or like a fine crystal. See also note 25 and the discussion of *Singer*, above.

79. See Weiss, chapter IX.

80. Lindsay was the first to trace the history of the Campbell panels in "Kandinsky in 1914 New York: Solving a Riddle," *Art News*, vol. LV, May 1956, pp. 32–33, 58. See also Rudenstine, p. 283, where Eddy's sketch of the room is reproduced.

fig. 43
Vasily Kandinsky
Fishing Boats, Sestri. 1905
Oil on board
Collection The Solomon R. Guggenheim
Museum, New York

Lines (cat. no. 332), both completed at the very end of 1913. A comparison between *Black Lines*, which may be designated an "improvisation" and *Landscape with Red Spots* (also called *Landscape with Church I*) (cat. no. 331) of the same year, an "impression" clearly based on direct observation of nature, indicates that the old schism between lyric improvisation and naturalistic impression still existed in 1913. At the same time, the two paintings, in contrast to a similar pairing, such as *Motley Life* of 1907 (fig. 21) and *Fishing Boats, Sestri* of 1905 (fig. 43) reveals the distance he had traveled from the earlier years. *Landscape with Red Spots* was purchased by Kandinsky's poet friend Karl Wolfskehl, who also provided the German translation of Albert Verwey's poem "An Kandinsky" for the 1913 Sturm catalogue of Kandinsky's retrospective in Berlin.

In both *Black Lines* and *Landscape with Red Spots*, Kandinsky transferred graphic line into painting, a goal he later discussed in his notes for the lecture he planned to deliver in Cologne in 1914 and in a 1932 letter to Grohmann. Linear devices and complexes have become integral painterly elements of the construction of each composition. The free, over-all scattering of these elements (as graphic hieroglyphs in *Black Lines* and as linear forms obscured by color spots in *Landscape*) are at once prophetic of much later developments in twentieth-century painting, and at the same time reminiscent of the "over-all" tapestry-like effects of Kandinsky's earlier works such as *Composition II*. But in such lyric abstractions as *Black Lines*, though we may persist in reading the fragmented rainbows, horizons, mountains and suns of *Landscape with Red Spots*, we must concede that Kandinsky had at last escaped the gravitational pull of history.[81]

Unquestionably, Kandinsky had now opened the door to that paradise for which he had searched so long. But fate was to close it all too cruelly. World War I brought global catastrophe and the tragic death of his fellow warriors who had fought with him in that other, far nobler conflict. It brought deep personal suffering as well. His long and intimate friendship with Münter was severed;[82] he was forced to leave behind the dreams of that long-gone radiant Munich. The succeeding months and years brought another descent

81. A comparison of the preparatory drawings for these two paintings reveals a startling similarity and suggests that, indeed, *Black Lines* may have been inspired by *Landscape with Red Spots*, or by the same natural landscape. (See Hanfstaengl, no. 222, GMS 442, p. 90 and Rudenstine, fig. a, p. 278.)

82. For a sensitive discussion of Kandinsky's break with Münter, see Sara H. Gregg, "The Art of Gabriele Münter: An Evaluation of Content," Master's thesis, State University of New York at Binghamton, 1980, and by the same author, "Gabriele Münter in Sweden: Interlude and Separation," *Arts Magazine*, vol. 55, May 1981, pp. 116–119. Ms. Gregg served as Hilla Rebay intern at the Guggenheim Museum, and I wish to express my gratitude here for her unstinting efforts in the early stages of preparation for this exhibition and for her recent help with various aspects of the catalogue.

fig. 44
Vasily Kandinsky
Picnic. 1916
Watercolor, India ink and pencil on paper
Collection The Solomon R. Guggenheim
Museum, New York

into self-doubt and despair, a descent reflected directly in his painting. Indeed, he ceased painting in oils altogether in 1915. The works of 1916 and 1917 suggest moods of mingled joy in memory (fig. 44) and despair before an uncertain future.

Only with a new transformation wrought in the early twenties, introduced during the period of his Soviet sojourn and consolidated in the geometric style of the Bauhaus—the school dedicated to the goal of the integrated artistic environment—did Kandinsky's old confidence return. And with it, the Blue Rider, St. George returned triumphant. For in *In the Black Square* of 1923 (fig. 3), the saint on horseback reappeared in grand heroic style, once again in terms of a "battle in white and black." He is a St. George equal to the heights of mountains, made of the landscape of paradise and gleaming with the sun. Horse and rider sail together on a white trapezoidal plane of inner conviction, easily escaping from and at the same time victorious over the flat black plane of the dragon in his lair.[83] In further transformations the Blue Rider became a cosmic blue circle and the dragon a wavy, whiplash line (cat. no. 343, fig. 6).

Thus Kandinsky's life may be seen in terms of a series of encounters and transformations. A hero of "things becoming," a foe of "Holdfast, keeper of the past," Kandinsky with his Blue Rider leapt the barriers of tradition, conservatism and complacency to open a new way in art. It was in Munich that he set out upon his quest, there that he encountered both dreams and demons, and there that the Blue Rider achieved a monumental transformation in the art of this century.

In many things I must condemn myself, but to one thing I shall remain forever true—to the inner voice, which has determined my goal in art and which I hope to obey to the last hour.
 Kandinsky
 "Rückblicke"
 Munich, June 1913

83. An unpublished graphic analysis of *In the Black Square* undertaken by Edward J. Kimball, my student at Columbia University in 1975, convinced me of the validity of this interpretation.

CATALOGUE

Now, about woodcuts. . . . You needn't ask the purpose of this or that work: they all have only one purpose—I had to make them, because I can free myself in no other way from the thought (or dream). Nor do I think of any practical use. I simply must *make the thing. Later you will understand me better. You say: Play! Of course! Everything the artist makes is after all only play. He agonizes, tries to find an expression for his feelings and thoughts; he speaks with color, form, drawing, resonance [Klang], word, etc. What for? Great question! About that later, in conversation. Superficially only play. For him (the artist) the question "what for" has little sense. He only knows a "why." So arise works of art, so arise also things that are as yet not works of art, but rather only stations, ways to that end, but which already have within them also a little glimmer of light, a resonance. The first ones and likewise the second (the first are all too infrequent) had to be made because otherwise one has no peace. You saw in Kallmünz how I paint. So I do everything that I must: it is ready within me and it* must *find expression. If I play in this way every nerve in me vibrates, music rings in my whole body and God is in my heart. I don't care if it is hard or easy, takes much or little time, is useful or not. And here and there I find people who are grateful for my things, who get something out of them. . . .*

Kandinsky to Gabriele Münter, August 10, 1904

I. MUNICH: ENCOUNTER AND APPRENTICESHIP

INTRODUCTION

Franz von Stuck

1 Poster for *7th International Art Exhibition in the Glass Palace (VII. Internationale Kunstausstellung im Glaspalast).* 1897
Lithograph on paper, 13¼ x 18⁵⁄₁₆″ (33.7 x 48 cm.)
Collection Münchner Stadtmuseum, Munich

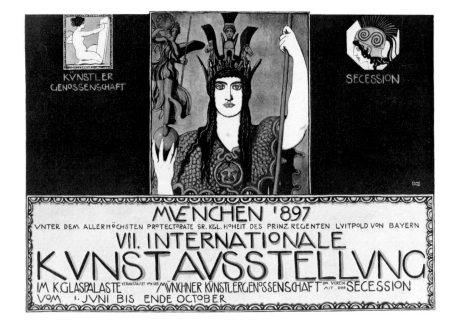

* Indicates not in exhibition
† Indicates not illustrated

Julius Diez

2 Poster for *Prinzregenten Theater Richard Wagner München.* 1901
Lithograph on paper, 42¹⁵/₁₆ x 29⁵/₁₆″
(109 x 74.5 cm.)
Collection Münchner Stadtmuseum,
Munich

Emil Rudolf Weiss

3 Poster for *First International Exhibition
of Art-Photographs in the Secession (Erste
Internationale Ausstellung von Kunst—
Photographien in der Secession).* 1898
Lithograph on paper, 42⁵⁄₁₆ x 29⁹⁄₁₆″
(107.5 x 70 cm.)
Collection Münchner Stadtmuseum,
Munich

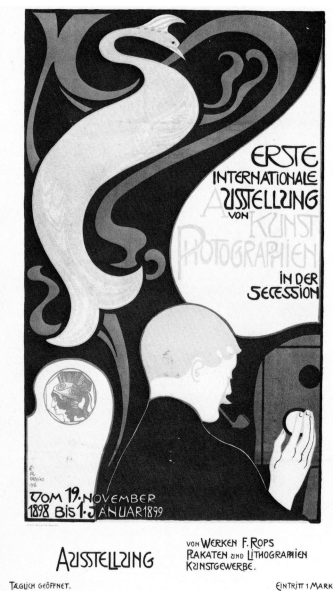

Bruno Paul

4 Poster for *Art in Handicrafts Exhibition (Ausstellung Kunst im Handwerk).* 1901
Lithograph on paper, 34⅞ x 23⁷⁄₁₆"
(88.5 x 59.5 cm.)
Collection Münchner Stadtmuseum,
Munich

Albert Weisgerber

5 *Peacock Dance (Pfauentanz).* 1902
Pen and brush, tusche and tempera on
paper, 16 x 11¹³⁄₁₆" (40.7 x 30.1 cm.)
Stiftung Saarländischer Kulturbesitz,
Saarbrücken

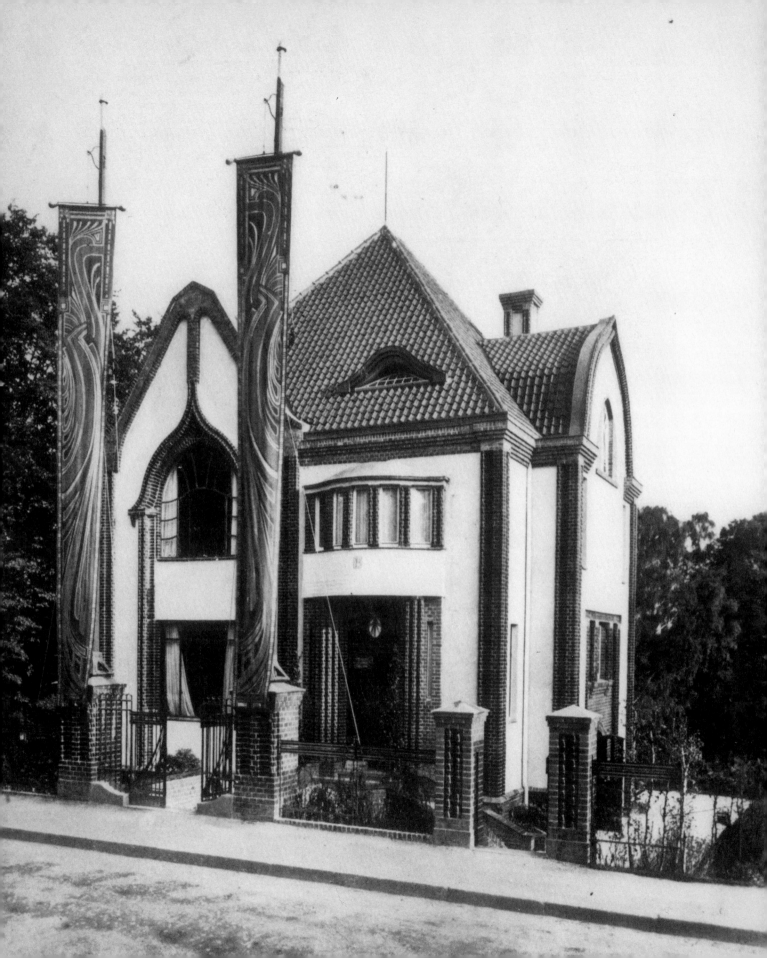

Thomas Theodor Heine

†6 Poster for *Simplicissmus.* 1897
Lithograph on paper, 34¹⁄₁₆ x 23⁷⁄₁₆″
(86.5 x 59.5 cm.)
Collection Münchner Stadtmuseum,
Munich

Ludwig von Zumbusch

†7 Poster for *Youth: Munich Illustrated
Weekly for Art and Life (Jugend: Münch-
ner Illustrierte Wochenschrift für Kunst
und Leben).* 1896
Lithograph on paper, 24¹³⁄₁₆ x 17¾″
(63 x 45 cm.)
Collection Münchner Stadtmuseum,
Munich

Robert Engels

†8 Poster for *Munich Artists' Theater
(Münchner Künstlertheater).* 1909
Lithograph on paper, 41⁵⁄₁₆ x 27⁹⁄₁₆″
(105 x 70 cm.)
Collection Münchner Stadtmuseum,
Munich

Ernst Stern

†9 *Café "Megalomania," Carnival (Café
"Grössenwahn," Karneval).* 1902
Portfolio of lithographs on paper, 9 sheets
printed on both sides, each 12⅝ x 19¹¹⁄₁₆″
(32 x 50 cm.)
Collection Stadtbibliothek mit Hand-
schriftensammlung, Munich

Peter Behrens

10a-b *Two Banners (Zwei Fahnen).* 1900–01
Oil on canvas, each 312 x 37⅝″ (795 x
95.6 cm.)
Shown at entrance to Behrens's house,
Darmstadt *Künstlerkolonie*
Private Collection

Bruno Paul

11 *"Art Dream of a Modern Landscapist"
("Kunsttraum eines modernen Land-
schafters").* 1897
Watercolor, pencil and ink on paper,
16⅛ x 11⅞″ (41 x 30.2 cm.)
Staatliche Graphische Sammlung, Munich

Bruno Paul

12 *"The Munich Fountain of Youth" ("Der
Münchner Jugendbrunnen").* 1897
Watercolor, pencil and ink on paper,
15 x 23¾″ (38.1 x 60.4 cm.)
Staatliche Graphische Sammlung, Munich

Bruno Paul

13 Title page of *Jugend*, vol. 1, no. 35,
August 29, 1896
11¹³⁄₁₆ x 8¹⁵⁄₁₆″ (30 x 22.7 cm.)
Collection Kunstbibliothek Staatliche
Museen Preussischer Kulturbesitz, Berlin

Poppel and Kurz
14 *The Glass Palace (Der Glaspalast).* 1854
Photograph of engraving
Collection Münchner Stadtmuseum,
Munich

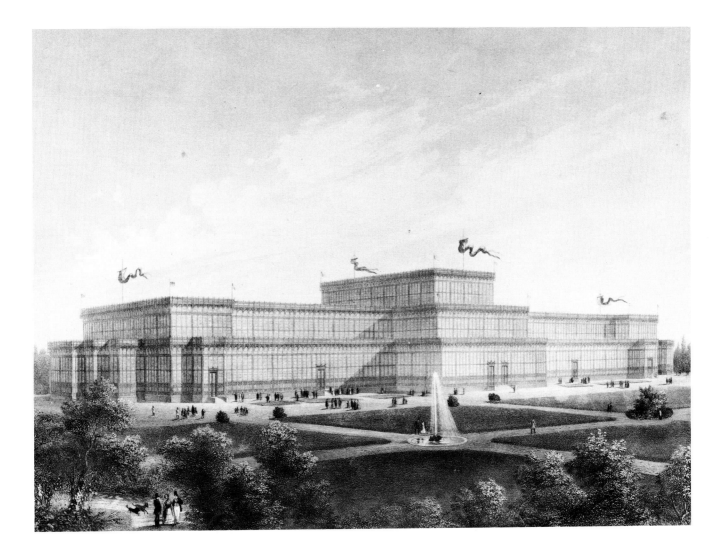

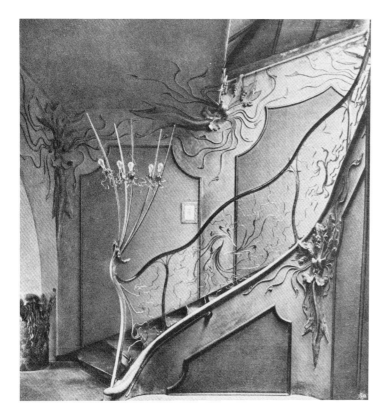

August Endell

15 *Stair Railing, Hofatelier Elvira, Munich (Treppenraum mit Geländer, Hofatelier Elvira, München).* 1896–97
Photograph

August Endell

16 *Reception Room, Hofatelier Elvira, Munich (Empfangszimmer, Hofatelier Elvira, München).*
Photograph

August Endell

17 *Entrance Gate, Hofatelier Elvira, Munich (Eingangsgitter, Hofatelier Elvira, München).*
Photograph

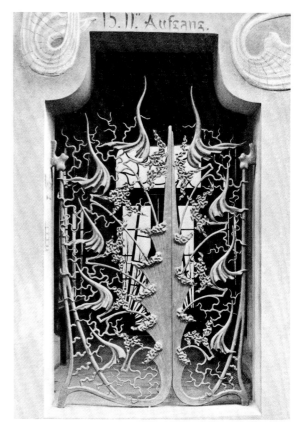

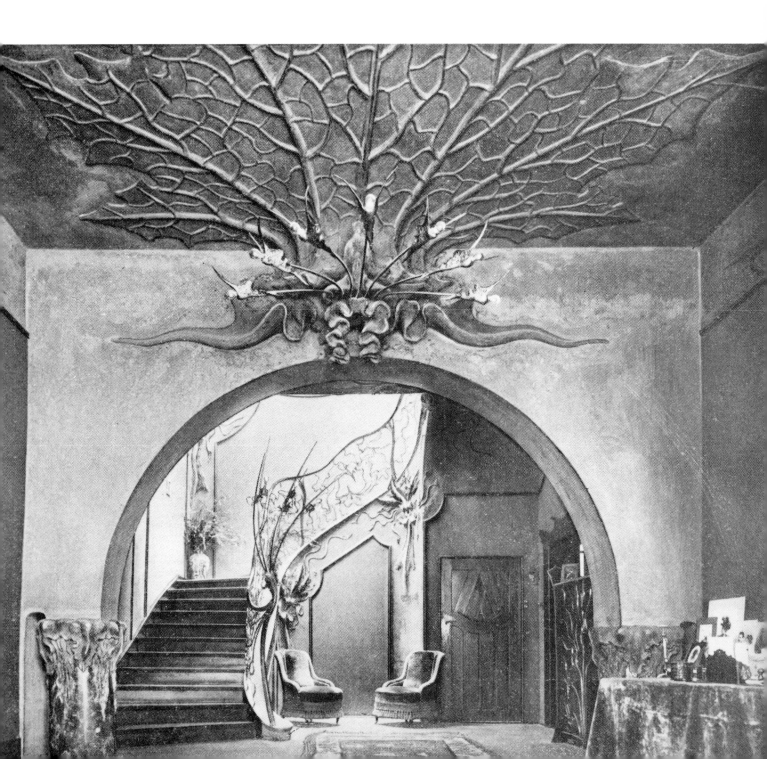

Hermann Obrist and Richard
Riemerschmid
18 *Room for a Friend of the Arts (Zimmer
eines Kunstfreundes).* ca. 1900
Embroideries by Obrist, music stand and
chairs by Riemerschmid
Photograph
Collection Museum Bellerive, Zürich

August Endell

19 *Table (Tisch).* 1899
Oak, 27¹⁵⁄₁₆ x 45¼ x 37³⁄₁₆″ (71 x 115 x 96 cm.)
Private Collection

Hermann Obrist

20 *Firelilies (Feuerlilien).* ca. 1895–1900
Gold thread flatstitch brocade on silk, 39⅜ x 19¹¹⁄₁₆″ (100 x 50 cm.)
Collection Münchner Stadtmuseum, Munich

August Endell
21 *Desk Chair (Schreibtischsessel).* 1896
Elm, 33 7/16″ (85 cm.) h.
Collection Siegfried Wichmann

Gertraud Schnellenbühel

22 *Candelabra (Tischleuchter).* 1902–08
Silver-plated brass, 18½ x 17¾″
(47 x 45 cm.)
Collection Münchner Stadtmuseum,
Munich

Richard Riemerschmid

23 *Music Room Chair (Musikzimmerstuhl).*
1898
Elm, 30¹⁵⁄₁₆″ (77 cm.) h.
Collection Siegfried Wichmann

Richard Riemerschmid

24 *Study for Door Frame and Stucco Frieze (Entwurf für Türrahmen und Stuckfries).* 1899
Pencil with colored crayons on paper, 19¹⁵⁄₁₆ x 17⁵⁄₁₆" (50.7 x 44 cm.)
Architektursammlung der Technischen Universität, Munich

Richard Riemerschmid

†*25 *Phantom Clouds II (Wolkengespenster II).* ca. 1897
Tempera on canvas, 17¾ x 30⁵⁄₁₆" (45 x 77 cm.)
Collection Städtische Galerie im Lenbachhaus, Munich

August Endell

26 *Trunk from Heiseler House, Brannenburg (Truhe aus Haus Heiseler, Brannenburg).* 1899
Prepared elm with metal sheathing, 17¾ x 53⁹⁄₁₆ x 29⅛" (45 x 136 x 74 cm.)
Collection Münchner Stadtmuseum, Munich

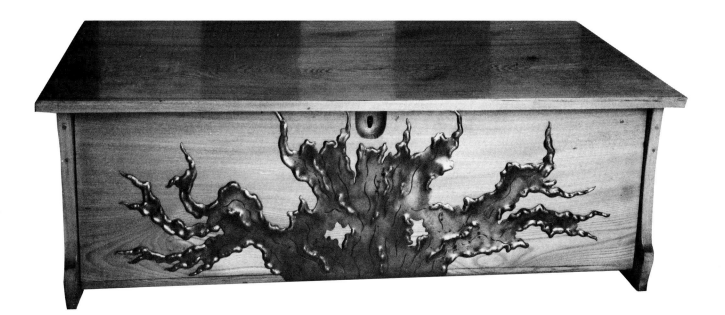

Vasily Kandinsky

36 *Rider (Reiter).* ca. 1908–09
Painted wood, 11 7/16 x 9 7/8″ (29 x 25 cm.)
Collection Gabriele Münter-Johannes
Eichner Stiftung, Munich

Vasily Kandinsky

37 *Watch Stand (Uhrenständer).* ca. 1908
Painted wood, 5 7/8 x 3 1/8 x 1 9/16″
(15 x 8 x 4 cm.)
Collection Gabriele Münter-Johannes
Eichner Stiftung, Munich

Gabriele Münter

38 *Still Life with St. George (Stilleben mit Heiligem Georg).* 1911
Oil on cardboard, 20⅛ x 26¾″ (51.1 x 68 cm.)
Collection Städtische Galerie im Lenbachhaus, Munich

Vasily Kandinsky

39 *Sancta Francisca.* 1911
Glass painting (oil and tempera [?] on
glass), 6⅛ x 4⅝″ (15.6 x 11.8 cm.)
Collection The Solomon R. Guggenheim
Museum, New York

Franz Marc

†40 *Cock, Goat and Boar (Hahn, Ziege und
Eber).* ca. 1912
Wool embroidery on muslin, 8¹¹⁄₁₆″
(22 cm.) d.
Embroidered by Ada Campendonk
Collection Städtische Galerie im
Lenbachhaus, Munich

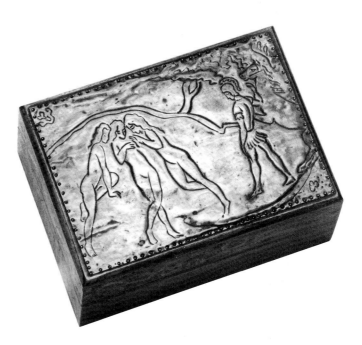

August Macke

41 *Box, "The Judgment of Paris" (Kästchen,
"Das Urteil des Paris").* 1913
Wood box with embossed silver-plate and
painted lid, 2¹⁵⁄₁₆ x 7⅜ x 5¼″ (7.4 x
18.7 x 13.2 cm.)
Collection Heirs of Dr. W. Macke, Bonn

Moissey Kogan

42 *Female Head (Weiblicher Kopf).* n.d.
Wool embroidery on linen, 6⁹⁄₁₆ x 6¹⁵⁄₁₆″
(16.7 x 17.7 cm.)
Collection Städtische Galerie im
Lenbachhaus, Munich

Vasily Kandinsky
43 *Painting No. 199.* 1914
Oil on canvas, 63⅞ x 48⅛″ (162.4 x
122.3 cm.)
Collection The Solomon R. Guggenheim
Museum, New York

Vasily Kandinsky

44 *Painting No. 201.* 1914
Oil on canvas, 63⅞ x 48⅛″ (162.3 x
122.8 cm.)
Collection The Solomon R. Guggenheim
Museum, New York

Vasily Kandinsky

45 *Panel (3).* 1914
Oil on canvas, 64 x 36¼″ (162.5 x 92 cm.)
Collection The Museum of Modern Art,
New York, Mrs. Simon Guggenheim
Fund, 1954

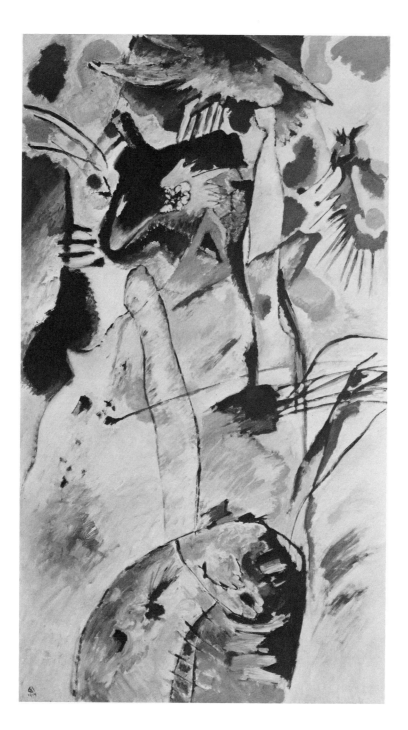

Vasily Kandinsky

46 *Panel (4).* 1914
Oil on canvas, 64 x 31½″ (162.5 x 80 cm.)
Collection The Museum of Modern Art,
New York, Mrs. Simon Guggenheim
Fund, 1954

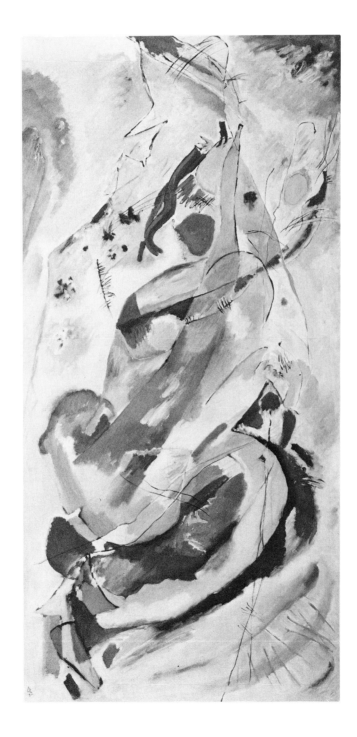

Vasily Kandinsky

47 *Watercolor Study for the Panel "Summer"*
for Edwin R. Campbell (Aquarellentwurf
zu dem Paneel "Sommer" für Edwin R.
Campbell). 1914
Watercolor and tusche over pencil on
paper, 13 3/16 x 9 7/8" (33.4 x 25.1 cm.)
Collection Städtische Galerie im
Lenbachhaus, Munich

Vasily Kandinsky

48 *Watercolor "Idea for a Mural for*
Campbell" (Aquarell "Idee zu einem
Wandbild für Campbell"). 1914
Watercolor, tusche and zinc white over
pencil on paper, 13 3/16 x 9 7/8" (33.3 x
25.1 cm.)
Collection Städtische Galerie im
Lenbachhaus, Munich

Vasily Kandinsky

49 *Watercolor Study for the Panel "Spring"*
for Edwin R. Campbell (Aquarellentwurf
zu dem Paneel "Frühling" für Edwin R.
Campbell). 1914
Watercolor, tusche and pencil on paper,
13 3/16 x 9 7/8" (33.4 x 25.1 cm.)
Collection Städtische Galerie im
Lenbachhaus, Munich

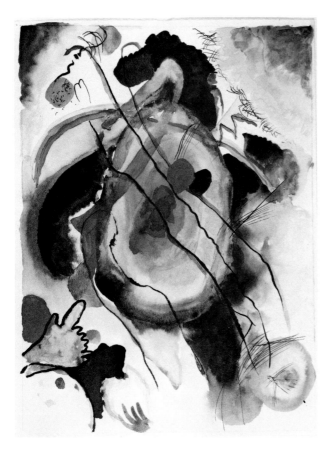

August Endell
50 *Facade, Hofatelier Elvira, Munich.*
ca. 1896–97
Photograph

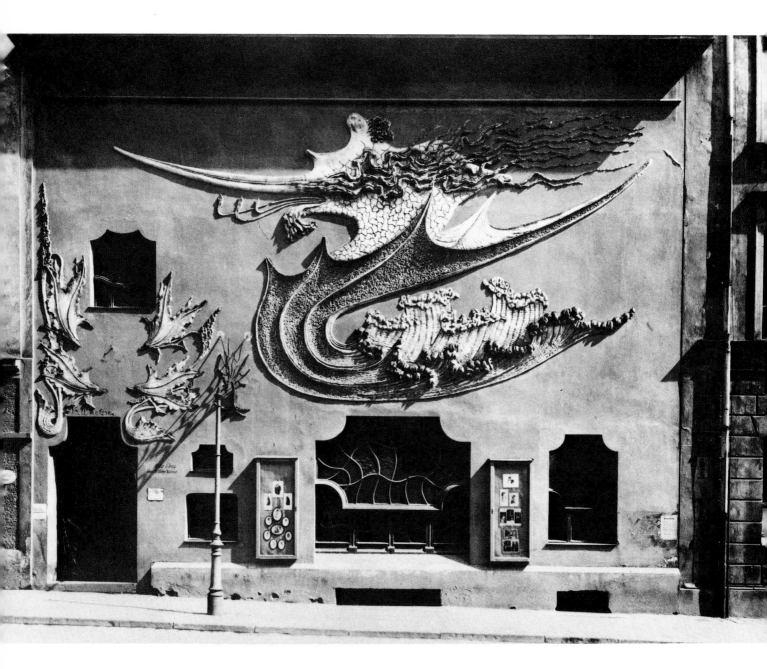

Franz von Stuck

*51 *The Guardian of Paradise (Der Wächter des Paradieses).* 1889
Oil on canvas, 98⅝ x 65¹⁵⁄₁₆″ (250.5 x 167.5 cm.)
Collection Museum Villa Stuck, Munich

Hermann Obrist

*52 *Whiplash (Peitschenhieb).* 1895
Silk flatstitch embroidery on wool,
47¹⁄₁₆ x 72¼″ (119.5 x 183.5 cm.)
Collection Münchner Stadtmuseum,
Munich

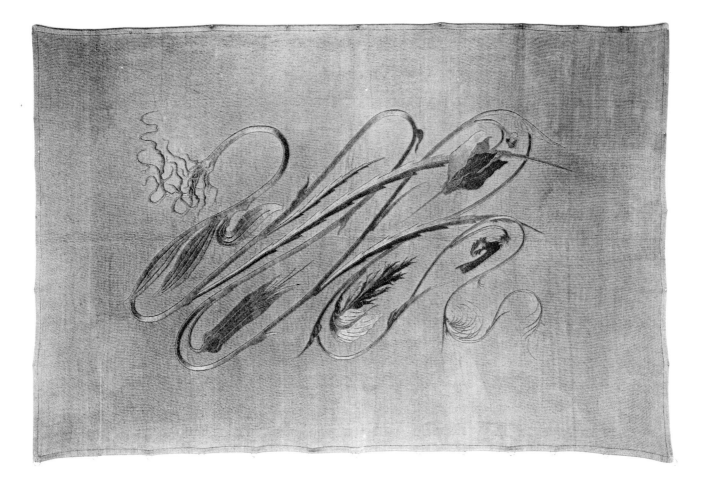

Hans Schmithals

53 *Polar Star and Star Constellation Dragon
(Polarstern und Sternbild Drache).* 1902
Gouache on paper, 18⅞ x 43⁵⁄₁₆″ (48 x
110 cm.)
Collection Münchner Stadtmuseum,
Munich

Hans Schmithals

54 *Composition in Blue (Komposition in Blau).* ca. 1900
Pastel and mixed media on paper,
51¾ x 31⁵⁄₁₆″ (131.5 x 79.5 cm.)
Bayerische Staatsgemäldesammlungen,
Munich

Hans Schmithals

55 *The Glacier (Der Gletscher).* ca. 1903
Mixed media on paper, 45¼ x 29½″
(114.8 x 74.7 cm.)
Collection The Museum of Modern Art,
New York. Matthew T. Mellon
Fund 90.60

Hans Schmithals

56 *Study (Studie).* n.d.
Pastel and crayon on paper, 21¼ x 15¹³⁄₁₆″
(54 x 40.2 cm.)
Collection Siegfried Wichmann

Akseli Gallen-Kallela

57 *Flame (Flamme).* 1899; 1913
Wool rug, 120 x 67¾″ (305 x 172 cm.)
Collection Museum of Applied Arts,
Helsinki

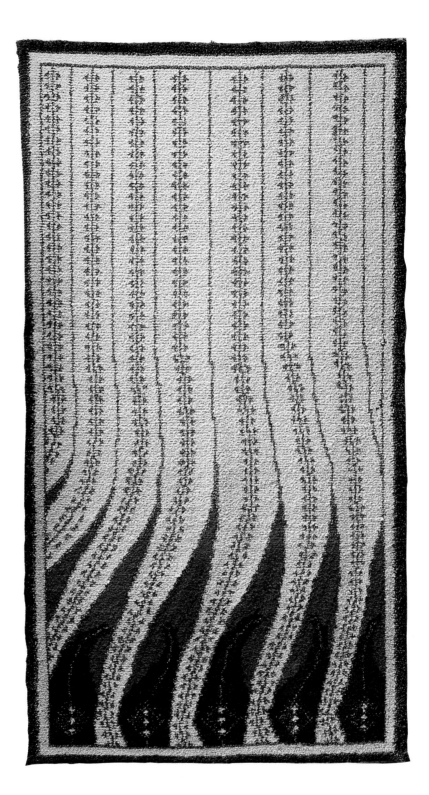

Hermann Obrist

58 *Untitled (Sea Garden) (Ohne Titel [Meeresgarten]).* n.d.
Pencil on paper, 7¹⁄₁₆ x 3½" (17.9 x 8.8 cm.)
Staatliche Graphische Sammlung, Munich

Hermann Obrist

59 *Untitled ("Stone Organ") (Ohne Titel ["Steinerne Orgel"]).* ca. 1895
Pencil on paper, 6½ x 2¾" (16.5 x 7 cm.)
Staatliche Graphische Sammlung, Munich

Hermann Obrist

60 *Study for a Monument (Entwurf für einem Denkmal).* ca. 1898
Pencil on paper, 5⁷⁄₁₆ x 4" (14.5 x 10.1 cm.)
Staatliche Graphische Sammlung, Munich

Hermann Obrist

61 *Rock Grotto with Flaming River (Fels-grotte mit loderndem Fluss).* ca. 1895
Watercolor, pastel, pencil and charcoal on paper, 11¼ x 7⅜" (28.5 x 18.8 cm.)
Staatliche Graphische Sammlung, Munich

Hermann Obrist

62 *Vortex Above a Battlement (Strudel über Zinnen).* ca. 1898
Pencil on transparent paper, 9⅝ x 4⅞" (24.5 x 12.5 cm.)
Staatliche Graphische Sammlung, Munich

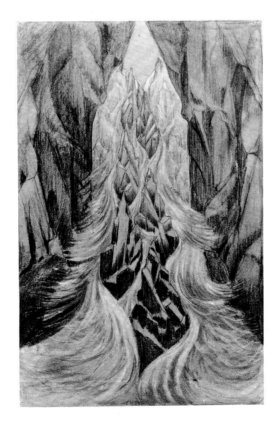

Hermann Obrist

63 *"More ground out of which . . ." (Fire Flower II) (Feuerblume II).* ca. 1895
Pastel and pencil on paper, 6³⁄₁₆ x 3³⁄₈″ (15.7 x 8.5 cm.)
Staatliche Graphische Sammlung, Munich

Hermann Obrist

64 *Untitled ("Smouldering Plant") (Ohne Titel ["Schwelende Pflanze"]).* ca. 1895
Charcoal and pencil on transparent paper, 10⅝ x 7¹³⁄₁₆″ (27 x 19.8 cm.)
Staatliche Graphische Sammlung, Munich

Hermann Obrist

†65 *Twisted Bough with Branch and Flaming Blossom (Gewundener Ast mit Zweig und Flammenblüte).* ca. 1896
Pencil on paper, 7⅜ x 21⅛″ (18.7 x 68.9 cm.)
Collection Siegfried Wichman

Hermann Obrist

66 *Fantastic Shell (Phantastische Muschel).*
ca. 1895
Charcoal and pencil on paper, 10¹¹⁄₁₆ x
6³⁄₈" (27.1 x 16.2 cm.)
Staatliche Graphische Sammlung, Munich

Hermann Obrist

67 *"Yet longer beneath . . ." ("Thorny
Stalk . . .") ("Noch länger unten . . ."
["Dorniger Stengel . . ."]).* ca. 1898
Pencil on transparent paper, 16³⁄₁₆ x
9¹⁵⁄₁₆" (41 x 25.3 cm.)
Staatliche Graphische Sammlung, Munich

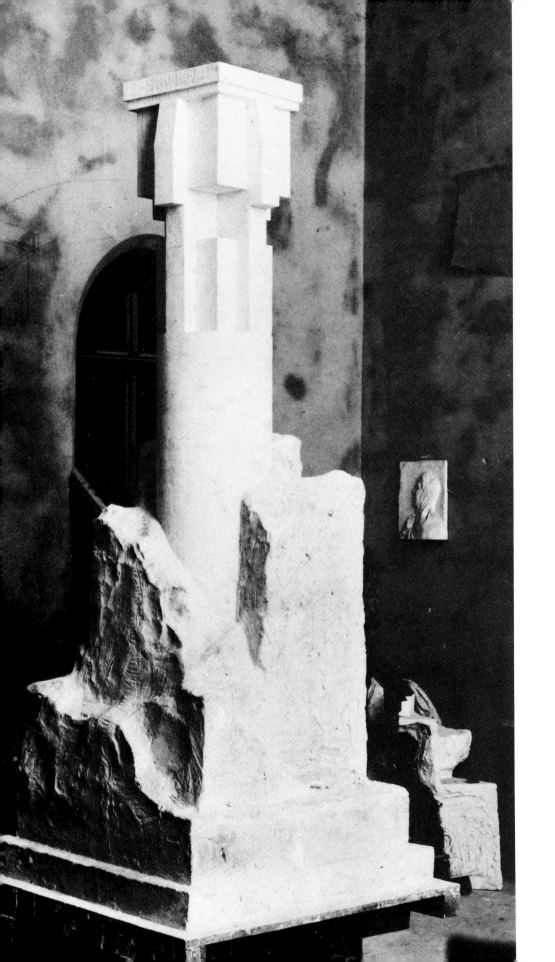

Hermann Obrist
68 *Arch Pillar (Gewölbepfeiler).* before 1900
 Photograph
 Collection Museum Bellerive, Zürich

Hermann Obrist
69 *Tapestry (Wandteppich).* before 1897
 Photograph
 Collection Museum Bellerive, Zürich

Hermann Obrist
*70 *Motion Study (Bewegungsstudie).*
ca. 1895
Reworked cast plaster, two sections, total
72 7/16 x 28¾ x 28¾″ (184 x 73 x 73 cm.)
Collection Museum Bellerive, Zürich

Hermann Obrist

71 *Sketch for a Monument (Entwurf zu einem Denkmal).* ca. 1898–1900
Reworked cast plaster, 34¹¹⁄₁₆ x 14¹⁵⁄₁₆ x 20½″ (88 x 38 x 52 cm.)
Collection Museum Bellerive, Zürich

Anton Ažbe
72 *In the Harem (Im Harem).* ca. 1905
Oil on canvas, 17⁷⁄₁₆ x 20³⁄₁₆″ (44.3 x
51.3 cm.)
Collection Narodna Galerija, Ljubljana

Anton Ažbe

73 *Self-Portrait (Selbstbildnis).* 1886
Oil on canvas, 25⅝ x 20¹⁄₁₆″ (65 x 51 cm.)
Collection Narodna Galerija, Ljubljana

Anton Ažbe

74 *Half-Nude Woman (Weiblicher Halbakt).*
1888
Oil on canvas, 39⅜ x 31⅞" (100 x 81 cm.)
Collection Narodna Galerija, Ljubljana

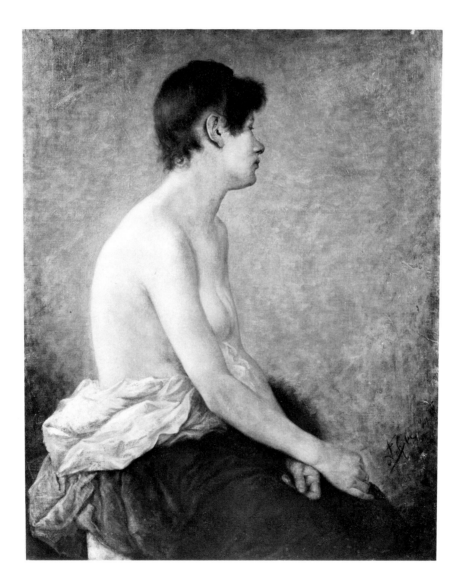

Anton Ažbe

75 *Portrait of a Negress (Bildnis einer Negerin).* 1895
Oil on wood, 21¾ x 15½″ (55.2 x 39.4 cm.)
Collection Narodna Galerija, Ljubljana

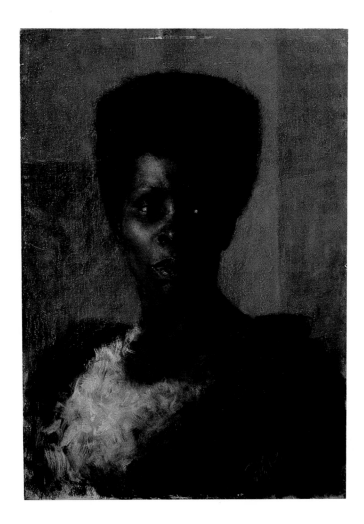

Vasily Kandinsky

76 *Six Female Nudes, Standing (Sechs weib-*
liche Akte, stehend). ca. 1897–1900
Tusche, pen and brush on paper, 8 3/16 x
12 7/8″ (20.8 x 32.7 cm.)
Collection Städtische Galerie im Len-
bachhaus, Munich

Vasily Kandinsky

77 *Five Male Nudes (Fünf männliche Akte).*
ca. 1897–1900
Tusche, pen and brush, watercolor and
opaque white on paper, 8 1/4 x 12 13/16″
(20.9 x 32.6 cm.)
Collection Städtische Galerie im Len-
bachhaus, Munich

Vasily Kandinsky

78 *Female Nudes and St. Hubertus (Weib-*
liche Akte und St. Hubertus).
ca. 1897–1900
Tusche, pen and brush and watercolor on
paper, 8¼ x 12⅞″ (20.9 x 32.7 cm.)
Collection Städtische Galerie im Len-
bachhaus, Munich

Vasily Kandinsky

79 *Sketchbook (Skizzenbuch).* 1897–1900;
1910–11
Page 3 of 53 sheets, pencil on paper, 14 x
8¹¹⁄₁₆″ (35.5 x 22 cm.)
Collection Städtische Galerie im Len-
bachhaus, Munich

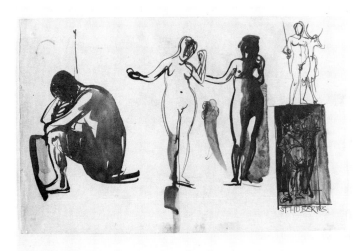

Vasily Kandinsky

80 *Munich.* ca. 1901–02
 Oil on canvasboard, 9⅜ x 12⅝″ (23.8 x
 32.1 cm.)
 Collection The Solomon R. Guggenheim
 Museum, New York

Vasily Kandinsky

81 *English Garden in Munich (Englischer Garten in München).* 1901
Oil on canvasboard, 9⅜ x 12¹¹⁄₁₆″ (23.7 x 32.3 cm.)
Collection Städtische Galerie im Lenbachhaus, Munich

Franz von Stuck

82 *Autumn Evening (Autumn Landscape with Rider) (Herbstabend [Herbstlandschaft mit Reiter]).* 1893
Oil on canvas, 24¼ x 30⅛″ (61.5 x 76.5 cm.)
Collection Städtische Galerie im Lenbachhaus, Munich

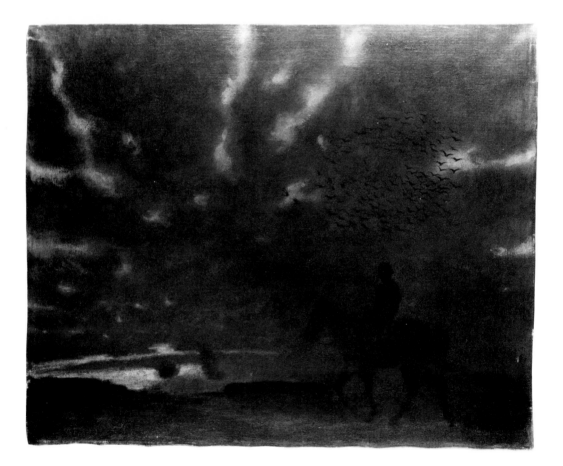

Vasily Kandinsky

83 *In the Forest (Im Walde).* 1903
Tempera on wood, 10¼ x 7¹³⁄₁₆″ (26 x
19.8 cm.)
Collection Städtische Galerie im Len-
bachhaus, Munich

Vasily Kandinsky

84 *Sketchbook (Skizzenbuch).* ca. 1903
Rider in Landscape (Reiter in Landschaft),
page 30 of 40 sheets, colored pencil on
paper, 6¹¹⁄₁₆ x 4⁵⁄₁₆″ (17 x 11 cm.)
Collection Städtische Galerie im Len-
bachhaus, Munich

Karl Schmoll von Eisenwerth

85 *Forest Ride (Waldritt).* ca. 1904
Color woodcut on paper, 8⅝ x 7⁵⁄₁₆″
(22 x 19.5 cm.)
Collection Professor J. A. Schmoll-
Eisenwerth, Munich

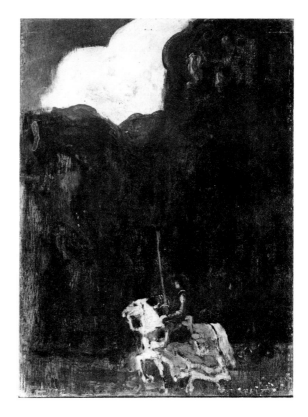

Franz von Stuck

86 *Franz and Mary Stuck—Artists' Festival*
(Franz und Mary Stuck—Künstlerfest).
1900
Oil on wood, 19⁵⁄₁₆ x 19½" (49 x 49.5 cm.)
Collection Städtische Galerie im Len-
bachhaus, Munich

Franz von Stuck

87 *Amazon (Amazone).* 1897
Bronze, 14³⁄₁₆″ (36 cm.) h.
Collection Münchner Stadtmuseum,
Munich

Franz von Stuck

88 *Villa Stuck with Poplars (Villa Stuck mit Pappelgruppe)*
Photograph
Courtesy Gerhard Weiss, Munich

Franz von Stuck

89 *Sketch for Furniture in the Villa Stuck (Entwurf für Möbel in der Villa Stuck).*
ca. 1895–97
Pencil and pen with tusche on yellowish paper, 12⅞ x 8⅜″ (32.8 x 21.2 cm.)
Private Collection

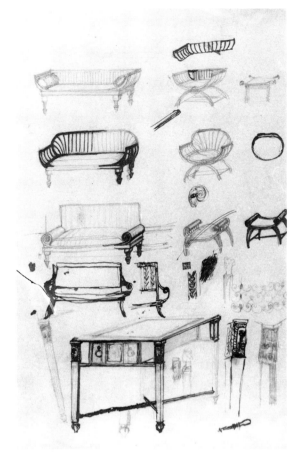

Vasily Kandinsky

90 *Young Woman in Oriental (?) Costume (Junge Frau in orientalischer [?] Tracht).* ca. 1900
Watercolor over pencil on paper, 7⅝ x 4¼″ (19.3 x 10.8 cm.)
Collection Städtische Galerie im Lenbachhaus, Munich

Vasily Kandinsky

91 *Townsmen and Peasant Costumes of the 16th Century (Bürger und Bauerntracht des 16. Jahrhunderts).* n.d.
Colored pencil on gray-blue paper, 8½ x 12⅜″ (21.7 x 31.4 cm.)
Collection Städtische Galerie im Lenbachhaus, Munich

Vasily Kandinsky

92 *Comet (Night Rider ?) (Der Komet [Nächtlicher Reiter ?]).* 1900
Tempera and goldbronze on red paper mounted on black cardboard, 7¹³⁄₁₆ x 9″ (19.8 x 22.9 cm.)
Collection Städtische Galerie im Lenbachhaus, Munich

Franz von Stuck

93 Poster for *International Art Exhibition
(Internationale Kunstausstellung).* 1893
Lithograph on paper, 24¼ x 14⅜″ (61.5
x 36.5 cm.)
Collection Münchner Stadtmuseum,
Munich

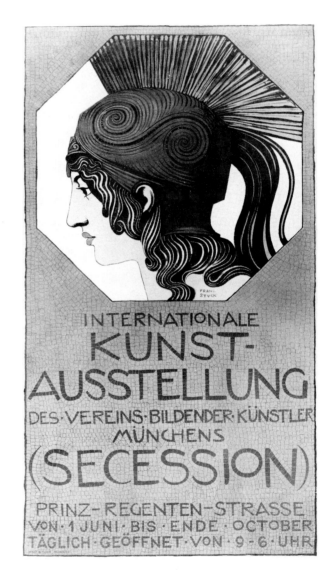

Vasily Kandinsky

94 Poster for *First Phalanx Exhibition*
(I. Phalanx Ausstellung). 1901
Color lithograph on paper, 18⅝ x 23¾″
(47.3 x 60.3 cm.)
Collection The Solomon R. Guggenheim
Museum, New York, Gift, Kenneth C.
Lindsay, Binghamton, New York

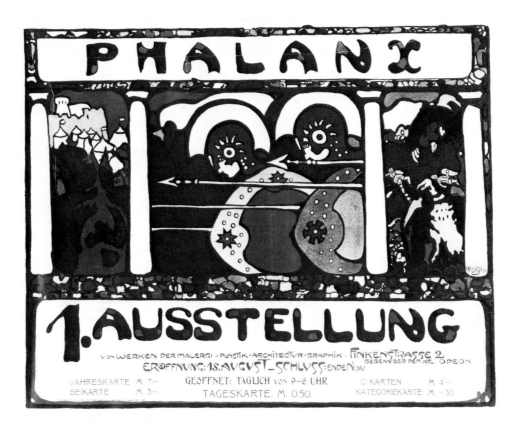

Thomas Theodor Heine
95 *Guest Performance: The Eleven Executioners (Gastspiel: Die Elf Scharfrichter).*
1903
Color lithograph on paper, 43¹¹/₁₆ x 26″
(111 x 66 cm.)
Collection Kunsthalle Bremen

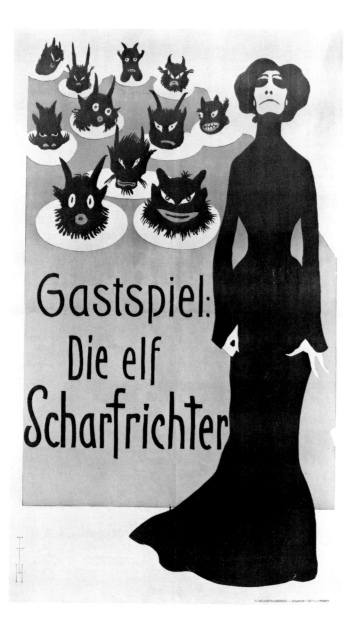

Waldemar Hecker

96a-g *Seven Puppets (Sieben Marionetten).*
n.d.
Painted wood, each 15¾″ (40 cm.) h.
Collection Münchner Stadtmuseum,
Munich

Albert Bloch

97 *The Green Dress (Das grüne Gewand).*
1913
Oil on canvas, 51½ x 33½″ (130.8 x
85.1 cm.)
Private Collection on extended loan to
Everson Museum of Art, Syracuse,
New York

Rolf Niczky

98 Poster for *Munich Lyric Theater "Über-
brettl" (Lyrisches Theater Münchner
Überbrettl).* ca. 1900
Lithograph on paper, 44⅞ x 34⅞″ (114
x 88.5 cm.)
Collection Münchner Stadtmuseum,
Munich

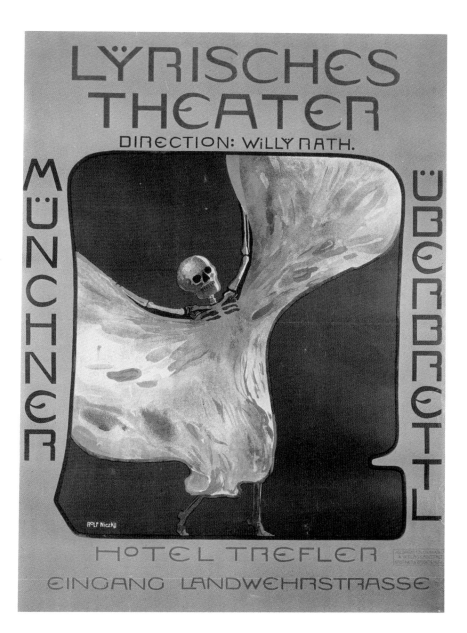

Wilhelm Hüsgen

99 *Mask of Frank Wedekind (Maske von Frank Wedekind).* ca. 1901–02
Plaster cast, 13½ x 10⅝" (35 x 27 cm.)
Collection Stadtbibliothek mit Handschriftensammlung, Munich

Ernst Stern

100 *Program for the Eleven Executioners (Elf Scharfrichter Programm).* November 1903
Lithograph on paper, 10½ x 7¼" (26 x 18 cm.)
Collection Stadtbibliothek mit Handschriftensammlung, Munich

Ernst Stern

101 *Program for the Eleven Executioners (Elf Scharfrichter Programm).* February 1902
Lithograph on paper, 10½ x 7¼" (26 x 18 cm.)
Collection Stadtbibliothek mit Handschriftensammlungen, Munich

Arpad Schmidhammer

102 Cover for *Program for the Eleven Executioners (with program for Wedekind's "Lulu")* (Umschlag für *Elf Scharfrichter Programbuch [mit Programm für Wedekinds "Lulu"]*). n.d.
Lithograph on paper, 10½ x 7¼" (26 x 18 cm.)
Collection Stadtbibliothek mit Handschriftensammlungen, Munich

Ernst Stern

†103 *Program for the Eleven Executioners (Elf Scharfrichter Programm).* April 13, 1901
Lithograph on paper, 10½ x 7¼″ (26 x 18 cm.)
Collection Stadtbibliothek mit Handschriftensammlungen, Munich

DIE SCHWARZE FLASCHE
Drama in einem Aufzuge von E. von KEYSERLING

PERSONEN:

Max, Student, 23 Jahre alt CARL NEUBERT
Milli, Musikschülerin, 18 Jahre alt . YELLA WAGNER
Ein Kellner PAUL LARSEN
Ein Stubenmädchen MIZZI MEIER

LULU
Tragödie in einem Aufzug vom Scharfrichter FRANK WEDEKIND

PERSONEN:

Lulu YELLA WAGNER
Gräfin Geschwitz ADELE BAUMBACH
Dr. Alwa Schön CARL NEUBERT
Schigolch PAUL LARSEN
Mr. Hopkins HANS DORBE
Kungu Poti, Erbprinz von Uahube . OTTO SCHLOSSER
Dr. Hilti FRANK WEDEKIND
Jack PAUL SCHLESINGER

Ort der Handlung: London.

Stadtbibliothek
München
2272 /59

2

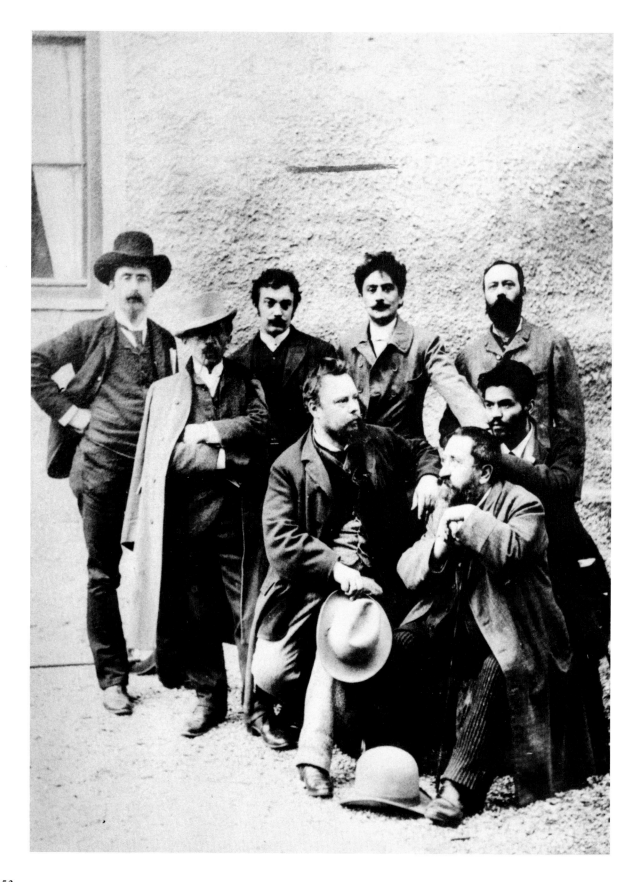

104 *Frank Wedekind with Seven Members of
the Eleven Executioners (Frank Wedekind
mit Sieben Mitglieder der Elf Scharfrichter)*
Photograph
Collection Münchner Stadtmuseum,
Munich

105 *Marya Delvard and Marc Henry.* ca. 1905
Photograph
Collection Delvard Nachlass, Münchner
Stadtmuseum, Munich

106 *Marya Delvard with Wilhelm Hüsgen.*
1958
Photograph
From album of Doris Hüsgen; courtesy
David Lee Sherman

Peter Behrens
†107 *Poster: A Document of German Art (Plakat: Ein Dokument Deutscher Kunst).*
1901
Color lithograph on paper, 49⅝ x 16¹⁵⁄₁₆″ (126 x 43 cm.)
Collection Hessisches Landesmuseum, Darmstadt

Peter Behrens
108 Cover for *Die Kunst für Alle.* October 1, 1901
12³⁄₁₆ x 8⁹⁄₁₆″ (30.9 x 21.7 cm.)
Collection Kunstbibliothek Staatliche Museen Preussischer Kulturbesitz, Berlin

Vasily Kandinsky

109 *Sketchbook (Skizzenbuch).* 1897–1900;
1902–03
Furniture (Möbel), page 40 of 51 sheets,
pencil, watercolor, goldbronze and col-
ored crayon on paper, 8½ x 5⁵⁄₁₆″ (21.5 x
13.5 cm.)
Collection Städtische Galerie im Len-
bachhaus, Munich

Vasily Kandinsky

110 *Sketchbook (Skizzenbuch).* ca. 1902–03
Designs for Furniture (Möbelentwürfe),
page 34 of 34 sheets, pencil on paper,
6⅞ x 10¼″ (17.5 x 26 cm.)
Collection Städtische Galerie im Len-
bachhaus, Munich

Hans Christiansen

III *Presentation Vase with Red, Green and
Blue Decoration with Gold Overlay
(Prunkvase mit rotem, grünem und
blauem Dekor, Goldauflage).* 1901
Glazed earthenware, 6½ x 12¹³⁄₁₆″ (16.5
x 32.5 cm.)
Collection Wächtersbacher Keramik,
Brachttal, Germany

Hans Christiansen

120 *Study for Inkwell (Entwurf für ein Tin-*
tenfass). ca. 1901
Watercolor and pencil on paper, 9¾ x
9¹⁵⁄₁₆" (24.8 x 25.2 cm.)
Collection Wächtersbacher Keramik,
Brachttal, Germany

Hans Christiansen

121 *Study for a Flat Plate with Blue and Green*
Leaf Decoration (Entwurf für einen
flachen Teller mit blauem und grünem
Blattdekor). 1901
Gouache on paper, 8⁹⁄₁₆" (21.7 cm.) d.
Collection Städtisches Museum Flensburg

Hans Christiansen

122 *Study for a Plate (Serving Plate) (Entwurf*
für eine Platte [Servierplatte]). ca. 1901
Watercolor and pencil on paper, 12¾ x
18¼" (32.4 x 46.3 cm.)
Collection Wächtersbacher Keramik,
Brachttal, Germany

Patriz Huber

123 *Belt Clasp (Gürtelschliesse).* ca. 1900
Silver, gold and agate, 1⅞ x 2⅞″ (4.8 x 7.2 cm.)
Collection Badisches Landesmuseum, Karlsruhe

Patriz Huber

124 *Money Purse (Geldbörse).* Mainz, 1902
Silver, goatskin and calfskin, 4¹¹⁄₁₆ x 3⅛ x ¾″ (12 x 8 x 2 cm.)
Collection Württembergisches Landesmuseum, Stuttgart

Hans Christiansen

125 *Studies for Silver (Toilet Articles) (Entwürfe für Silberarbeiten [Toilettentisch Garnitur]).* 1901
Watercolor and pencil on paper, 15⅜ x 11¹¹⁄₁₆″ (39 x 28.2 cm.)
Collection Städtisches Museum Flensburg

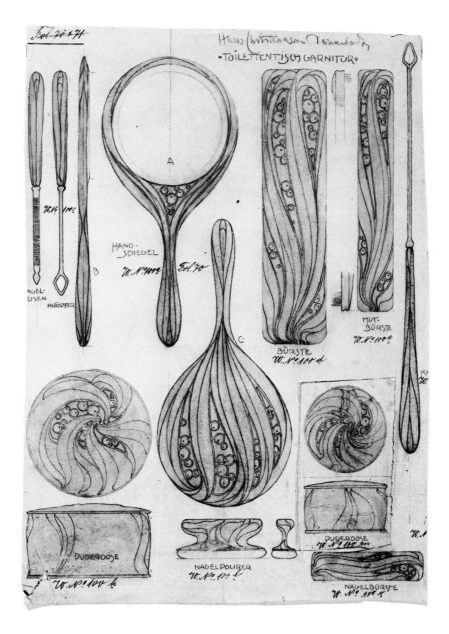

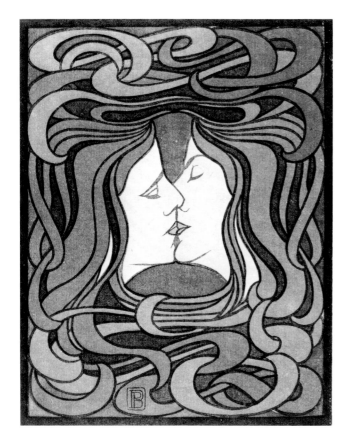

Peter Behrens

126 *The Kiss (Der Kuss).* 1898
Color woodcut on paper, 10¾ x 8½″
(27.2 x 21.6 cm.)
Collection The Museum of Modern Art,
New York, Gift of Peter H. Deitsch

Rudolf Bosselt

†**127** *Medal with Dedication to Grand Duke
Ernst Ludwig (Medaille mit Widmung an
Grossherzog Ernst Ludwig).* 1901
Silver, 2⅜″ (6 cm.) d.
Collection Hessisches Landesmuseum,
Darmstadt

Emmy von Egidy

128 *Picture with Branch and Moon (Bild mit
Ast und Mond).* n.d.
Watercolor and colored chalk on paper,
17¾ x 41⁵⁄₁₆″ (45 x 105 cm.)
Collection Siegfried Wichmann

Emmy von Egidy

129 *Candy Dish (Bonbonniere).* ca. 1901
Ceramic with silver, 2¹⁵⁄₁₆ x 9⁷⁄₁₆ x 5⅞″
(7.5 x 24 x 15 cm.)
Collection Siegfried Wichmann

Hans Christiansen

135 *Study for Book Design: The Four Elements: Water (Entwurf für einen Buchschmuck: Die Vier Elemente: Wasser).*
1898
Gouache on paper, 12⅝ x 9⅜″ (32 x 23.8 cm.)
Collection Städtisches Museum Flensburg

Hans Christiansen

136 *Study for Book Design: The Four Elements: Air (Entwurf für einen Buchschmuck: Die Vier Elemente: Luft).*
1898
Gouache on paper, 12⅜ x 9¼″ (31.5 x 23.5 cm.)
Collection Städtisches Museum Flensburg

Vasily Kandinsky

137 *The Hunter (Der Jäger).* 1907
Color linocut on paper, 9⅝ x 2⅝″ (24.5 x
6.7 cm.)
Collection Städtische Galerie im Len-
bachhaus, Munich

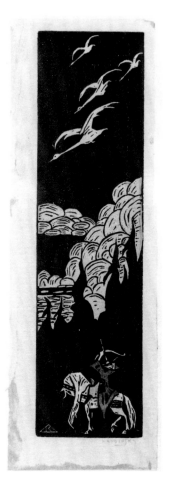

Hans Christiansen

138 *Autumn I (Herbst I).* 1901
Wool and hemp tapestry, 28⁵⁄₁₆ x 53³⁄₁₆″
(72 x 135 cm.)
Collection Städtisches Museum Flensburg

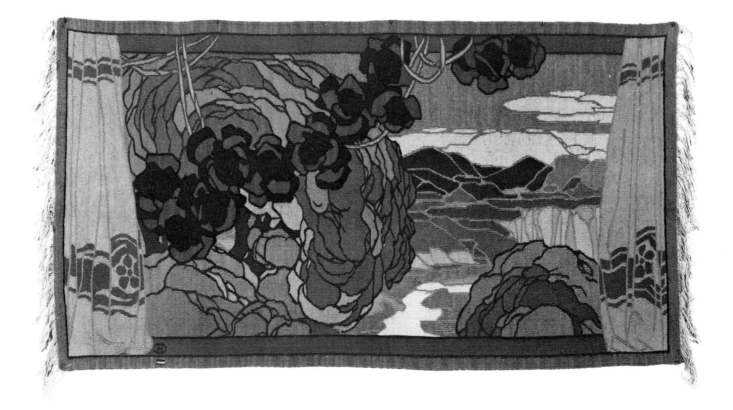

Vasily Kandinsky

139 *Walled City in Autumn Landscape (Um-
mauerte Stadt in Herbstlandschaft).*
ca. 1902
Colored crayon and tempera on red
paper, 6¼ x 14⅜″ (15.8 x 36.6 cm.)
Collection Städtische Galerie im Len-
bachhaus, Munich

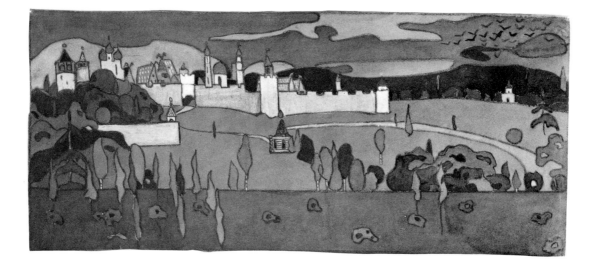

Vasily Kandinsky

148 *Sketchbook (Skizzenbuch).* 1904
Designs for Rings (Entwürfe für Finger-ringe), page 23 of 111 sheets, pencil on paper, 6⁵⁄₁₆ x 4⅛″ (16 x 10.5 cm.)
Collection Städtische Galerie im Lenbachhaus, Munich

Vasily Kandinsky

149 *Sketchbook (Skizzenbuch).* ca. 1900–04
Designs for Locks and Keys (Entwürfe für Schlüsselochbeschläge und Schlüssel), page 52 of 52 sheets, pencil, watercolor and goldbronze on graph paper, 5¼ x 8½″ (13.3 x 21.5 cm.)
Collection Städtische Galerie im Lenbachhaus, Munich

August Macke

150 *Keyhole Designs (Schlüsselloch Entwürfe).*
1910
Pencil on paper (reverse of telegram
form), 8⅝₁₆ x 10¼″ (21.1 x 26 cm.)
Collection Heirs of Dr. W. Macke, Bonn

Franz Marc

†151 *Keyhole Fitting (Schlüssellochbeschlag).*
n.d.
Bronze, 2¾ x 1½″ (7 x 3.8 cm.)
Collection Städtische Galerie im Len-
bachhaus, Munich

Franz Marc

†152 *Keyhole Fitting (Schlüssellochbeschlag).*
n.d.
Bronze, 2¾ x 2¹¹₁₆″ (7 x 6.8 cm.)
Collection Städtische Galerie im Len-
bachhaus, Munich

Franz Marc

†153 *Belt Clasp (Gürtelschliesse).* 1910
Bronze, 2⅜ x 2¹³₁₆″ (6 x 7.2 cm.)
Collection Städtische Galerie im Len-
bachhaus, Munich

Vasily Kandinsky

†154 *Embroidery—Designs with Landscapes
(Stickerei—Entwürfe mit Landschaften).*
1902–05
Pencil on paper, 10⅝ x 8³₁₆″ (27 x
20.8 cm.)
Collection Städtische Galerie im Len-
bachhaus, Munich

179

Vasily Kandinsky

155 *Bird in a Circle and Other Designs
(Vogel im Rund und andere Entwürfe).*
May–June 1904
Pencil on paper, 8³⁄₁₆ x 6⅛ (20.8 x
15.5 cm.)
Collection Städtische Galerie im Len-
bachhaus, Munich

Vasily Kandinsky

156 *Three Designs for Pendants (Drei Ent-
würfe für Anhänger).* n.d.
Pencil on paper, 4⅜ x 9¹¹⁄₁₆″ (11.1 x
24.5 cm.)
Collection Städtische Galerie im Len-
bachhaus, Munich

Vasily Kandinsky

157 *Embroidery Design with Stylized Trees (Stickereientwurf mit stilisierten Bäumen).*
1902–05
Tempera and white crayon on black paper, 4¹⁵⁄₁₆ x 7⁵⁄₁₆″ (12.5 x 18.5 cm.)
Collection Städtische Galerie im Lenbachhaus, Munich

Vasily Kandinsky

158 *Volga Ships (Wolgaschiffe).* 1905
Appliqué with beaded embroidery,
20⅞ x 32¹¹⁄₁₆″ (53 x 83 cm.)
Executed by Gabriele Münter
Collection Gabriele Münter-Johannes
Eichner Stiftung, Munich

Vasily Kandinsky

159 *Embroidery Design with Sun and Small Apple Trees (Stickereientwurf mit Sonne und Apfelbäumchen).* n.d.
Tempera and white crayon on black paper, 4⅞ x 7¼″ (11.2 x 18.4 cm.)
Collection Städtische Galerie im Lenbachhaus, Munich

Vasily Kandinsky

160a-d *Four Small Purses for Sewing Articles (Vier Täschchen für Nähzeug).* ca. 1905
Beaded embroidery, a. 5⅛ x 5⅞″ (13 x 15 cm.)
Executed by Gabriele Münter
Collection Gabriele Münter–Johannes Eichner Stiftung, Munich

Vasily Kandinsky

161 *Two Ladies in a Park with Monopteros and Pond (Zwei Damen in einer Parkanlage mit Monopteros und Teich).* ca. 1903
Pencil on transparent paper, 5⅝ x 2⅜″ (14.2 x 6 cm.)
Collection Städtische Galerie im Lenbachhaus, Munich

August Macke

162 *Sketch for Worringer Tea Salon (Entwurf für Worringer Tee-Salon).* 1912
Pencil on paper, 5¼ x 3¼" (13.3 x 8.2 cm.)
Collection Heirs of Dr. W. Macke, Bonn

August Macke

163 *Study: Two Vases with Handles (Entwurf: Zwei Henkelkannen).* 1912
Watercolor on paper, 10⅝ x 12⅝" (27 x 32 cm.)
Collection Heirs of Dr. W. Macke, Bonn

August Macke

164 *Study: Two Vases (Entwurf: Zwei Bauchvasen).* 1912
Watercolor on paper, 10⅝ x 12⅝" (27 x 32 cm.)
Collection Heirs of Dr. W. Macke, Bonn

165 *Hermann Obrist and Wilhelm von Deb-*
schitz in Obrist's Studio (Hermann Obrist
und Wilhelm von Debschitz im Atelier
von Obrist). 1902
Photograph
Collection Münchner Stadtmuseum,
Munich

Wolfgang von Wersin

166 *Abstract Study (Abstrakte Studie).*
1903–04
Watercolor and lithograph on paper, 6¹¹/₁₆
x 9⁵/₁₆″ (17 x 23.6 cm.)
Collection Münchner Stadtmuseum,
Munich

Wolfgang von Wersin

167 *Abstract Study (Abstrakte Studie).* n.d.
Watercolor and lithograph on paper, 6⁷/₁₆
x 9⁵/₈″ (16.3 x 24.5 cm.)
Collection Münchner Stadtmuseum,
Munich

Wolfgang von Wersin

168 *Abstract Study (Abstrakte Studie).*
1903–04
Watercolor and lithograph on paper, 5⁵⁄₁₆
x 8³⁄₁₆″ (13.5 x 20.8 cm.)
Collection Münchner Stadtmuseum,
Munich

Wolfgang von Wersin

169 *Abstract Study (Abstrakte Studie).* n.d.
Watercolor and lithograph on paper, 2¹¹⁄₁₆
x 5½″ (6.7 x 13.9 cm.)
Collection Münchner Stadtmuseum,
Munich

Wolfgang von Wersin

170 *Abstract Study (Abstrakte Studie).* 1903-04
Watercolor and lithograph on paper, 5 x
7¼″ (12.7 x 18.5 cm.)
Collection Münchner Stadtmuseum,
Munich

Paul Klee

171 *Ten Studies for Diverse Sketches for End-*
papers (Zehn diverse Entwürfe für Vor-
satzpapier). 1909–14
Pen and India ink over pencil and water-
color on checkered writing paper on card-
board, 12⅝ x 9½″ (32.1 x 24.1 cm.)
Collection Paul Klee-Stiftung, Kunst-
museum Bern

After Franz Marc

172 *Orpheus and the Animals (Orpheus und die Tiere).* 1907
Oil on canvas, 29⁵⁄₁₆ x 52¹⁵⁄₁₆″ (74.5 x 134.5 cm.)
Collection Städtische Galerie im Lenbachhaus, Munich

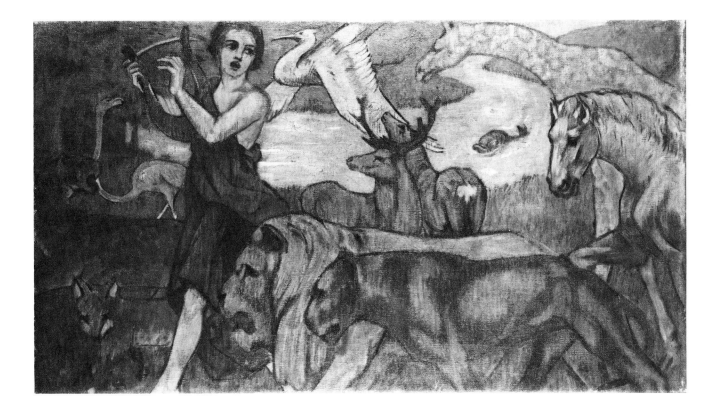

Franz Marc

173 *Ex Libris Daniel Pesl.* 1901
Color lithograph on paper, 4¼ x 2¾″
(10.8 x 7 cm.)
Collection Städtische Galerie im Lenbachhaus, Munich

Franz Marc

174 *Ex Libris Paul Marc.* 1902
Color lithograph on paper, 3⁷⁄₁₆ x 2⅞″
(8.7 x 7.5 cm.)
Collection Städtische Galerie im Lenbachhaus, Munich

Franz Marc

†175 *Ex Libris Daniel Pesl.* 1902
Color lithograph on paper, 5⁵⁄₁₆ x 1¹³⁄₁₆″
(12.8 x 4.6 cm.)
Collection Städtische Galerie im Lenbachhaus, Munich

Franz Marc

176 *Ex Libris.* 1902
Color lithograph on paper, 5¹⁄₁₆ x 1¹³⁄₁₆″
(12.8 x 4.6 cm.)
Collection Städtische Galerie im Lenbachhaus, Munich

Franz Marc

177 *Ex Libris.* 1905
 Color lithograph on paper, 3½ x 3½"
 (8.9 x 8.9 cm.)
 Collection Städtische Galerie im Len-
 bachhaus, Munich

Vasily Kandinsky

178 *Sketch for a Poster for a French Brewery
 (Entwurf für eine Affiche einer franzö-
 sischen Brauerei).* 1906–07
 Gouache on paper, 17½ x 20¼" (44.5 x
 51.5 cm.)
 Lent by Davlyn Gallery, New York

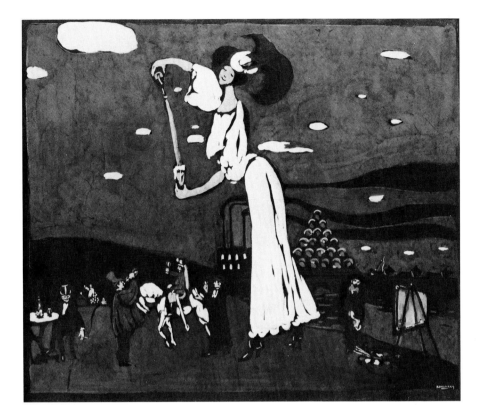

Akseli Gallen-Kallela
179 *Defense of the Sampo (Verteidigung des Sampos).* 1900
Gouache and paper on cardboard mounted on canvas, 57½ x 59³⁄₁₆″ (146 x 152 cm.)
Collection The Art Museum of the Ateneum, Helsinki, Antell Collection

Akseli Gallen-Kallela

180 *Landscape Under Snow (Winterbild).*
1902
Tempera on canvas, 29¹⁵/₁₆ x 56¹¹/₁₆"
(76 x 144 cm.)
Collection The Art Museum of the
Ateneum, Helsinki, Antell Collection

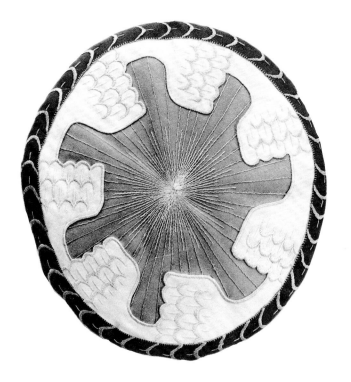

Akseli Gallen-Kallela
181 *Wing (Flügel)*. 1900–02
Appliqué and embroidery on broadcloth and cotton cushion, 14³⁄₁₆″ (36 cm.) d.
Executed by Mary Gallen-Kallela
Collection Gallen-Kallela Museum, Espoo, Finland

Akseli Gallen-Kallela
182 *Seaflower (Meeresblume)*. 1977 copy of 1900–02 original
Appliqué and embroidery on broadcloth cushion, 15³⁄₈ x 15³⁄₈″ (39 x 39 cm.)
Collection Gallen-Kallela Museum, Espoo, Finland

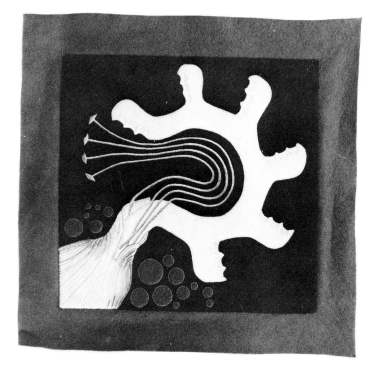

Akseli Gallen-Kallela

183 *Defense of the Sampo (Verteidigung des Sampos).* 1895
Woodcut on paper, 9¹/₁₆ x 7⅛″ (23 x 18 cm.)
Collection Gallen-Kallela Museum, Espoo, Finland

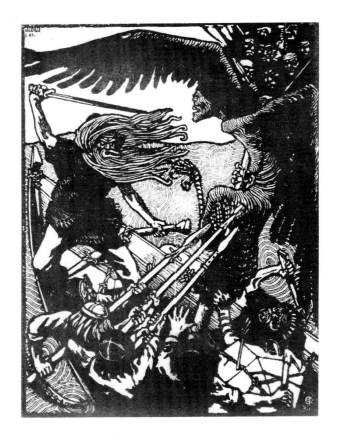

Vasily Kandinsky

184 *Twilight (Dämmerung).* 1901
Tempera, colored and black pencil, silver and goldbronze on cardboard, 6³⁄₁₆ x 18¹³⁄₁₆" (15.7 x 47.7 cm.)
Collection Städtische Galerie im Lenbachhaus, Munich

Vasily Kandinsky

185 *Trumpet (Trompete).* 1907
Color linocut on paper, 2⁹⁄₁₆ x 8⁷⁄₈" (6.5 x 22.6 cm.)
Collection Städtische Galerie im Lenbachhaus, Munich

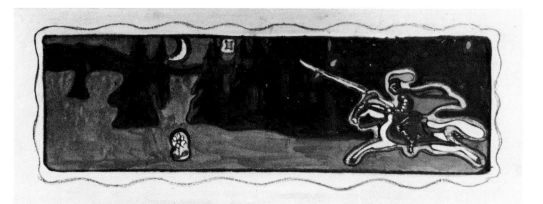

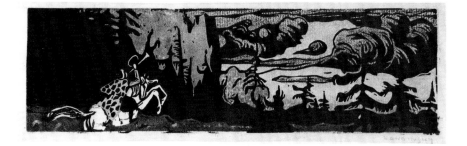

Vasily Kandinsky

†186 *Sketchbook (Skizzenbuch).* ca. 1903–04
Trumpet-Blowing Rider (Trompete-blasenden Reiter), page 31 of 40 sheets, pen and ink on paper, 6⅝ x 4⁵⁄₁₆″ (16.8 x 11 cm.)
Collection Städtische Galerie im Lenbachhaus, Munich

Vasily Kandinsky

187 *Landscape with Trumpet-Blowing Rider (Landschaft mit trompeteblasendem Reiter).* 1908–09
Tusche brush over pencil on paper, 6½ x 8¼″ (16.5 x 20.9 cm.)
Collection Städtische Galerie im Lenbachhaus, Munich

Vasily Kandinsky

†188 *Landscape with Rider and Bridge (Landschaft mit Reiter und Brücke).* 1908–09
Oil on paper mounted on cardboard, 12⅜ x 10″ (32.7 x 25.4 cm.)
Collection Städtische Galerie im Lenbachhaus, Munich

Vasily Kandinsky

†189a-f *Six Letters to Akseli Gallen-Kallela (Sechs Briefe an Axel Gallen-Kallela).*
March 19, May 8, May 26, June 9, June 10, June 13, 1902
Pen and ink on paper (*Phalanx* letterhead), each ca. 8½ x 5¾″ (21.6 x 14.6 cm.)
Collection Gallen-Kallela Museum, Espoo, Finland

Gustav Freytag

†190 *Letter to Akseli Gallen-Kallela (Brief an Axel Gallen-Kallela).* April 28, 1902
Pen and ink on paper (*Phalanx* letterhead), ca. 8½ x 5¾″ (21.6 x 14.6 cm.)
Collection Gallen-Kallela Museum, Espoo, Finland

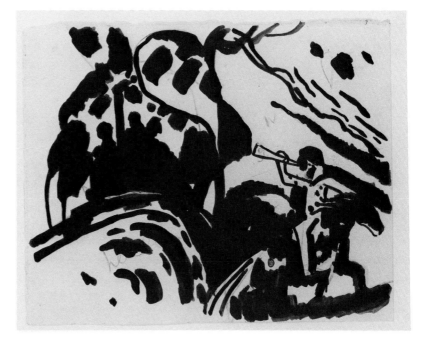

Vasily Kandinsky

191 Poster for *VII Exhibition of Phalanx (VII. Ausstellung Phalanx).* 1903
Color lithograph on paper, 32⅞ x 24¹⁄₁₆″ (83.5 x 61.2 cm.)
Collection Münchner Stadtmuseum, Munich

Gabriele Münter

192 *Portrait of Kandinsky.* 1906
Color woodcut on paper, 10¼ x 7½″
(25.9 x 19 cm.)
Collection The Solomon R. Guggenheim
Museum, New York

Gabriele Münter

193 *Kandinsky at Landscape Painting (Kandinsky beim Landschaftsmalen).* 1903
Oil on canvasboard, 6⅝ x 9¹³⁄₁₆" (16.9 x 25 cm.)
Collection Städtische Galerie im Lenbachhaus, Munich

Vasily Kandinsky

194 *Gabriele Münter Painting in Kallmünz. (Gabriele Münter beim Malen in Kallmünz).* 1903
Oil on canvas, 23¹⁄₁₆ x 23¹⁄₁₆" (58.5 x 58.5 cm.)
Collection Städtische Galerie im Lenbachhaus, Munich

Vasily Kandinsky

195 *Sunday, Old Russian (Sonntag, altrussisch).* 1904
Oil on canvas, 17¾ x 37⁷⁄₁₆″ (45 x 95 cm.)
Collection Museum Boymans-van Beuningen, Rotterdam

Vasily Kandinsky

196 *Beach Baskets in Holland (Strandkörbe in Holland).* 1904
Oil on canvasboard, 9⁷⁄₁₆ x 12⁷⁄₈″ (24 x 32.6 cm.)
Collection Städtische Galerie im Lenbachhaus, Munich

Carl Strathmann

197 *The King of Fishes (Der König der Fische).* ca. 1900
Gouache, watercolor and ink on paperboard, 20¹⁄₁₆ x 14¹³⁄₁₆″ (51 x 37.6 cm.)
Collection Badisches Landesmuseum, Karlsruhe

Carl Strathmann

†198 *Title Page Design, "Before My Chamber Door, Lullaby, Before the Battle, Dance of Death" (Titelblattentwurf, "Vor meiner Kammertür, Schlummerlieder, Vor der Schlacht, Totentanz").* before 1899
Tusche and watercolor highlighted with gold on paper, 13⅝ x 10⅝″ (34.5 x 27 cm.)
Collection Münchner Stadtmuseum, Munich

Vasily Kandinsky

199 *Three-headed Dragon (Dreiköpfiger Drache).* 1903
Woodcut on paper, 5¾ x 2¹⁵⁄₁₆″ (14.6 x 7.4 cm.)
Collection Städtische Galerie im Lenbachhaus, Munich

Carl Strathmann

200 *The World Serpent (Die Weltschlange).* before 1900
Watercolor and ink on paper, 9⅛ x 9⅛″ (23.2 x 23.2 cm.)
Collection Badisches Landesmuseum, Karlsruhe

Carl Strathmann

201 *Satan.* 1902
Watercolor on cardboard, 28$\frac{11}{16}$ x 28$\frac{9}{16}$″ (72.8 x 72.5 cm.)
Collection Münchner Stadtmuseum, Munich

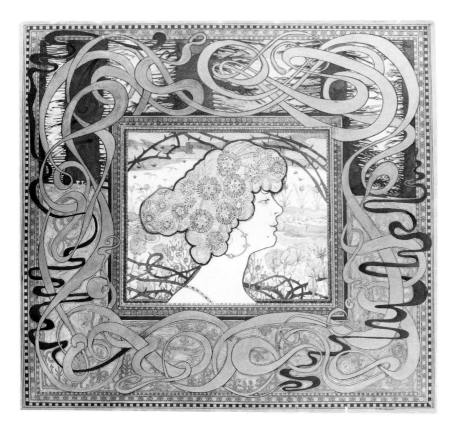

Carl Strathmann

202 *Decorative Painting with Frame (Dekoratives Bild mit Rahmen).* ca. 1897
Tusche and watercolor on paper, ca. 19¹¹⁄₁₆ x 23⅝" (50 x 60 cm.)
Collection Münchner Stadtmuseum, Munich

Carl Strathmann

203 *Small Serpent (Kleine Schlange).* 1897–98
Watercolor on paper, 9¼ x 13¼" (23.5 x 35 cm.)
Collection Städtische Galerie im Lenbachhaus, Munich

Paul Klee

204 *Untitled/2 Fish, 2 Hooks, 2 Worms (Ohne Originaltitel/2 Fische, 2 Angelhaken, 2 Würmer).* 1901
Watercolor and ink on paper, 6 x 8⁹⁄₁₆″ (15.2 x 21.7 cm.)
Collection Felix Klee, Bern

Paul Klee

205 *Untitled/1 Fish, 2 Hooks, 1 Little Creature (Ohne Originaltitel/1 Fisch, 2 Angelhaken, 1 kleines Geiter).* 1901
Watercolor and ink on paper, 6⁵⁄₁₆ x 9¼″ (16.1 x 23.5 cm.)
Collection Felix Klee, Bern

Paul Klee

206 *Untitled/2 Fish, 1 Hook, 1 Worm (Ohne Originaltitel/2 Fische, 1 Angelhaken, 1 Wurm).* 1901
Watercolor and ink on paper, 6⅜ x 9³⁄₁₆″ (16.2 x 23.3 cm.)
Collection Felix Klee, Bern

Paul Klee

207 *Untitled/2 Fish, One on the Hook (Ohne Originaltitel/2 Fische, einer am Haken).* 1901
Watercolor and ink on paper, 6 x 8¾″ (15.2 x 22.6 cm.)
Collection Felix Klee, Bern

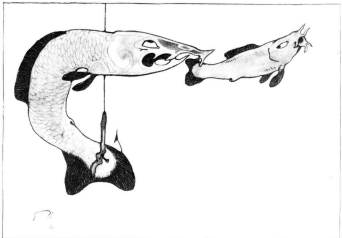

207

Alfred Kubin
208 *The Pearl (Die Perle).* 1906–08
Tempera on paper, 15 x 16¾″ (38 x
42.5 cm.)
Private Collection

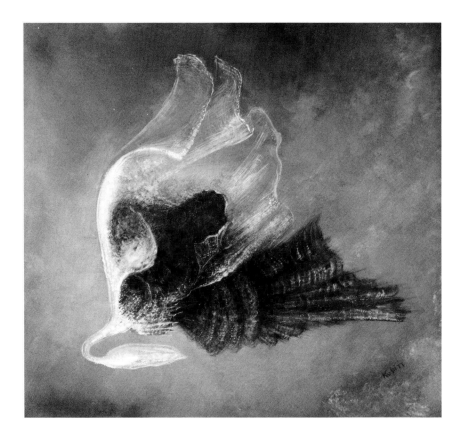

Alfred Kubin

209 *Portfolio with Facsimile Prints After 15 Colored Pen Drawings (Mappe mit Faksimile Drucken nach 15 getönten Federzeichnungen).* 1903
Each sheet, 9⅞ x 14³⁄₁₆″ (25 x 36 cm.)
Published by Hans von Weber, Munich
Collection Städtische Galerie im Lenbachhaus, Munich

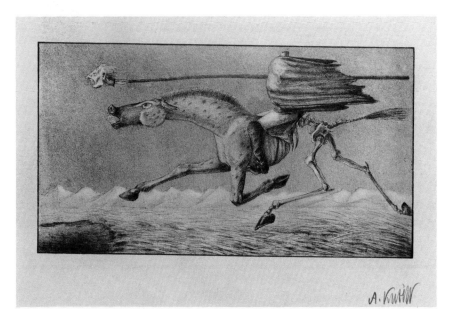

III. THE LYRIC MODE: ENCOUNTERS WITH WOODCUT, POETRY, CALLIGRAPHY, THEATER

POETRY AND WOODCUTS

Vasily Kandinsky
210 Title Page for *"Verses Without Words"* (*"Gedichte ohne Worte"*). ca. 1903–04
Woodcut on paper, 9$\frac{3}{16}$ x 6$\frac{9}{16}$" (23.3 x 16.7 cm.)
Collection The Museum of Modern Art, New York, Gift of Mrs. John D. Rockefeller 3rd

Vasily Kandinsky
†211 *Bustling Life* from *"Verses Without Words"* (*Bewegtes Leben* von *"Gedichte ohne Worte"*). 1903
Woodcut on paper, 3$\frac{1}{16}$ x 6$\frac{7}{16}$" (7.8 x 16.4 cm.)
Collection The Museum of Modern Art, New York, Gift of Mrs. John D. Rockefeller 3rd

Vasily Kandinsky

212 *Xylographies.* 1909

Portfolio of 5 prints plus cover and title page, heliogravure on paper, each 12⅝ x 12⅝″ (32 x 32 cm.)

Collection The Solomon R. Guggenheim Museum, New York

Vasily Kandinsky

213 *Birds (Vögel).* 1907

Woodcut on paper, 5⅜ x 5¹¹⁄₁₆″ (13.6 x 14.4 cm.)

Collection Städtische Galerie im Lenbachhaus, Munich

Vasily Kandinsky

214 *The Night (Die Nacht).* 1907
Tempera and white ink on dark gray
lined cardboard, 11¾ x 19⅝" (29.8 x
49.8 cm.)
Collection Städtische Galerie im Len-
bachhaus, Munich

Vasily Kandinsky

215 *Farewell (Abschied).* 1903
Color woodcut on paper, 11¹³⁄₁₆ x 12³⁄₁₆″
(30 x 31 cm.)
Collection Städtische Galerie im Lenbachhaus, Munich

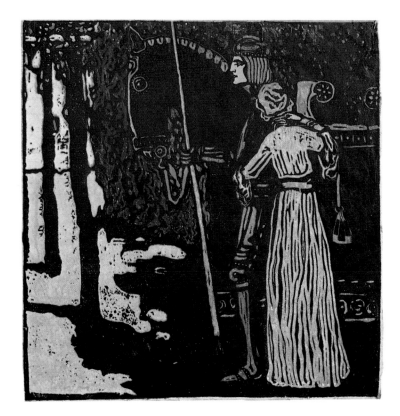

Vasily Kandinsky
216 *The Mirror (Der Spiegel).* 1907
Color woodcut on paper, 12½ x 6¼"
(32.1 x 15.9 cm.)
Collection The Solomon R. Guggenheim
Museum, New York

Vasily Kandinsky
217 *In Summer (Im Sommer).* 1904
Color woodcut on paper, 12¹/₁₆ x 5⅞"
(30.6 x 15 cm.)
Collection Städtische Galerie im Len-
bachhaus, Munich

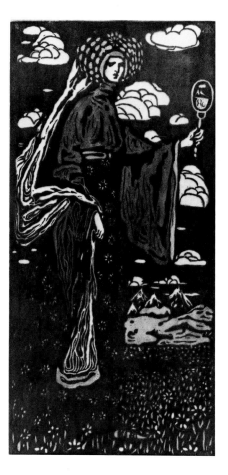

Vasily Kandinsky

†218 *Night (Large Version) (Die Nacht [Grosse Fassung]).* 1903
Color woodcut on paper, 11⁹⁄₁₆ x 4⅞"
(29.4 x 12.5 cm.)
Collection Städtische Galerie im Lenbachhaus, Munich

Vasily Kandinsky

219 *The Golden Sail (Das goldene Segel).*
1903
Color woodcut on paper, 5 x 11¾" (12.7
x 30.2 cm.)
Collection The Solomon R. Guggenheim
Museum, New York

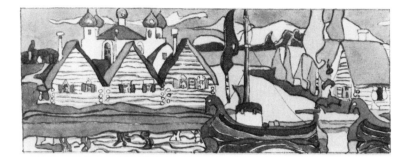

Vasily Kandinsky

220 *Russian Village on a River with Boats
(Russisches Dorf am Fluss mit Schiffen).*
ca. 1902
Tempera and colored pencil on paper,
6¹³⁄₁₆ x 6⁹⁄₁₆″ (17.3 x 16.7 cm.)
Collection Städtische Galerie im Len-
bachhaus, Munich

Karl Bauer

221 *Stefan George Circle: George with Wolf-
skehl, Schüler, Klages, Verwey in Munich
(Stefan George Kreis: George mit Wolf-
skehl, Schüler, Klages, Verwey in
München).* 1902
Photograph
Collection Schiller-Nationalmuseum,
Marbach

J. Hilsdorf Bingen

222 *Stefan George.* Munich, ca. 1903
Photograph
Collection Württembergische Landes-
bibliothek, Stuttgart

Karl Bauer

223 *Portrait of Karl Wolfskehl (Bildnis Karl
Wolfskehl).* 1900
Lithograph on paper, 7⅞ x 7⅜″ (20 x
18.6 cm.)
Collection Schiller-Nationalmuseum/
Deutsches Literaturarchiv, Marbach

Anonymous
224 Poster for *Alexander Sacharoff*. ca. 1910
Lithograph on paper, 41⅛ x 31½"
(104.5 x 80 cm.)
Collection Münchner Stadtmuseum,
Munich

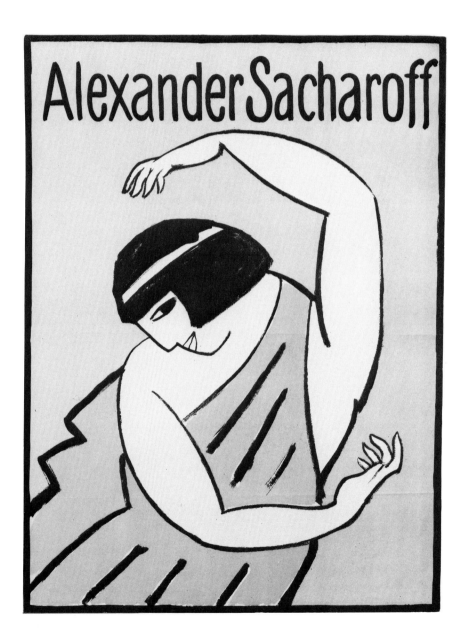

Fritz Erler

225 *Stage Designs—Brakls Modern Art Gallery—Faust—Hamlet (Bühnenentwürfe—Brakls Moderne Kunsthandlung—Faust—Hamlet).* ca. 1908?
Lithograph on paper, 39⅜ x 23⅝″ (100 x 60 cm.)
Collection Münchner Stadtmuseum, Munich

Max Littmann

226 *Model for Munich Artists' Theater*
(Modell des Münchner Künstlertheaters).
ca. 1907–08
Wood, 31½ x 65 x 20⅞" (80 x 165 x
53 cm.)
Collection Deutsches Theatermuseum,
Munich, Früher Clara Ziegler-Stiftung

Fritz Erler

***227** *Set Design for "Faust I" (Bühnenbildentwurf zu "Faust I").* 1908
Photograph
Collection Deutsches Theatermuseum,
Munich, Früher Clara Ziegler-Stiftung

Adolf Hengeler

228 *"Hoopoe" (Lark No. 1), Figure for Joseph Rüderer's "Wolkenkuckucksheim" ("Hoopoe" [Wiedehopf Nr. 1], Figur für Joseph Rüderers "Wolkenkuckucksheim").* 1908
Watercolor and pencil on paper, 10⅜ x 7¾" (26.3 x 19.8 cm.)
Collection Deutsches Theatermuseum, Munich, Früher Clara Ziegler-Stiftung

Rolf Hoerschelman

229 *Cover for Schwabinger Schattenspiel. Prospectus 1908 by Alexander Freiherr von Bernus (Einband, Schwabinger Schattenspiele Prospektbuch 1908 von Alexander Freiherr von Bernus).* 1908
Tusche on paper, 7³⁄₁₆ x 4⅝" (18.3 x 11.7 cm.)
Collection Stadtbibliothek mit Handschriftensammlung, Munich

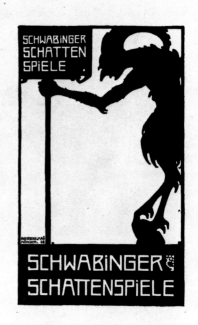

Vasily Kandinsky

230 *Study for a Cover or Title Page of an Album with Music and Graphics (Entwurf für Einband oder Titelblatt eines Albums mit Musik und Graphik).* 1908–09
Watercolor over pencil on paper, $10^{15}/_{16}$ x $9^{1}/_{16}$" (27.8 x 23 cm.)
Collection Städtische Galerie im Lenbachhaus, Munich

Vasily Kandinsky

231 *The Veil (Die Schleier).* 1907-08
Watercolor over pencil on paper, $6^{7}/_{8}$ x $8^{7}/_{8}$" (17.6 x 22.5 cm.)
Collection Städtische Galerie im Lenbachhaus, Munich

Vasily Kandinsky

232 *Four Musicians in a Landscape (Vier Musikanten in Landschaft).* 1908–09
Watercolor and charcoal over pencil on paper, $4^{9}/_{16}$ x $7^{1}/_{4}$" (11.7 x 18.4 cm.)
Collection Städtische Galerie im Lenbachhaus, Munich

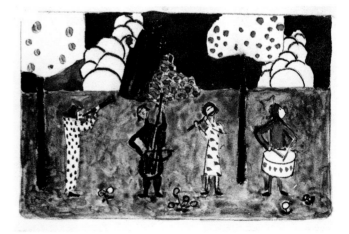

Adolf Hölzel

233 *Black Ornaments on Brown Ground (Schwarze Ornamente auf braunem Grund).* before 1900
Tusche on brown paper, 13 x 8¼" (33 x 21 cm.)
Pelikan-Kunstsammlung, Hannover

Adolf Hölzel

234 *Abstract Ornament with Text: 30 July 1898 (Abstraktes Ornament mit Schrift: 30 Juli 1898).* 1898
Ink on paper, 3¹⁵⁄₁₆ x 9⁷⁄₁₆" (10 x 24 cm.)
Private Collection

Adolf Hölzel

235 *Abstract Ornament with Text (Abstraktes Ornament mit Schrift).* ca. 1898
India ink on paper, 13 x 8¼" (33 x 21 cm.)
Private Collection

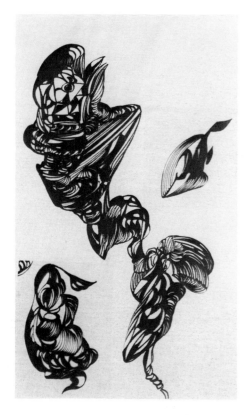

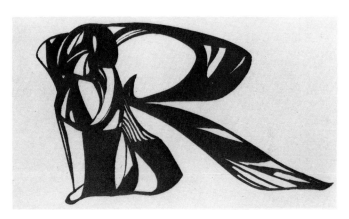

Paul Klee
236 *Monogram PK (Monogramm "PK").*
1892
Watercolor and India ink on school note-book cover, 9⅛ x 7³⁄₁₆″ (23.2 x 18.2 cm.)
Collection Felix Klee, Bern

Adolf Hölzel
237 *Initial "R" (Initiale "R").* before 1900
India ink on paper, 4½ x 8¹⁄₁₆″ (11.5 x 20.5 cm.)
Private Collection

Vasily Kandinsky

238 *Sketchbook (Skizzenbuch).* 1903–04
Designs for Embroideries (Entwürfe für Stickereien), page 45 of 45 sheets, pencil on paper, 6⅛ x 3¹⁵⁄₁₆″ (15.5 x 10 cm.)
Collection Städtische Galerie im Lenbachhaus, Munich

Vasily Kandinsky

239 *Study with Loop Motifs (Entwurf mit Schlingenmuster).* ca. 1903
Tempera and white crayon on black paper, 5¼ x 6¹⁵⁄₁₆″ (13.4 x 17.7 cm.)
Collection Städtische Galerie im Lenbachhaus, Munich

Vasily Kandinsky

240 *Sketchbook (Skizzenbuch).* 1904
Decorative Design (Dekorativer Entwurf), page 21 of 112 sheets, pencil on graph paper, 6⅜ x 4¹⁄₁₆″ (16.1 x 10.3 cm.)
Collection Städtische Galerie im Lenbachhaus, Munich

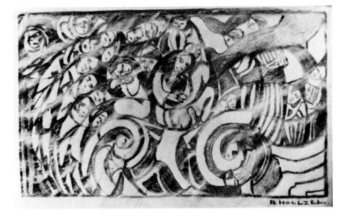

Adolf Hölzel

241 *Ornamental Figure Composition in Circular Forms (Adoration) (Ornamentalische Figuren-Komposition in Kreisenden Formen [Huldigung]).* n.d.
Pencil on paper (envelope), 4 x 7″ (10.2 x 17.8 cm.)
Pelikan-Kunstsammlung, Hannover

Adolf Hölzel

242 *Four Bowing Figures with Text Base (Vier sich verneigende Figuren mit Schriftsockel).* ca. 1914–15
Pen and ink on lined paper, 13 x 9³⁄₁₆″ (33 x 20.8 cm.)
Pelikan-Kunstsammlung, Hannover

Vasily Kandinsky

243 *Untitled Watercolor (with Text) (Aquarell ohne Titel [mit Schrift]).* ca. 1913
Watercolor and tusche on paper, 9⁷⁄₁₆ x 11¹⁵⁄₁₆″ (23.9 x 30.3 cm.)
Collection Städtische Galerie im Lenbachhaus, Munich

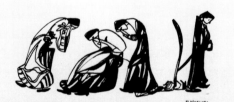

Adolf Hölzel

244 *Composition. Picture and Text Pen Drawing (Komposition. Bild und Schrift Federzeichnung)* n.d.
Pen and ink on gray paper, 9 7/8 x 6 1/2″ (25 x 16.5 cm.)
Pelikan-Kunstsammlung, Hannover

Vasily Kandinsky

245 *Sketchbook from the Tunisia Trip (Skizzenbuch von der Tunis Reise).* 1905
Arabic Calligraphy (Arabischer Kalligraphie), page 32 of 40 sheets, pencil on paper, 6½ x 4⁵⁄₁₆″ (16.5 x 11 cm.)
Collection Städtische Galerie im Lenbachhaus, Munich

August Macke

246 *Abstract Signs III (Abstrakte Zeichen III).* ca. 1913
Tusche on paper, 4 x 6⅜″ (10.2 x 16.2 cm.)
Collection Heirs of Dr. W. Macke, Bonn

August Macke

247 *Abstract Signs X (Abstrakte Zeichen X).* ca. 1913
Tusche on paper, 4 x 6⅜″ (10.2 x 16.2 cm.)
Collection Heirs of Dr. W. Macke, Bonn

Adolf Hölzel

248 *Ornamental Figure Composition (Orna-*
mentalische Figuren-Komposition).
n.d.
Quill pen and ink on paper, 11⅝ x 8⅝″
(29.5 x 21.8 cm.)
Pelikan-Kunstsammlung, Hannover

Adolf Hölzel

249 *Composition with Two Abstract Figura-*
tions (Komposition mit zwei abstrakten
Figurationen). n.d.
Quill pen and ink on paper, 11¹¹⁄₁₆ x 8⅜″
(29.7 x 21.7 cm.)
Pelikan-Kunstsammlung, Hannover

Adolf Hölzel

250 *Figuration in Black, Green and Orange*
(Figuration in Schwarz, Grün und
Orange). n.d.
Tusche and watercolor on paper (pros-
pectus sheet), 6¼ x 8″ (15.8 x 20.3 cm.)
Pelikan-Kunstsammlung, Hannover

Adolf Hölzel

251 *The Battle (Die Schlacht).* n.d.
Pen and ink with colored pencil on news-
print, 7¾ x 6¹⁵⁄₁₆″ (19.7 x 17.7 cm.)
Pelikan-Kunstsammlung, Hannover

Adolf Hölzel

252 *Figure Ornament with Edging Strip
(Figurenornament mit Randleiste).*
ca. 1916
Quill pen and ink on paper, 13 x 8¼″
(33 x 21 cm.)
Pelikan-Kunstsammlung, Hannover

Adolf Hölzel

253 *Free Ornament (Freies Ornament).*
ca. 1915–16
Quill pen drawing on paper, 8½ x 7⅞″
(21.6 x 20 cm.)
Pelikan-Kunstsammlung, Hannover

233

Paul Klee

254 *Suburb (North Munich) (Vorstadt [München Nord]).* 1913
Pen, brush, tusche, wash and zinc white on paper, 4¼ x 7⅝″ (12.1 x 19.4 cm.)
Collection Städtische Galerie im Lenbachhaus, Munich

Eugen von Kahler

255 *Garden of Love (Liebesgarten).* 1910–11
Watercolor and ink on paper, 7½ x 10¹¹⁄₁₆″ (19 x 27.1 cm.)
Collection Städtische Galerie im Lenbachhaus, Munich

Albert Bloch

256 *To the Clown Picture IV (Zum Klownbild IV).* 1914
Watercolor on paper, 13¾ x 17¹¹⁄₁₆″ (34.9 x 44.9 cm.)
Collection Felix Klee, Bern

Alfred Kubin

257 *The Fisherman (Der Fischer).* 1911–19
Ink on paper, 8⅞ x 5⅞″ (22.5 x 14.8 cm.)
Private Collection

234

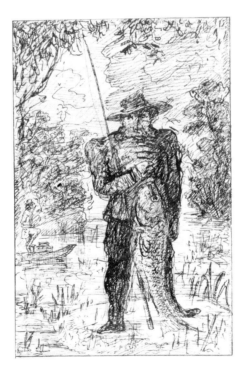

IV. DEPARTURES AND RETURNS: TRANSITION AND SELF-REALIZATION

Vasily Kandinsky

258 *Riding Couple (Reitendes Paar).* 1907
Oil on canvas, 21$^{11}/_{16}$ x 19$^7/_8$″ (55 x
50.5 cm.)
Collection Städtische Galerie im Len-
bachhaus, Munich

Martha Cunz

259 *View of the Säntis (Blick auf den Säntis).*
1904
Color woodcut on paper, 9$^3/_4$ x 11$^3/_4$″
(24.7 x 29.8 cm.)
Collection Kunstmuseum St. Gallen

Vasily Kandinsky

260 *Landscape near Murnau with Locomotive
(Murnaulandschaft).* 1909
Oil on board, 19$^7/_8$ x 25$^5/_8$″ (50.4 x 65 cm.)
Collection The Solomon R. Guggenheim
Museum, New York

Vasily Kandinsky

261 *Improvisation VI (African) (Improvisation VI [Afrikanisches]).* 1909
Oil on canvas, 42⅛ x 37⅝″ (107 x 95.5 cm.)
Collection Städtische Galerie im Lenbachhaus, Munich

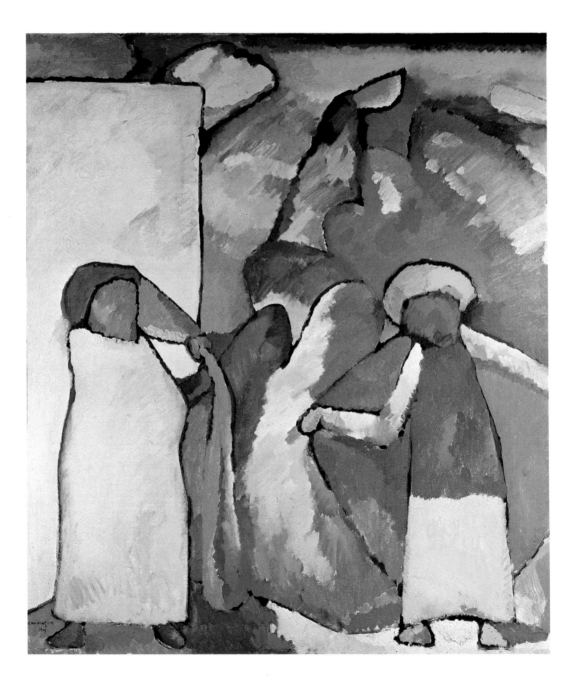

Adolf Hölzel

262 *Composition in Red I (Komposition in Rot I).* 1905
Oil on canvas, 26¾ x 33½″ (68 x 85 cm.)
Kunstmuseum Hannover mit Sammlung Sprengel—Loan from Pelikan-Kunstsammlung

Adolf Hölzel

***263** *Prayer of the Children (Gebet der Kinder).*
1916
Collage on canvas, 19⁵⁄₁₆ x 15¾" (50 x
40 cm.)
Kunstmuseum Hannover mit Sammlung
Sprengel—Loan from Pelikan-
Kunstsammlung

Adolf Hölzel

264 *Autumn (Herbst).* 1914
Oil on canvas, 33½ x 26⅜″ (85 x 67 cm.)
Kunstmuseum Hannover mit Sammlung
Sprengel—Loan from Pelikan-
Kunstsammlung

Vasily Kandinsky

265 *White Sound (Weisser Klang).* 1908
Oil on cardboard, 27⅝ x 27¾″ (70.2 x
70.5 cm.)
Collection of Mr. and Mrs. Benjamin J.
Fortson, Fort Worth

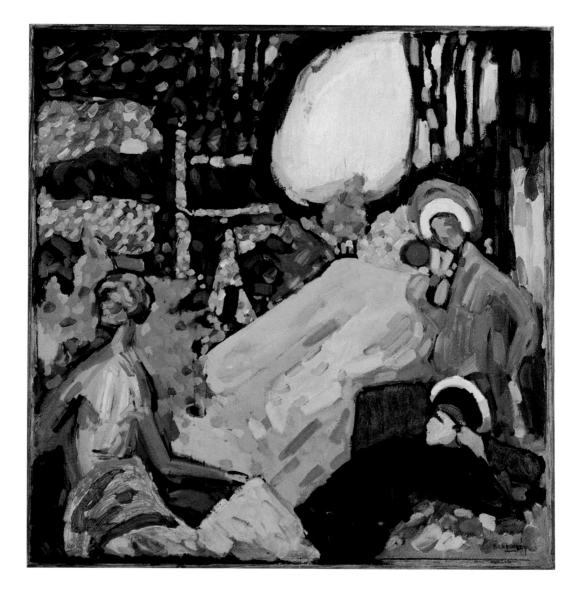

Vasily Kandinsky
266 *White Sound (Weisser Klang).* 1911
Color woodcut on paper, 3 7/16 x 3 13/16"
(8.8 x 9.7 cm.)
Collection Städtische Galerie im Len-
bachhaus, Munich

Vasily Kandinsky

267 *Lyrical (Lyrisches).* 1911
Oil on canvas, 37 x 51 3/16″ (94 x 130 cm.)
Collection Museum Boymans-van
Beuningen, Rotterdam

Vasily Kandinsky

†268 *Lyrical (Lyrisches).* 1911
Color woodcut on paper, 5 11/16 x 8 9/16″
(14.5 x 21.7 cm.)
Collection Städtische Galerie im Len-
bachhaus, Munich

Vasily Kandinsky

269 *Archer (Bogenschütze).* 1908–09
Color woodcut on paper, 12⅜ x 9½″
(31.4 x 24.2 cm.)
Collection The Solomon R. Guggenheim
Museum, New York

Vasily Kandinsky

270 *The Guardian (Der Wächter).* ca. 1907
Pencil and zinc white on blue paper, 6³⁄₁₆
x 10⁵⁄₁₆″ (15.7 x 26.2 cm.)
Collection Städtische Galerie im Len-
bachhaus, Munich

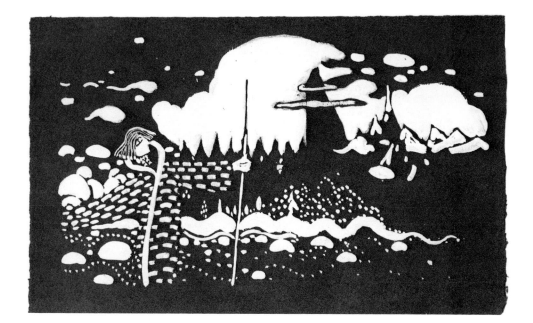

Vasily Kandinsky
271 Poster for *I Exhibition of the Neue
Künstlervereinigung München (Neue
Künstlervereinigung München, Ausstel-
lung I)*. 1909
Lithograph on paper, 10⅝ x 8½″ (27.1 x
21.7 cm.)
Private Collection

Vasily Kandinsky

272 *Study for Signet for the Neue Künstler-vereinigung München (Entwurf für das Signet der Neuen Künstlervereinigung München).* 1908–09
Wash over pencil on paper, 2¾ x 4⁷⁄₁₆″ (7.1 x 11.2 cm.)
Collection Städtische Galerie im Lenbachhaus, Munich

Vasily Kandinsky

273 *Study for Signet for the Neue Künstler-vereinigung München (Entwurf für das Signet der Neuen Künstlervereinigung München).* 1908–09
Wash over pencil on paper, 2⅞ x 4⁷⁄₁₆″ (7.4 x 11.2 cm.)
Collection Städtische Galerie im Lenbachhaus, Munich

Vasily Kandinsky

274 *Study for Signet for the Neue Künstler-vereinigung München (Entwurf für das Signet der Neuen Künstlervereinigung München).* 1908–09
Wash over pencil on paper, 3¹⁄₁₆ x 4½″ (7.8 x 11.5 cm.)
Collection Städtische Galerie im Lenbachhaus, Munich

Vasily Kandinsky

275 *Cliffs (Felsen).* 1908–09
Woodcut on paper, 4⅞ x 5¹¹⁄₁₆″ (12.3 x 14.4 cm.)
Collection Städtische Galerie im Lenbachhaus, Munich

Vasily Kandinsky

†276 *Membership Card for the Neue Künstlervereinigung München (Neue Künstlervereinigung München, Mitgliedskarte).* 1909
Woodcut on paper, 6⁵⁄₁₆ x 6⅝″ (16 x 16.6 cm.)
Private Collection

Vasily Kandinsky

277 Poster for *II Exhibition of the Neue Künstlervereinigung München (Neue Künstlervereinigung München, Ausstellung II).* 1910
Lithograph on paper, 10⅝ x 8½″ (27 x 21.5 cm.)
Collection Münchner Stadtsmuseum, Munich

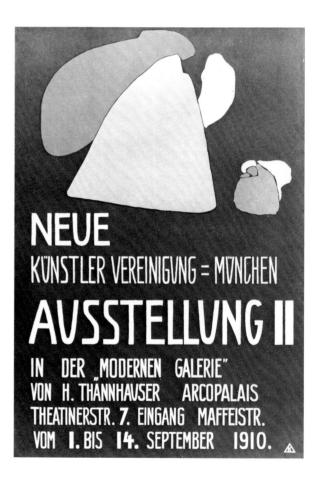

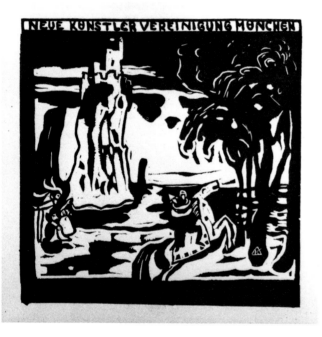

278 *Neue Künstlervereinigung München:*
Entry Card for the Exhibition Sponsored
by the Society (Eintrittskarte für die von
der Vereinigung veranstalteten Ausstel-
lung). ca. 1909
Multiple copy typeset on pasteboard, 3¼
x 4⁵⁄₁₆″ (8.3 x 11 cm.)
Private Collection

279 *Neue Künstlervereinigung München: Jury*
Form for the Exhibitions of the Society
(Vordruck für die Jury der Ausstellungen
der Vereinigung). ca. 1909
Multiple copy typeset on paper, 6¹⁵⁄₁₆ x
4⅜″ (17.7 x 11.2 cm.)
Private Collection

NEUE KÜNSTLER-
VEREINIGUNG
MÜNCHEN E. V.

EINTRITTS-KARTE

FÜR ...

...

FÜR DIE ZEIT VOM ...

BIS ...

BEITRAG
BEZAHLT

NEUE KÜNSTLER-
VEREINIGUNG
MÜNCHEN E. V.

Ew. Hochwohlgeboren!

Hierdurch teilen wir Ihnen das
Resultat der Jury Ihrer Werke
höflichst mit:

genommen nicht genommen

Hochachtungsvoll
Der Vorstand.

280 *Neue Künstlervereinigung München: Communication Inviting Participation in the Catalogue of the Second Exhibition of the Society (Mitteilung zur Gestaltung des Kataloges der zweiten Ausstellung der Vereinigung).* 1910–11
Multiple copy typeset on paper, 8¾ x 6¹⁵⁄₁₆″ (22.2 x 17.7 cm.)
Private Collection

281 *Neue Künstlervereinigung München: Communication Inviting Participation in the Catalogue of the Second Exhibition of the Society (Mitteilung zur Gestaltung des Kataloges der zweiten Ausstellung der Vereinigung).* 1910–11
Multiple copy typeset on paper, 8¾ x 6¹⁵⁄₁₆″ (22.2 x 17.7 cm.)
French text
Private Collection

MÜNCHEN, Juni 1910.

Euer Hochwohlgeboren!

Die » Neue Künstlervereinigung München" hat beschlossen, in den Katalog der nächsten internationalen Ausstellung jedem teilnehmenden Künstler die Möglichkeit zu geben, auch durch Wort sich an das Publikum zu wenden und das im Worte zu sagen, was seine Ansicht über Kunst und eigenes Schaffen beleuchten und klarer machen kann. Manchmal sagt ein kurzes Wort des Künstlers dem hörenden Beschauer gerade das, was weder ausgedehnte Artikel der Kritiker vom Beruf, noch viele Bände einer Kunstgeschichte im Stande sind zu sagen.

So kann dem suchenden Beschauer der richtige Weg zur Kunst gezeigt werden, welchen er oft allein nicht finden kann oder welchen er nicht findet, da er von der »Kritik» auf verschiedene Umwege mitgezogen wird.

Die "Neue Künstlervereinigung München" erlaubt sich zu hoffen, dass auch Sie ihr in dieser Aufgabe zu helfen geneigt sein werden, indem Sie ein kurzes Wort (ca. eine gedruckte Seite in Quart) ihr zur Verfügung stellen werden.

Letzter Termin der Einsendung ist 1. August ds.J.

Mit vorzüglicher Hochachtung

MÜNCHEN, DEN Juin 1910.

La "Société Novelle d'artistes Munich" a résolu de donner aux artistes participant à sa prochaine exposition internationale, une occasion d'adresser parole directement au public, et ouvre cette fin les pages de son catalogue à ceux d'entre eux, qui voudraient par quelques mots, expliquer tant leur point de vue général sur l'art que leur oeuvre personnelle.

L'artiste trouve souvent l'expression explicite qui dit mieux et plus que ce qu'on dirait un long article de critique professionnelle ou un gros livre d'histoire de l'art.- Et cette allocution directe de l'artiste au spectateur fait trouver à ce dernier son chemin vers le vrai plus sûrement qu'il ne saurait le faire seul ou sous la conduite erronée d'une savante critique.

La "Société Novelle d'artistes Munich" se permet de croire que vous, Monsieur, ne lui refuserez pas en ceci votre aimable concours et lui enverrez quelques mots de chaude condition.

On destine à chaque artiste une page empримée in 4. Le 1 août est le terme dernier per l'envoi de cette contribution littéraire.

Recevez, Monsieur, l'expression de notre haute considération

282 *Neue Künstlervereinigung München:*
Circular Announcing Society on Folded
Sheet (Zirkular auf Faltblatt). ca. 1909
Multiple copy typeset on paper, 8¾ x
6¹⁵⁄₁₆″ (22.2 x 17.7 cm.)
Private Collection

Moissey Kogan
283 *Medal for the Neue Künstlervereinigung*
München (Medaille der Neuen Künstler-
vereinigung München). 1910
Cast bronze, 1⅛″ (2.9 cm.) d.
Collection Städtische Galerie im Len-
bachhaus, Munich

MÜNCHEN, DEN

NEUE KÜNSTLER-
VEREINIGUNG
MÜNCHEN. □□□

EW. HOCHWOHLGEBOREN!

Wir erlauben uns, Ihre Aufmerksamkeit
auf eine Künstlervereinigung zu lenken, die im
Januar 1909 ins Leben getreten ist und die
Hoffnung hegt, durch Ausstellung ernster
Kunstwerke nach ihren Kräften an der För-
derung künstlerischer Kultur mitzuarbeiten.
Wir gehen aus von dem Gedanken, dass der
Künstler ausser den Eindrücken, die er von
der äusseren Welt, der Natur, erhält, fort-
während in einer inneren Welt Erlebnisse
sammelt; und das Suchen nach künstlerischen
Formen, welche die gegenseitige Durchdrin-
gung dieser sämtlichen Erlebnisse zum Aus-
druck bringen sollen — nach Formen, die von

allem Nebensächlichen befreit sein müssen,
um nur das Notwendige stark zum Ausdruck
zu bringen, — kurz, das Streben nach künst-
lerischer Synthese, dies scheint uns eine
Losung, die gegenwärtig wieder immer mehr
Künstler geistig vereinigt. Durch die Gründung
unserer Vereinigung hoffen wir diesen geisti-
gen Beziehungen unter Künstlern eine mate-
rielle Form zu geben, die Gelegenheit schaffen
wird, mit vereinten Kräften zur Oeffentlichkeit
zu sprechen.

Hochachtungsvollst

NEUE KÜNSTLERVEREINIGUNG
MÜNCHEN.

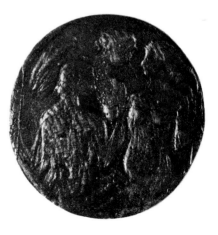

Vasily Kandinsky

284 *Group in Crinolines (Reifrockgesell-
schaft).* 1909
Oil on canvas, 37½ x 59⅛″ (95.2 x
150.1 cm.)
Collection The Solomon R. Guggenheim
Museum, New York

Vasily Kandinsky

285 *Study for "Composition II" (Skizze für "Komposition 2").* 1909–10
Oil on canvas, 38⅜ x 51⅝" (97.5 x 131.2 cm.)
Collection The Solomon R. Guggenheim Museum, New York

Pierre Girieud

286 *Judas.* ca. 1909
Oil on canvas, 36⁵⁄₁₆ x 28¾″ (92.3 x
73 cm.)
Lent by Galerie Gunzenhauser, Munich

Erma Barrera-Bossi

287 *Moonlit Night (Mondnacht).* 1909
Oil on canvas, 26 x 34 1/16″ (66 x 86.5 cm.)
Private Collection

Marianne von Werefkin

288 *Early Spring (Vorfrühling).* 1907
 Oil and tempera on board, 21¾ x 28¾″
 (55.2 x 73 cm.)
 Collection Thomas P. Whitney

Franz Marc

289 Poster for *Franz Marc Exhibition, Brakls Modern Art Gallery (Ausstellung Franz Marc, Brakls Moderne Kunsthandlung)*.
1909–10
Lithograph on paper, 36¼ x 25″ (92 x 63.5 cm.)
Collection Münchner Stadtmuseum, Munich

Gabriele Münter
290 *Jawlensky and Marianne von Werefkin.*
1908–09
Oil on cardboard, 12⅞ x 17¼″ (32.7 x
44.5 cm.)
Collection Städtische Galerie im Len-
bachhaus, Munich

Gabriele Münter

291 *Man in a Chair (Paul Klee) (Mann im Sessel [Paul Klee]).* 1913
Oil on canvas, 37 7/16 x 44 5/16" (95 x 112.5 cm.)
Bayerische Staatsgemäldesammlungen, Munich

Paul Klee

292 *Drawing for an Occasion (Figure with Streaming Hair) (Gelegenheitszeichnung [Figur mit Haarsträhnen]).* 1913
Ink on paper, 2⅝ x 2″ (6.6 x 5.1 cm.)
Postcard to Münter dated June 26, 1913
Collection Städtische Galerie im Lenbachhaus, Munich

Franz Marc

293 *Byzantine Saint (Seated Saint) (Byzantinischer Heiliger [Sitzender Heiliger]).* 1913
Tempera and oil on paper, 5½ x 3⁷⁄₁₆″ (14 x 9 cm.)
Postcard to Kandinsky dated June 8, 1913
Collection Städtische Galerie im Lenbachhaus, Munich

Franz Marc

294 *Cinnabar Greeting (Zinnobergruss).* 1913
Tempera on paper, 5½ x 3⁷⁄₁₆″ (14 x 9 cm.)
Postcard to Kandinsky
Collection Städtische Galerie im Lenbachhaus, Munich

Franz Marc

295 *Four Foxes (Vier Füchse).* 1913
Watercolor on paper, 5½ x 3⁷⁄₁₆″ (14 x 9 cm.)
Postcard to Kandinsky
Collection Städtische Galerie im Lenbachhaus, Munich

Vasily Kandinsky

296 *Blue Mountain (Der blaue Berg).*
1908–09
Oil on canvas, 41¾ x 38″ (106 x 96.6 cm.)
Collection The Solomon R. Guggenheim
Museum, New York

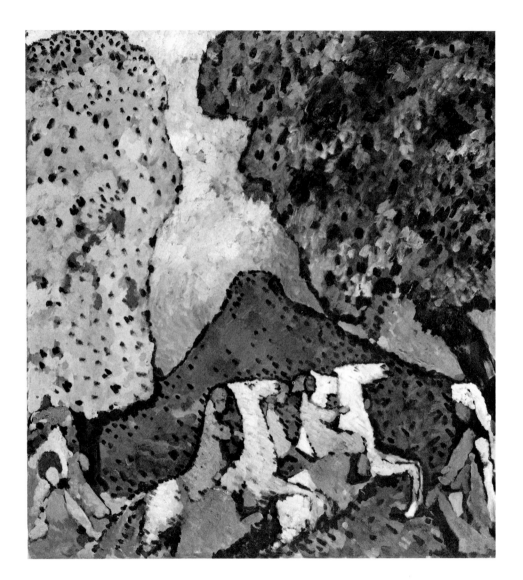

Vladimir von Bechtejeff

297 *Battle of the Amazons (Die Amazonen-*
schlacht). 1910
Oil on canvas, 41⅜ x 61⁷⁄₁₆″ (105 x
156 cm.)
Bayerische Staatsgemäldesammlungen,
Munich

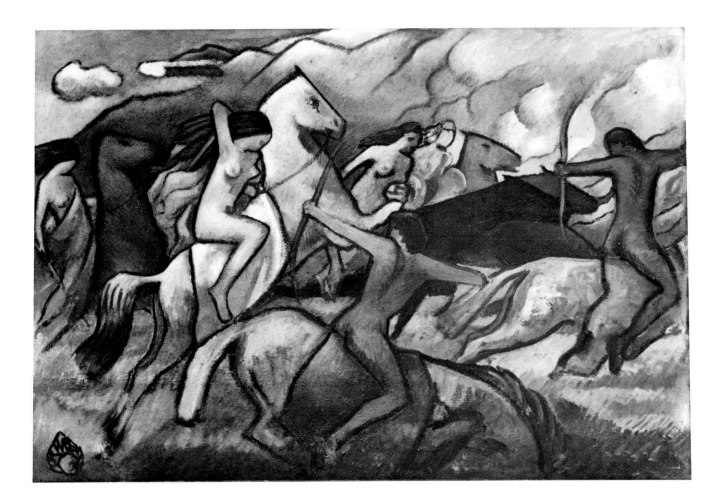

Gabriele Münter

298 *Man at the Table (Kandinsky) (Mann am Tisch [Kandinsky]).* 1911
Oil on cardboard, 20�5⁄16 x 27″ (51.6 x 68.5 cm.)
Collection Städtische Galerie im Lenbachhaus, Munich

Vasily Kandinsky

299 *Before the City (Vor der Stadt).* 1908
Oil on paper, 27⅛ x 19⅝″ (68.8 x 49 cm.)
Collection Städtische Galerie im Len-
bachhaus, Munich

V. THE BLUE RIDER:
EXORCISM AND TRANSFORMATION

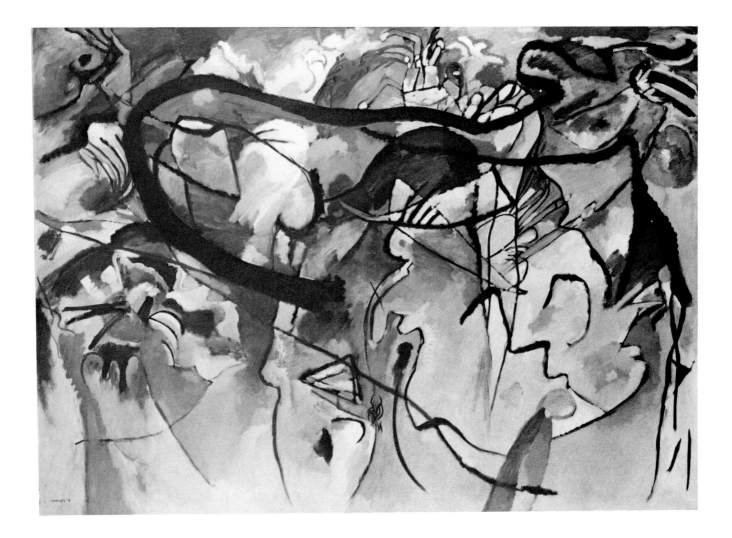

Vasily Kandinsky

*300 *Composition V.* 1911
Oil on canvas, 74¹³⁄₁₆ x 108⁵⁄₁₆" (190 x 275 cm.)
Private Collection, Switzerland

Vasily Kandinsky

301 *Cover Design for "Concerning the Spiritual in Art" (Einbandentwurf für "Über das Geistige in der Kunst").* ca. 1910
Tusche and opaque colors over pencil on paper mounted on paper, 6⅞ x 5¼" (17.5 x 13.3 cm.)
Collection Städtische Galerie im Lenbachhaus, Munich

Gabriele Münter

302 *First Blaue Reiter Exhibition (Erste Aus-
tellung der Blauer Reiter).* 1911-12
Photograph
Collection Gabriele Münter-Johannes
Eichner Stiftung, Munich

Franz Marc

303 *Yellow Cow (Gelbe Kuh).* 1911
Oil on canvas, 55⅜ x 74½" (140.5 x
189.2 cm.)
Collection The Solomon R. Guggenheim
Museum, New York

304 *Figure of the God Xipe Totec, "The Flayed God" (Figur des Gottes Xipe Totec, "Unseres Herrn, des Geschundenen").* Aztec, Huextla, Mexico
Clay, 6⁷⁄₁₆″ (16.2 cm.) h.
Collection Staatliches Museum für Völkerkunde, Munich

***305** *Sculpture from the Cameroons (Plastik aus Kamerun).*
Wood, 68½ x 13³⁄₁₆″ (174 x 33.5 cm.)
Collection Staatliches Museum für Völkerkunde, Munich

Vasily Kandinsky

316 *Design for the Cover of the Blaue Reiter Almanac (Entwurf für den Umschlag des Almanachs "Der Blaue Reiter").* 1911
Watercolor over pencil on paper, 10⅞ x 8⁹⁄₁₆″ (27.7 x 21.8 cm.)
Collection Städtische Galerie im Lenbachhaus, Munich

Vasily Kandinsky

317 *Design for the Cover of the Blaue Reiter Almanac (Entwurf für den Umschlag des Almanachs "Der Blaue Reiter").* 1911
Watercolor over pencil on paper, 10⅞ x 8⁹⁄₁₆″ (27.5 x 21.8 cm.)
Collection Städtische Galerie im Lenbachhaus, Munich

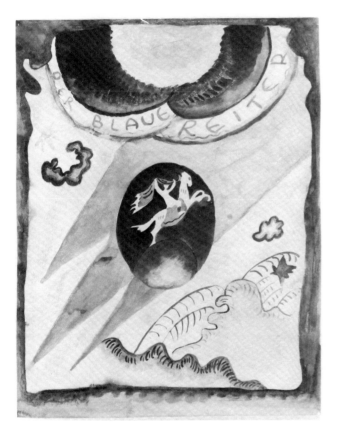

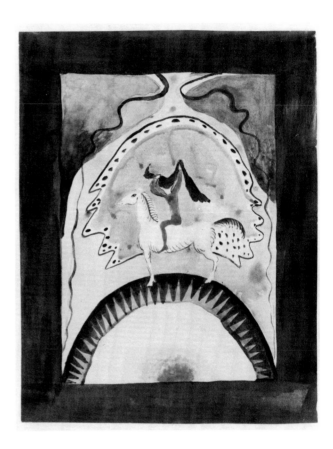

VI. CONCLUSION: TO THE EDGE OF ABSTRACTION

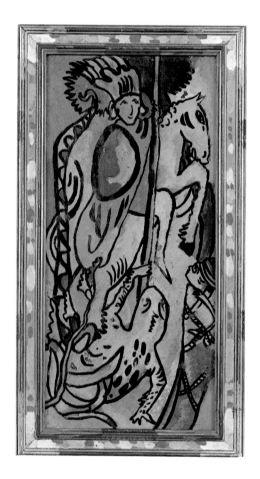

Vasily Kandinsky

318 *St. George II (Heiliger Georg II).* 1911
Glass painting, 11¾ x 5¹³⁄₁₆″ (29.8 x
14.7 cm.)
Collection Städtische Galerie im Len-
bachhaus, Munich

Vasily Kandinsky

319 *St. George No. 3 (St. Georg Nr. 3).* 1911
Oil on canvas, 38⅜ x 42⁵⁄₁₆″ (97.5 x
107.5 cm.)
Collection Städtische Galerie im Len-
bachhaus, Munich

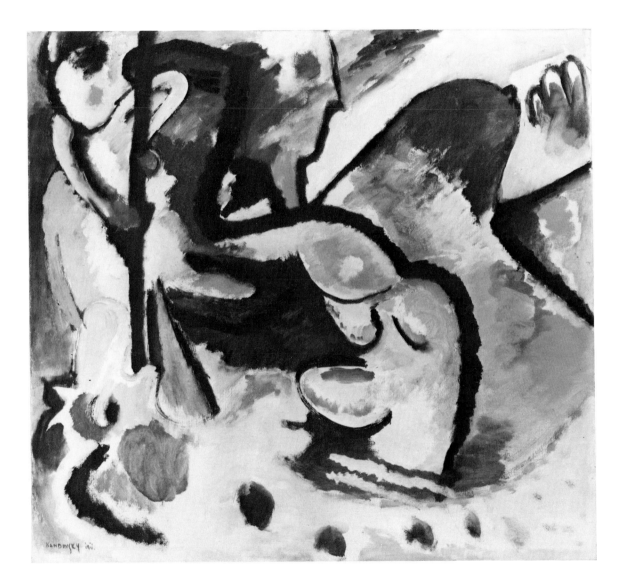

Vasily Kandinsky

320 *Small Pleasures (Kleine Freuden).* 1911
Glass painting, 12$\frac{1}{16}$ x 15$\frac{7}{8}$" (30.6 x
40.3 cm.)
Collection Städtische Galerie im Len-
bachhaus, Munich

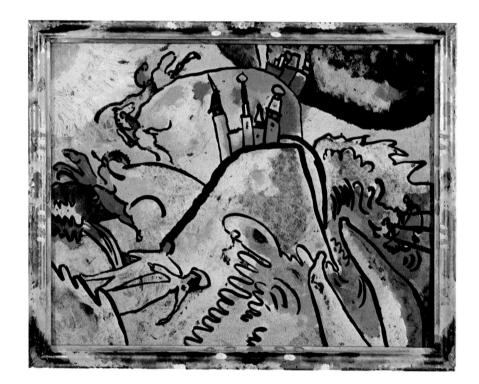

Vasily Kandinsky
321 *Small Pleasures (Kleine Freuden).*
June 1913
Oil on canvas, 43¼ x 47⅛″ (109.8 x
119.7 cm.)
Collection The Solomon R. Guggenheim
Museum, New York

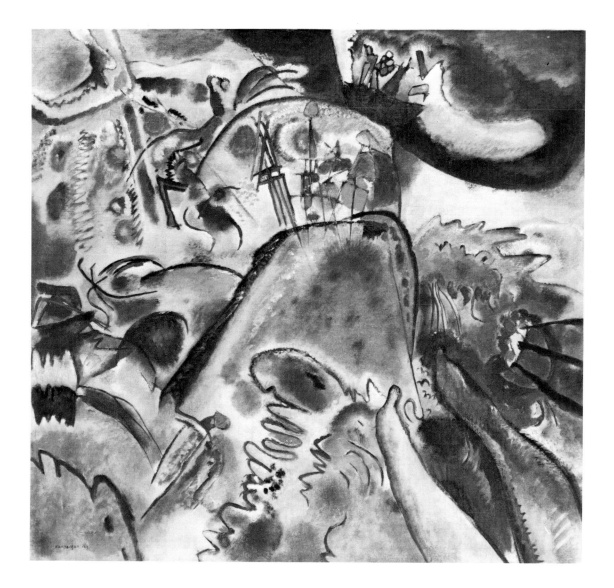

Vasily Kandinsky

322 *With Three Riders (Mit drei Reitern).*
1911
Tusche and watercolor on paper, 9⅞ x
12⅝″ (25 x 32 cm.)
Collection Städtische Galerie im Lenbachhaus, Munich

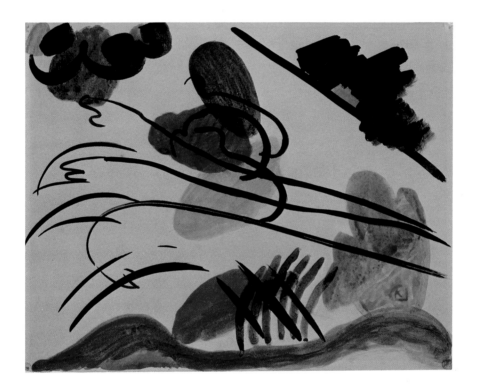

Vasily Kandinsky

323 *Painting with White Border (Das Bild mit weissem Rand).* May 1913
Oil on canvas, 55¼ x 78⅞″ (140.3 x 200.3 cm.)
Collection The Solomon R. Guggenheim Museum, New York

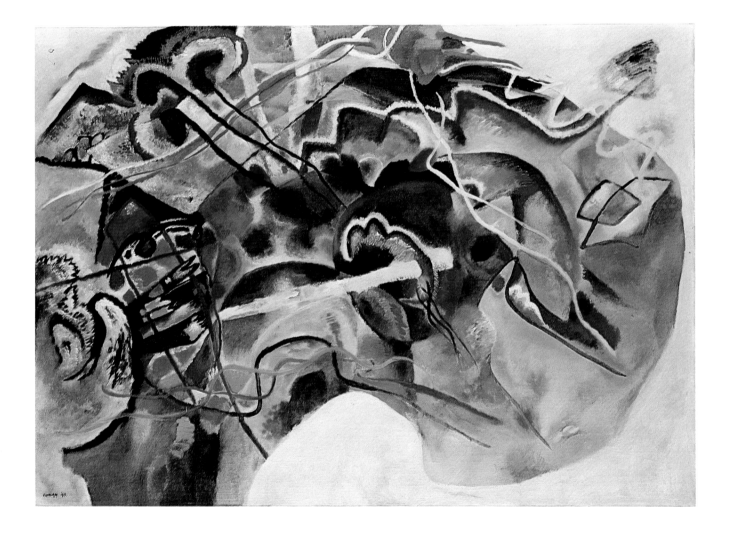

Vasily Kandinsky

324 *Detail Studies for "Painting with White Border" (Detailstudien zu "Bild mit weissem Rand").* 1913
Pencil on gray paper, $10\frac{13}{16}$ x $14\frac{7}{8}''$ (27.5 x 37.8 cm.)
Collection Städtische Galerie im Lenbachhaus, Munich

Vasily Kandinsky

325 *Study for Painting with White Border
(Studie zum Bild mit weissem Rand).*
1912
Ink on paper, 10 x 9¾″ (25.5 x 24.6 cm.)
Collection Musée National d'Art
Moderne, Paris

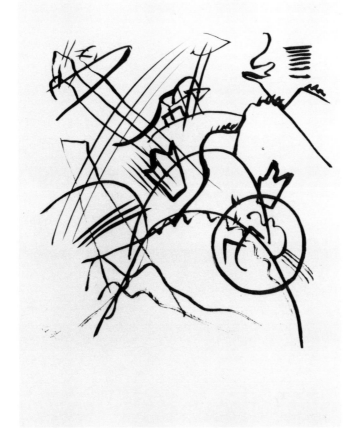

Vasily Kandinsky

326 *Color Study with Lozenges (Farbstudie mit Rauten).* ca. 1913
Watercolor and pencil on paper, 11^{15}/$_{16}$ x 9^{7}/$_{16}$″ (30.3 x 24 cm.)
Collection Städtische Galerie im Lenbachhaus, Munich

Vasily Kandinsky

327 *Color Study: Squares with Concentric Rings (Farbstudie: Quadrate mit konzentrischen Ringen).* ca. 1913
Watercolor and opaque colors with crayon on paper, 9 $\frac{7}{16}$ x 12 $\frac{7}{16}$" (23.9 x 31.6 cm.)
Collection Städtische Galerie im Lenbachhaus, Munich

Vasily Kandinsky

328 *Color Theory Observations and Sketches
(Farbtheoretische Betrachtungen und
Skizzen).* ca. 1913
Ink on paper, 10¹³⁄₁₆ x 8⁵⁄₁₆" (27.5 x
21.1 cm.)
Collection Städtische Galerie im Len-
bachhaus, Munich

Vasily Kandinsky

329 *Color Theory Observations and Sketches
(Farbtheoretische Betrachtungen und
Skizzen).* ca. 1913
Ink on paper, 10¹³⁄₁₆ x 8⁵⁄₁₆" (27.5 x
21.1 cm.)
Collection Städtische Galerie im Len-
bachhaus, Munich

Vasily Kandinsky

330 *Color Theory Observations and Sketches
(Farbtheoretische Betrachtungen und
Skizzen).* ca. 1913
Crayon on paper, 10¹³⁄₁₆ x 8⁵⁄₁₆" (27.5 x
21.1 cm.)
Collection Städtische Galerie im Len-
bachhaus, Munich

Vasily Kandinsky

331 *Landscape with Church I (Landschaft mit der Kirche I).* 1913
Oil on canvas, 30¹¹⁄₁₆ x 39⅜″ (78 x 100 cm.)
Collection Museum Folkwang, Essen

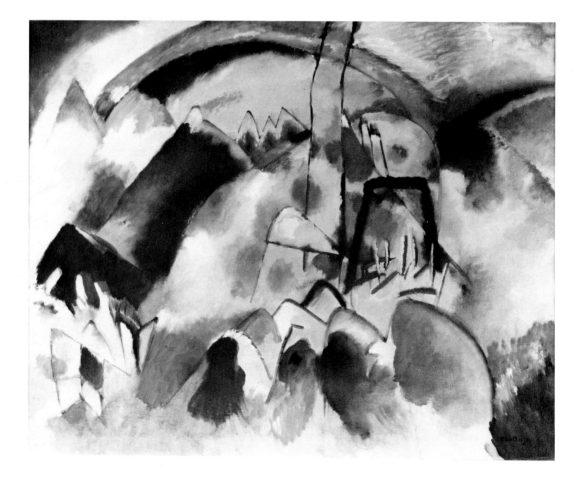

Vasily Kandinsky

332 *Black Lines (Schwarze Linien).*
December 1913
Oil on canvas, 51 x 51¼" (129.4 x
131.1 cm.)
Collection The Solomon R. Guggenheim
Museum, New York

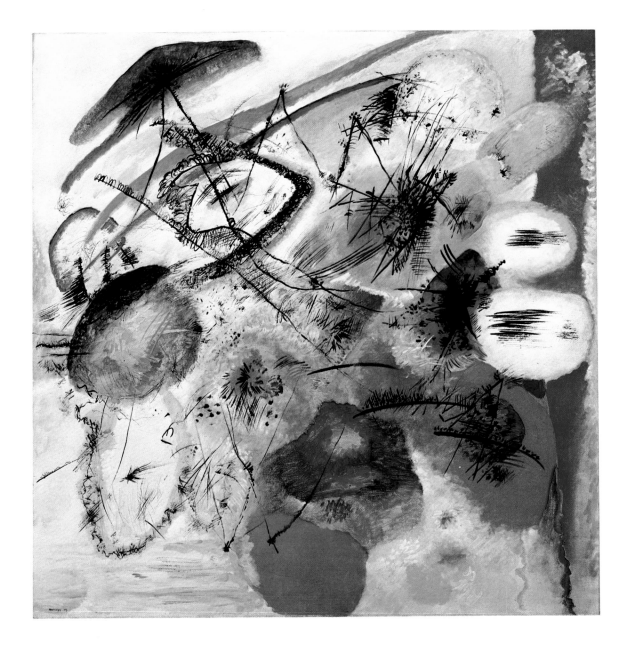

Vasily Kandinsky

333 *Untitled Watercolor (Aquarell ohne Titel).*
1913
Watercolor on paper, 19¹¹⁄₁₆ x 21⅝″
(50 x 65 cm.)
Collection Musée National d'Art
Moderne, Paris

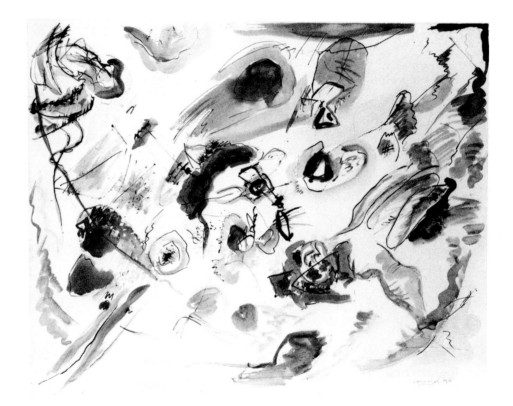

Vasily Kandinsky

334 *Paradise (Paradies).* 1911–12
Tusche and watercolor over pencil on
paper mounted on cardboard, 9 7⁄16 x
6 5⁄16″ (24 x 16 cm.)
Collection Städtische Galerie im Len-
bachhaus, Munich

Franz Marc

335 *Caliban: Costume Study for Shakespeare's "The Tempest" (Caliban: Kostümentwurf zu "Der Sturm" von Shakespeare).* 1914
Watercolor and opaque white on paper, 18⅛ x 15⅝" (46 x 39.7 cm.)
Collection Kupferstichkabinett, Kunstmuseum Basel

Franz Marc

336 *Miranda: Costume Study for Shakespeare's "The Tempest" (Miranda: Kostümentwurf zu "Der Sturm" von Shakespeare).* 1914
Watercolor and tempera on paper, 18⅛ x 15⁹⁄₁₆" (46 x 39.6 cm.)
Collection Kupferstichkabinett, Kunstmuseum Basel

Thomas de Hartmann

†337 *Fragments of the Score for The Yellow
Sound (Fragmente der Partitur, Der gelbe
Klang).* ca. 1909
Collection Music Library, Yale University, New Haven

Vasily Kandinsky

†338 *Scenario for The Yellow Sound with
Annotations by de Hartmann and Kandinsky (Szenar, Der gelbe Klang, mit
Anmerkungen von de Hartmann und
Kandinsky).* ca. 1911
Collection Music Library, Yale University, New Haven

August Macke

339 *Jest on The Blue Rider (Persiflage auf den
Blauen Reiter).* 1913
Watercolor, pencil and crayon on paper,
10¼ x 8¼" (26 x 21 cm.)
Collection Städtische Galerie im Lenbachhaus, Munich

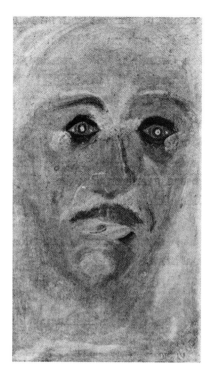

Arnold Schönberg

340 *Vision.* 1910
Oil on canvas, 12⅝ x 7⅞" (32 x 20 cm.)
Collections of the Library of Congress,
Washington, D.C.

341 *Arnold Schönberg.* 1911
Photograph
Collection Gabriele Münter-Johannes
Eichner Stiftung, Munich

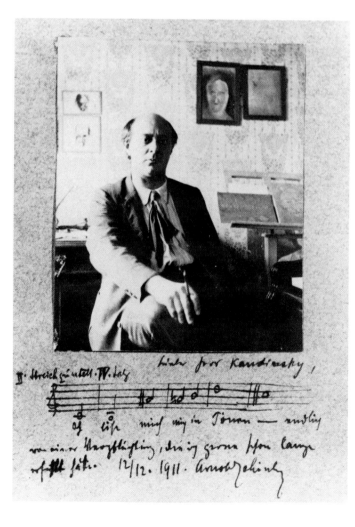

Arnold Schönberg

342 *Self-Portrait (Selbst porträt).* 1911
Oil on cardboard, 19¼ x 17″ (48.9 x
43.2 cm.)
Collection Schönberg Estate, Los Angeles

Vasily Kandinsky

343 *Cover, Transition, no. 27, April–May 1932 (Umschlag für Transition).* 1932
Screenprint on paper, 7⅞ x 5¼"
(20 x 13.3 cm.)
Collection The Art Reference Library, The Brooklyn Museum, New York

DOCUMENTS

August Endell

344 *Um die Schönheit . . . (On Beauty . . .),* Munich, Verlag Emil Franke, 1896
Collection Bayerische Staatsbibliothek, Munich

345 *Die Insel (Monatschrift mit Buchschmuck und Illustrationen) (The Island [Monthly Magazine with Book Decoration and Illustrations]),* vol. I, no. 7 (3rd quarter), 1900
Published by Schuster & Loeffler, Berlin
Collection Library of Congress, Washington, D.C.

346 *Jugend (Youth),* vol. II, parts, I, II, 1897
Published by Georg Hirth, Munich
Collection Library of Congress, Washington, D.C.

347 *Deutsche Kunst und Dekoration (German Art and Decoration),* vol. I, October–March, 1897–98
Published by Alexander Koch, Darmstadt
Collection The New York State Library, The University of the State of New York, Cultural Education Center, Albany

348 *Münchner Almanach: Ein Sammelbuch neuer deutscher Dichtung (Munich Almanac: An Anthology of Recent German Literature),* Munich and Leipzig, R. Piper & Co., 1905
Essays, plays, poetry and music by Oskar A. H. Schmitz, George Fuchs, Wilhelm Worringer and others
Private Collection, United States

Hermann Obrist

349 *Neue Möglichkeiten (New Possibilities),* Leipzig, Eugen Diederichs, 1903
Essays
Printed by Oscar Brandstetter, Leipzig
Private Collection, United States

350 *Linie und Form (Line and Form)*, exhibition catalogue, Kaiser Wilhelm-Museum, Krefeld, April–May 1904
Published and printed by Kramer & Baum, Krefeld
Private Collection, United States

351 *Farbenschau im Kaiser Wilhelm-Museum (Color Show in the Kaiser Wilhelm-Museum)*, exhibition catalogue, Kaiser Wilhelm-Museum, Krefeld, April 1902
Cover design by Ludwig von Hofmann, text design by Richard Grimm
Published and printed by G. A. Hohns Söhne, Krefeld
Private Collection, United States

Walter Crane
352 *Line and Form*, 3rd edition, London, George Bell & Sons, 1904
Private Collection, United States

Walter Crane
353 *Linie und Form (Line and Form)*, trans. Paul Seliger, 1st German edition, Munich, Hermann Seeman Nachfolger, 1901
Cover design and illustrations by Walter Crane
Private Collection, United States

354 *Katalog der II. Ausstellung der Münchner Künstler-Vereinigung, Phalanx (Catalogue of the II. Exhibition of the Munich Artists' Association Phalanx)*, Munich, January–March 1902
Collection Städtische Galerie im Lenbachhaus, Munich

Franz Marc
355 *Web-Muster entworfen von Franz Marc für den Plessmannschen Handwebestuhl (Weaving Patterns Designed by Franz Marc for the Plessman Handloom)*, Munich, Simon A. von Eckhardt, Verlag der Münchner Lehrmittelhandlung, Wilhelm Plessman, 1909
Collection Price-Gilbert Memorial Library, Georgia Institute of Technology, Atlanta

356 *Katalog der IV. Ausstellung der Münchner Künstler-Vereinigung Phalanx (Catalogue of the IV. Exhibition of the Munich Artists' Association Phalanx)*, Munich, 1902
Collection Gallen-Kallela Museum, Espoo, Finland

357 *Katalog der VII. Ausstellung der Münchner Künstler-Vereinigung Phalanx (Catalogue of the VII. Exhibition of the Munich Artists' Association Phalanx)*, Munich, May–June 1903
Collection Städtische Galerie im Lenbachhaus, Munich

358 *Katalog der VIII. Ausstellung der Münchner Künstler-Vereinigung Phalanx (Catalogue of the VIII. Exhibition of the Munich Artists' Association Phalanx)*, Munich, November–December 1903
Collection Städtische Galerie im Lenbachhaus, Munich

Alfred Kubin
359 *Die andere Seite (The Other Side)*, Munich, Georg Müller, 1909
Blau Memorial Collection, Princeton University, New Jersey

Vasily Kandinsky
360 *Klänge (Sounds)*, Munich, R. Piper & Co., 1913
38 poems in prose, 12 color woodcuts, 44 black and white woodcuts
Collection The Solomon R. Guggenheim Museum, New York

Stefan George and Karl Wolfskehl
361 *Deutsche Dichtung (German Poetry)*, vol. II, *Goethe*, Berlin, Blätter für die Kunst, 1900–02
Title page illumination by Melchior Lechter
Collection Library of Congress, Washington, D.C.

Stefan George
362 *Teppich des Lebens und die Lieder von Traum und Tod mit einem Vorspiel (The Tapestry of Life and the Songs of Dream and Death with a Prelude)*, Berlin, Blätter für die Kunst, 1900
Designed and illustrated by Melchior Lechter
Collection Library of Congress, Washington, D.C.

Stefan George
363 *Das Jahr der Seele (The Year of the Soul)*, Berlin, Blätter für die Kunst, 1897
Collection Library of Congress, Washington, D.C.

364 *Katalog der II. Ausstellung der Neuen Künstlervereinigung München (Catalogue of the II. Exhibition of the Neue Künstlervereinigung München)*, Turnus, 1910–11
Introductory statements by Le Fauconnier, Dmitri and Vladimir Burliuk, Kandinsky and Odilon Redon
Collection Städtische Galerie im Lenbachhaus, Munich

365 *Der Blaue Reiter Almanach (The Blue Rider Almanac)*, 2nd edition, Munich, R. Piper & Co., 1914
Special Collections, University Library, State University of New York at Binghamton

366 *Katalog der I. Ausstellung der Blauer Reiter (Catalogue of the I. Exhibition of the Blue Rider)*, Munich, 1910–11
Collection Kenneth C. Lindsay, Binghamton, New York

Vasily Kandinsky
367 *Über das Geistige in der Kunst (Concerning the Spiritual in Art)*, 1st edition, R. Piper & Co., 1912
Collection Kenneth C. Lindsay, Binghamton, New York

Hugo von Tschudi
368 *Gesammelte Schriften zur neueren Kunst (Collected Writings on Recent Art)*, Dr. E. Schwedeler-Meyer, ed., 1912
Private Collection, United States

Vasily Kandinsky
369 *Point and Line to Plane (Punkt und Linie zu Fläche)*, trans. Howard Dearstyne and Hilla Rebay, New York, The Solomon R. Guggenheim Foundation, 1947
Collection The Solomon R. Guggenheim Museum, New York

*There was a piebald horse (with yellow ochre body and bright yellow mane)
in a game of horse race which my aunt and I especially liked. We always fol-
lowed a strict order: I was allowed one turn to have this horse under my
jockeys, then my aunt one. To this day I have not lost my love for these
horses. It is a joy for me to see one such piebald horse in the streets of Munich:
he comes into sight every summer when the streets are sprinkled. He awakens
the sun living in me. He is immortal, for in the fifteen years that I have known
him he has not aged. It was one of my first impressions when I moved to
Munich that long ago—and the strongest. I stood still and followed him for
a long time with my eyes. And a half-conscious but sunny promise stirred in
my heart. It brought the little lead horse within me to life and joined Munich
to the years of my childhood. This piebald horse suddenly made me feel at
home in Munich. As a child I spoke a great deal of German (my maternal
grandmother came from the Baltic). The German fairy tales which I had so
often heard as a child came to life. The high, narrow roofs of the Promenaden
Platz and the Maximilian Platz, which have now disappeared, old Schwabing,
and particularly the Au which I once discovered by chance, transformed these
fairy tales into reality. The blue tramway passed through the streets like the
embodiment of a fairy-tale atmosphere that makes breathing light and joyful.
The yellow mailboxes sang their canary-yellow-loud song on the corners. I
welcomed the inscription "art mill" and felt that I was in a city of art, which
was the same to me as a fairy-tale city. From these impressions came the
medieval pictures which I later painted.*

Kandinsky
"Rückblicke," 1913

CHRONOLOGY

So many sources have been consulted in the compilation of this chronology that it is not possible to cite them all. However, it should be noted that in addition to the standard studies (such as Eichner, Grohmann and Gordon), the following more recent works also cited in the bibliography have been particularly helpful: Röthel and Benjamin, *Kandinsky*, New York, 1979; *Post-Impressionism Cross-Currents in European Painting*, Royal Academy exh. cat., New York, 1979; and the Kandinsky-Münter correspondence, Lindsay collection. Only the years covered by this exhibition, 1896–1914, are treated in detail here.

1866
December 4. Kandinsky born in Moscow (according to old Russian calendar, November 22).

1869
Travels to Italy with parents.

1871
Family moves to Odessa, where he studies art and music, and later attends humanistic Gymnasium.

1886
Enters University of Moscow, studies law and economics.

1889
Participates in expedition to Vologda province sponsored by Society of Natural Science and Anthropology; writes study of peasant laws and customs, which Society publishes. Kandinsky is much impressed by vigorous peasant folk art. Visits St. Petersburg and Paris.

1892
Completes university studies, passes law examination. Marries Ania Shemiakina, a cousin. Second trip to Paris.

1893
Becomes teaching assistant at University of Moscow.

1895
Works as an artistic director in Kušverev printing firm in Moscow.

1896
At exhibition of French painting in Moscow, Kandinsky is overwhelmed by Monet's *Haystack in the Sun* (fig. 9); observes that the object is not indispensable to the painting.
Rejects offer of teaching position at University of Dorpat (Tartu, Estonia) to devote himself to study of painting.
Moves to Munich, enters Ažbe atelier, where he studies for two years.

1897
June 1. Residence registered in Stadtarchiv as Georgenstrasse 62.
June 23. Moves to Giselastrasse 28.
Meets painters Alexej Jawlensky and Marianne von Werefkin. Visits Munich *Secession* exhibitions, encounters the heyday of Munich Jugendstil.

1898–99
Rejected by Munich Academy, works independently.

1899–1901
Resides at Georgenstrasse 35 (Münchner Stadtadressbuch).

1900
Studies with Franz Stuck at Munich Academy. Meets Ernst Stern, Alexander von Salzmann, Albert Weisgerber, Hans Purrmann. May have met Klee in passing at school.

1901
April 12. First performance of cabaret group *Elf Scharfrichter* in Munich.
April 17. Kandinsky's first art review, "Kritika kritikov" ("A Critique of Critics"), published in *Novosti dnia*, Moscow.
May. Founds *Phalanx* exhibition society with Rolf Niczky, Waldemar Hecker, Gustav Freytag and Wilhelm Hüsgen.
June. Establishment of *Phalanx* announced in *Kunst für Alle*, Munich.
July 14. Moves to Friedrichstrasse 1.

Mid–August. First *Phalanx* exhibition opens at Finkenstrasse 2; includes works by three members of *Elf Scharfrichter*.
Late summer or early autumn. Becomes president of *Phalanx*.
First visit to Rothenburg ob der Tauber.
Trip to Odessa.

1901–02
Winter. Kandinsky and other *Phalanx* members establish *Phalanx* school at Hohenzollernstrasse 6.

1902
Meets Gabriele Münter, who enters his painting class. Friendship with Hermann Obrist, who opens school for applied arts near *Phalanx* school.
January–March. Second *Phalanx* exhibition, devoted to Arts and Crafts Movement, features artists associated with Darmstadt *Künstlerkolonie*, including Peter Behrens. Kandinsky exhibits decorative designs, including *Twilight (Dämmerung)*, 1901 (cat. no. 184). Works by members of Munich's *Vereinigten Werkstätten für Kunst im Handwerk* also shown.
Writes review of Munich art scene, "Korrespondentsiia iz Miunkhena" ("Correspondence from Munich") for periodical *Mir Iskusstva*, St. Petersburg.
Participates in *World of Art Exhibition*, St. Petersburg.
Spring. Exhibits at Berlin *Secession*.
May–June. Third *Phalanx* exhibition (guest artists Lovis Corinth and Wilhelm Trübner).
Spends part of summer with his school at Kochel.
July–August. Fourth *Phalanx* exhibition (guest artists Akseli Gallen-Kallela and Albert Weissgerber).

1903
January (?). Fifth *Phalanx* exhibition (no catalogue, no reviews).
April (?). Sixth *Phalanx* exhibition (no catalogue, no reviews).
Spring and Summer. Kandinsky's interest

in woodcut grows; makes designs for embroideries, decorative drawings.

April. Visits Viennese *Sezession* exhibition.

May–July. Seventh *Phalanx* exhibition (guest artist, Claude Monet). Kandinsky escorts Prince Regent Luitpold through show.

June 10–12. Travels to Ansbach and Nürnberg with Münter. Spends part of summer with school at Kallmünz.

August 8–19. Travels to Nabburg, Regensburg and Landshut with Münter.

August. Behrens offers him directorship of decorative painting class at Düsseldorf Kunstgewerbeschule; he subsequently declines invitation.

September 2–November 1. Travels from Venice through Vienna to Odessa and Moscow; returns to Munich via Berlin and Cologne. Moved by Italian Renaissance masters he sees at Kunsthistorische Museum, Vienna, in September. Impressed by Zuloaga at international exhibition, Venice, in September; finds paintings and mosaics at San Marco "unforgettable." Sees Greek, Egyptian, old German and Italian masters in Berlin museums in October; comments enthusiastically on them in letters to Münter.

November 3–5. Travels to Würzburg, Rothenburg ob der Tauber with Münter.

November–December. Eighth *Phalanx* exhibition (guest artist, Carl Strathmann).

1904

January–February. Ninth *Phalanx* exhibition (guest artist, Alfred Kubin). Kandinsky shows color drawings and woodcuts.

February 15. Fifteen works exhibited at *Moscow Association of Artists.*

April. Writes to Münter that he is working on a theory of color and a *"Farbensprache"* (color language).

April–May. Tenth *Phalanx* exhibition includes Paul Signac, Theo van Rysselberghe, Félix Vallotton and Toulouse-Lautrec (no catalogue).

Eleventh *Phalanx* exhibition at Helbing's Salon, Wagmüllerstrasse, features graphic art. Kandinsky exhibits seven woodcuts including *Farewell,* 1903, and *Night (Large Version),* 1903 (cat. nos. 215, 218).

May 11–June 6. Travels with Münter to Krefeld, Düsseldorf, Cologne, Bonn, Rotterdam, The Hague, Haarlem, Amsterdam, Zaandam, Edam, Volendam, Marken, Brock, Hoorn and Arnheim.

Summer. Remains in Munich, where he works on woodcuts, exhibits at *Kunstverein.* Makes craft designs for *Vereinigung für angewandte Kunst.*

September. Separates from wife; moves from Friedrichstrasse.

October 5–16. With Münter to Frankfurt am Kreuznach and Münster am Stein.

October 10–November 21. Travels through Berlin to Odessa and returns to Munich via Berlin.

Kandinsky's *Verses Without Words,* album of woodcuts, published in Moscow. Participates in *XV Exhibition of Association of South Russian Artists* in Odessa; first exhibition of *New Society of Artists* in St. Petersburg.

November 22–26. Travels to Cologne and Bonn with Münter.

November 27–December 2. Travels alone to Paris.

December. Twelfth *Phalanx* exhibition reported in Darmstadt (no catalogue).

December 6–25. Travels with Münter to Tunisia via Strassbourg, Basel, Lyon, Marseille, spends Christmas in Bizerta.

1905

January–March. In Tunisia with Münter, visits Carthage, Sousse and Kairouan.

March. Exhibits at *Moscow Association of Artists.*

April. Travels through Palermo, Naples, Florence, Bologna and Verona on return trip from Tunisia.

April 16–May 23. Travels to Innsbruck, Igels, Starnberg and Dresden.

May 24. Bicycle trip with Münter to Reichenbach, Lichtenstein, Chemnitz, Freiberg and Meissen.

June 1–August 15. In Dresden with Münter at Schnorrstrasse 44.

August 17–September 29. Works in Munich.

August and September. Bicycle trips from Munich to Seeshaupt, Tutzing, Herrsching, Starnberg; then visits Garmisch-Höllental area.

September 29–November 11. To Odessa with father via Vienna, Budapest, Lemberg. Returns to Munich through Vienna and Cologne.

Exhibits paintings, prints, craft designs at Salon d'Automne, Paris.

November 13–25. Meets Münter in Cologne; they travel to Düsseldorf, back to Cologne, Bonn, Lüttich and Brussels.

December 12. With Münter to Milan, Genoa, Sestri, Levante, Monoglia, Chiavari, St. Margerita and Monte Telegrafo.

December 1905–April 1906. Winters at Rapallo with Münter.

1906

Spring. Participates in Berlin *Secession.*

May. Travels via Switzerland to Paris, where he stays at 12, rue des Ursulines until June.

June. Moves to 4, petite rue des Binelles, in Sèvres near Paris, where he resides until June 1907.

Becomes member of *Union Internationale des Beaux-Arts et des Lettres,* Paris.

July. Visits Dinard and Mont St. Michel. Participates in *XVII Exhibition of Association of South Russian Artists,* Odessa; *Exhibition of Signs and Posters* organized by Leonardo da Vinci Society, Moscow. Works on woodcuts for *Xylographies,* some of which are published in *Les Tendances Nouvelles.*

October–November. Exhibits paintings, woodcuts, craft designs at Salon d'Automne, Paris.

Winter 1906–07. Exhibits with *Die Brücke* in Dresden, *Secession* in Berlin.

1907

January 4–5. Visits Chartres.

May 14. Visits St. Vres (Seine et Oise).

May. Shows 109 works at exhibition *Le Musée du Peuple,* Angers, sponsored by *Les Tendances Nouvelles.*

June 1–9. In Paris.

June 10–13. Returns to Munich.

June 14–July 23. Rest cure in Bad Reichenhall.

July 2–7. Travels through favorite Alpine areas (Rosenheim, Tölz, Kochel, Starnberg and Traunstein).

July. In Munich.

July 30–August. With Münter to Stuttgart and Singen; they bicycle from Schaffhausen to Zürich; then travel to Brienz, near Simplon Pass and Fliesch where they hike.

September (?). To Frankfurt, Bonn, Cologne, Hannover and Hildesheim. Participates in *XVIII Exhibition of Association of South Russian Artists,* Odessa.

September. To Berlin, where he stays with Münter until end of April 1908.

December 25–26. Spends Christmas in Wittenberg, Zerbst.

1908

March–May. Participates in Salon des Indépendants, Paris.

April–June. Hikes with Münter in South Tyrol; returns to Munich through Austria and Bavarian Alps, traveling by foot, one-horse carriage, mail coach and train.

June. Settles permanently in Munich.

June 12. Munich residence registered as Schellingstrasse 75.

June 17–19. Trip to Starnbergersee and Staffelsee at Murnau.

July 24–August 8. Travels to Stock am Cheimsee, then to Salzburg, Attersee, Wolfgangsee, Schafberg and Mondsee.
Mid-August–September 30. First long sojourn in Murnau.
September 4. Takes apartment at Ainmillerstrasse 36 in Munich's Schwabing sector (official registration, September 16).
October–November. Participates in Salon d'Automne, Paris; *XIX Exhibition of Association of South Russian Artists,* Odessa.
Winter. Exhibits at Berlin *Secession.*

1909
January. Founds *Neue Künstlervereinigung München (NKVM),* and is elected its president.
February–March. Travels to Garmisch, Mittenwald and Kochel.
Spring. Begins work on compositions for the stage, such as *Der gelbe Klang (The Yellow Sound),* which is later published in *Blaue Reiter* almanac.
March–May. Participates in Salon des Artistes Indépendants, Paris.
May. In Murnau with Münter.
Summer. Sees large exhibition of Japanese and East Asian art in Munich.
July–August. Münter acquires house in Murnau where she and Kandinsky reside intermittently until late summer 1914.
Summer (?). First *Hinterglasmalereien* (glass paintings), in emulation of this traditional Bavarian folk art.
Begins Improvisations.
Writes reviews, "Pismo iz Miunkhena" ("Letter from Munich"), for periodical *Apollon,* St. Petersburg; these are published through 1910.
Publication of *Xylographies,* woodcuts, Editions Tendances Nouvelles, Paris.
October–November. Participates in Salon d'Automne, Paris.
December 1–15. First exhibition of *NKVM,* Thannhauser's Moderne Galerie, Munich; Kandinsky shows paintings and woodcuts. Participates in *XX Exhibition of Association of South Russian Artists,* Odessa.

1910
Begins Compositions.
Early February (?). Travels alone to Kufstein in Austrian Alps.
February–April. Stays primarily in Murnau.
Summer. Sees monumental exhibition of Mohammedan Art in Munich.
July 1–mid-August. In Murnau.
July–October. Participates in *Sonderbund Westdeutscher Künstler,* Düsseldorf.

September 1–14. Second exhibition of *NKVM* at Thannhauser's Moderne Galerie, Munich, now with international participation. Kandinsky exhibits *Composition II, 1910, Improvisation 10, 1910, Boatride, 1910,* a landscape and six woodcuts.
Marc writes commentary on the show, which leads to his first meeting with Kandinsky.
September–October. Included in Salon d'Automne, Paris.
Mid-October. Travels to Russia via Weimar and Berlin.
October 14–November 29. In Moscow and St. Petersburg.
December 1–12. To Odessa where he shows fifty-two works in *Second Salon Izdebsky,* Odessa, which takes place following month. Participates in *XI Exhibition of Paintings of the Ekaterinoslav Art and Theater Society* in Ekaterinoslav.
December 22. Returns to Munich.
"First abstract watercolor," by Kandinsky, is dated 1910. (Lindsay has suggested that this work, which is a sketch for *Composition VII, 1913,* may accidentally have been misdated at a later time.) Completes manuscript of *Über das Geistige in der Kunst (Concerning the Spiritual in Art).*

1911
January 2. Attends Schönberg concert with Marc and other members of *NKVM.*
January 10. Resigns presidency of *NKVM.*
January 18. Initiates correspondence with Schönberg.
January 20–28. In Murnau.
February 5. Marc joins *NKVM.*
February. Publishes "Kuda idet 'novoe' iskusstvo," ("Whither the 'New' Art"), in periodical *Odesskie novosti,* Odessa.
April–June. Participates in Salon des Artistes Indépendants, Paris.
May 17–19. Visits Marc in Sindelsdorf, Bavaria.
May 23–June 13. In Murnau.
Early summer. Joins Marc and others with statement published in *Im Kampf um die Kunst* in answer to Carl Vinnen's pamphlet *Protest deutscher Künstler.*
June 19. Begins plans with Marc for *Blaue Reiter* almanac.
June 26–30. In Munich.
June 30–August 21. Works in Murnau.
Fall (?). Divorce from Ania Shemiakina is legally finalized.
October. Participates in *Kunst unserer Zeit* at Wallraf-Richartz-Museum, Cologne.

Mid-October. Meets with Marc and August Macke at Sindelsdorf to work on *Blaue Reiter* almanac.
October or November. Beginning of friendship with Klee.
November 1911–January 1912. Participates in *Neue Secession,* Berlin.
December 2. Kandinsky's *Composition V, 1911,* rejected by *NKVM* jury; Kandinsky, Marc, Münter and Alfred Kubin resign from the society.
December 18. *Erste Ausstellung der Redaktion der Blaue Reiter (First Exhibition of the Editorial Board of the Blaue Reiter)* opens at Thannhauser's Moderne Galerie, Munich (third exhibition of *NKVM* is held simultaneously).
December. *Über das Geistige in der Kunst* published by Piper of Munich, although it is dated 1912.
December 29–31. Abridged version of *Über das Geistige in der Kunst* read at *Second All-Russian Congress of Artists* in St. Petersburg.
Friendships with Marc, Kubin, Klee, Macke, Schönberg and Karl Wolfskehl documented in correspondence.

1912
January 23–31. First *Blaue Reiter* exhibition shown at Gereonsklub, Cologne.
January. Participates in fourth exhibition of *Neue Secession,* Berlin.
February 12–April. Second *Blaue Reiter* exhibition at Galerie Hans Goltz, Munich (315 works, all graphics).
March 12–May 10. First *Blaue Reiter* exhibition at Galerie Der Sturm, Berlin.
March–May. Participates in Salon des Artistes Indépendants, Paris.
April. Second edition of *Über das Geistige in der Kunst* published in Munich; "Formen und Farbensprache" ("Language of Forms and Colors"), from *Über das Geistige,* published in *Der Sturm,* Berlin.
May. *Blaue Reiter* almanac published in Munich.
May–June. In Murnau.
May–September. Participates in *Sonderbund Internationale Kunstausstellung,* Cologne.
July. Extracts from *Über das Geistige* published by Alfred Stieglitz in *Camera Work,* New York.
July (?). Participates in *Moderne Kunst* exhibition at Folkwang Museum, Hagen.
July 10. Undergoes hernia operation.
August. Recuperates in Murnau; remains there through September.
August 17. Michael Ernest Sadler and his

son Michael T. Sadleir visit Kandinsky and Münter in Murnau.

September. Signs contract with Piper for publication of *Klänge (Resonances)*, volume of prose poems and woodcuts.

Autumn. Third edition of *Über das Geistige in der Kunst* published in Munich.

October. "Über Kunstverstehen" ("On Understanding Art") appears in *Der Sturm*, Berlin.

October 6. First one-man exhibition opens at Galerie Der Sturm, Berlin; later tours to other German cities.

October 16–26. Travels from Berlin to Odessa.

October 27–December 13. In Moscow, also visits St. Petersburg where he lectures on "The Criterion for Evaluating a Painting" at *Art and Theater Association*. Participates in *Contemporary Painting* exhibition in Ekaterinodar.

December 15–16. Returns to Munich via Berlin.

December 22. Begins sketches for *Painting with White Border*, 1913 (cat. no. 323).

1913

Kandinsky and Marc prepare for second *Blaue Reiter* almanac, with contributions by Mikhail Larionov, Wolfskehl and others, but the volume is never realized.

January 13–15. In Murnau.

February–March. Works exhibited in *Armory Show* in New York, then in Chicago and Boston.

March–May. Primarily in Murnau.

Summer. Arthur Jerome Eddy of Chicago, one of first Americans to collect Kandinsky's work, visits the artist.

July 5–August. To Moscow via Berlin.

September 6. Returns from Russia to Munich via Berlin.

September 20–December 1. Participates in *Erster Deutscher Herbstsalon* at Galerie Der Sturm in Berlin.

Autumn. Publication of *Sturm Album*, Berlin, which includes Kandinsky's "Rückblicke" ("Reminiscences"). *Klänge* published by Piper in Munich; some of its poems had already appeared, without Kandinsky's permission, in the Russian avant-garde publication *A Slap in the Face of Public Taste*.

October. In Murnau.

Completes *Composition VI* and *Composition VII,* last Compositions executed before World War I.

1914

January 1. One-man exhibition, originally planned by Hans Goltz for Autumn 1912,

opens at Thannhauser's Moderne Galerie, Munich.

January. One-man exhibition at *Kreis für Kunst*, Cologne.

March. Second edition of *Blaue Reiter* almanac published in Munich.

February, April. In Murnau.

April 9–20. Visits Merano, Italy, with his mother.

April. *Über das Geistige in der Kunst* translated and published as *The Art of Spiritual Harmony,* with an introduction by Michael T. Sadler, in London and Boston.

Catalogue of *Spring Exhibition of Paintings in Odessa (Vesennaiaia vystavka Kartin)* published, with "O ponimanii iskusstva," Russian variant of Kandinsky's "Über Kunstverstehen."

Spring. Hugo Ball proposes performance of Kandinsky's *Der gelbe Klang* at Munich Künstlertheater.

May, June–August 1. In Murnau with trips to Oberammergau, Ettal, Garmisch and Höllentalklamm.

August 1. Returns to Munich as Germany declares war on Russia.

August 3, evening. Flight to Switzerland; travels to Lindau, accompanied by Münter; next day to Rorschach, then to Mariahalde near Goldach on Lake Constance where they stay until November 16. Klee and his family visit them. Begins work on manuscript *Punkt und Linie zu Fläche (Point and Line to Plane).*

November 16. To Zürich.

November 25. Begins trip to Russia, where he takes up residence.

Winter 1915–16. Last visit with Münter in Stockholm.

1917

Marries Nina de Andreevskaya.

1918–21

Engages in various activities as member of Commissariat for Cultural Progress (NARKOMPROS), Moscow. Teaches at the Moscow Svomas (Free State Art Studios); helps found Institute of Artistic Culture (Inkhuk) and Museum of Pictorial Culture, Moscow; instrumental in distributing paintings to twenty-two provincial museums.

1921

Leaves Russia for Berlin.

1922

Accepts post at Bauhaus at Weimar.

1923

Given first one-man exhibition in New York by *Société Anonyme*, of which he becomes vice-president.

1924

With Lyonel Feininger, Klee and Jawlensky forms *Blaue Vier (Blue Four)* group; Galka Scheyer is their representative in the United States.

1925

Moves with Bauhaus to Dessau.

1926

Punkt und Linie zu Fläche published in Munich.

1933

Moves to Paris when Nazis close Bauhaus. Settles at Neuilly-sur-Seine. During 1930s exhibits in Paris, San Francisco, New York and London.

1937

Nazis confiscate and sell many of Kandinsky's paintings as *entartete Kunst* (degenerate art).

1940

Despite invitations to come to United States, remains in France.

1944

Becomes ill in spring.

December 13. Dies in Neuilly.

SELECTED BIBLIOGRAPHY

For more extensive bibliographical information, the reader should consult the sources cited in footnote 2, p. 28.

Metin And, *Karagöz: Turkish Shadow Theatre,* Ankara, Dost Yayinlari, 1975

Dominik Bartmann, *August Macke Kunsthandwerk,* foreword by Leopold Reidemeister, Berlin, Gebr. Mann Verlag, 1979

Kristian Bäthe, *Wer wohnte wo in Schwabing?,* Munich, Süddeutscher Verlag, 1965

Bayern: Kunst und Kultur, exh. cat., Munich Stadtmuseum, Munich, Prestel Verlag, 1972

Silvie Lampe-von Bennigsen, *Hermann Obrist, Erinnerungen,* Munich, Verlag Herbert Post Presse, 1970

John E. Bowlt and Rose-Carol Washton Long, eds., *The Life of Vasilii Kandinsky in Russian Art: A Study of "On the Spiritual in Art,"* Newtonville, Massachusetts, Oriental Research Partners, 1980

Klaus Brisch, *Wassily Kandinsky, Untersuchung zur Entstehung der gegenstandslosen Malerei an seinem Werk von 1900–1921,* Ph.D. dissertation, University of Bonn, 1955

Tilmann Buddensieg, "Zur Frühzeit von August Endell—seine Münchener Briefe an Kurt Breysig," *Festschrift für Eduard Trier,* Berlin, Gebr. Mann Verlag, 1981

Joseph Campbell, *The Hero with a Thousand Faces,* New York, Meridian Books, 1960

_____, *The Masks of God: Occidental Mythology,* New York, Penguin Books, 1964

_____, *The Masks of God: Creative Mythology,* New York, Penguin Books, 1968

Volker Duvigneau, ed., *Plakate in München aus den Beständen der Plakat-sammlung des Münchner Stadtmuseums,* exh. cat., second revised edition, 1978

H. C. Ebertshäuser, *Malerei in 19. Jahrhundert Münchner Schule,* Munich, Keyersche Verlagsbuchhandlung, 1979

Johannes Eichner, *Kandinsky und Gabriele Münter, von ursprüngen Moderner Kunst,* Munich, Verlag Bruckmann, 1957

J. A. Schmoll gen. Eisenwerth, ed., *Franz von Stuck, Die Stuck-Villa zu ihrer Wiedereröffnung am 9. März 1968,* exh. cat., Munich, Karl M. Lipp, 1968; second revised edition, 1977

Richard Ettinghausen, "Early Shadow Figures," *Bulletin of the American Institute for Persian Art and Archaelogy,* no. 6, June 1934

Jonathan D. Fineberg, *Kandinsky in Paris 1906–07,* Ph.D. dissertation, Harvard University, 1975

Christian Geelhaar, "Paul Klee: Biographische Chronologie," in Armin Zweite, ed., *Paul Klee Das Frühwerk 1883–1922,* Munich, Städtische Galerie im Lenbachhaus, 1979

_____, *Paul Klee: Schriften, Rezensionen und Aufsätze,* Cologne, DuMont Buchverlag, 1976

Rosel Gollek, ed., *Der Blaue Reiter im Lenbachhaus München,* Munich, Prestel Verlag, 1974

Rosel Gollek, *Gabriele Münter 1877–1962: Gemälde, Zeichnungen, Hinterglasbilder und Volkskunst aus ihrem Besitz,* exh. cat., Städtische Galerie im Lenbachhaus, 1977

_____, *Franz Marc 1880–1916,* Munich, Städtische Galerie im Lenbachhaus, 1980

Donald E. Gordon, *Modern Art Exhibitions 1900–1916: Selected Catalogue Documentation,* 2 vols., Munich, Prestel Verlag, 1974

Sara H. Gregg, "The Art of Gabriele Münter: An Evaluation of Content," Master's thesis, State University of New York at Binghamton, 1980

_____, "Grabriele Münter in Sweden: Interlude and Separation," *Arts Magazine,* vol. 55, May 1981

Will Grohmann, *Wassily Kandinsky: Life and Work,* New York, Harry N. Abrams, Inc., 1958

Sonja Günther, *Interieurs um 1900: Bernhard Pankok, Bruno Paul und Richard Riemerschmid als Mitarbeiter der Vereinigten Werkstätten für Kunst im Handwerk,* Munich, Wilhelm Fink Verlag, 1971

Karl Gutbrod., ed., *"Lieber Freund . . .," Künstler schreiben an Will Grohmann,* Cologne, DuMont Schauberg, 1968

Jelena Hahl-Koch, ed., *Arnold Schönberg—Wassily Kandinsky: Briefe, Bilder und Dokumente einer aussergewöhnlichen Begegnung,* Salzburg and Vienna, Residenz Verlag, 1980

Jelena Hahl-Koch, "Kandinsky's Role in the Russian Avant-Garde," *The Avant-Garde in Russia, 1910–1930,* exh. cat., Los Angeles, Los Angeles County Museum of Art, 1980

_____, *Kandinsky, Die gesammelten Schriften: Stücke für die Bühne,* forthcoming

Edith Hamilton, *Mythology,* New York, Mentor Books, 1957

Erika Hanfstaengl, ed., *Wassily Kandinsky: Zeichnungen und Aquarelle im Lenbachhaus München,* Munich, Prestel Verlag, 1974

Ulrike von Hase, *Schmuck in Deutschland und Osterreich 1895–1914, Symbolismus-Jugendstil-Neohistorismus,* Munich, Prestel Verlag, 1977

Charles W. Haxthausen, "Klees künstlerisches Verhältnis zu Kandinsky während der Münchner Jahre," in Armin Zweite,

ed., *Paul Klee Das Frühwerk 1883–1922*, Munich, Städtische Galerie im Lenbachhaus, 1979

Marianne Heinz, ed., *Ein Dokument Deutscher Kunst Darmstadt 1901–1976*, vols. 1–5, exh. cat., Darmstadt, Eduard Roether Verlag, 1976

Adolf Hölzel, "Über Formen und Massenverteilung im Bilde," *Ver Sacrum*, IV, 1901

Peter Jelavich, "Die Elf Scharfrichter: The Political and Socio-cultural Dimensions of Cabaret in Wilhelmine Germany," in Gerald Chapple and Hans Schulte, eds., *The Turn of the Century: German Literature and Art 1890–1914*, Bonn, 1980

_____, *Theater in Munich 1890–1924: A Study of the Social Origins of Modernist Culture*, Ph.D. dissertation, Princeton University, 1981

Erich Kahler, "The Nature of the Symbol," in Rollo May, ed., *Symbolism in Religion and Literature*, New York, George Braziller, Inc., 1960

Kandinsky: Kollektiv-Ausstellung 1902–1912, introductory autobiographical sketch by Kandinsky, Munich, Verlag "Neue Kunst" Hans Goltz, 1912

Vasily Kandinsky, "Pismo iz München" (Letters from Munich), *Apollon*, I, October 1909; IV, January 1910; VII, April 1910; VIII, May–June 1910; XI, October–November 1910

_____, "Rückblicke," *Kandinsky, 1901–1913*, Berlin, Der Sturm, 1913

_____, Letter to Paul Westheim, "Der Blaue Reiter (Rückblick)," *Das Kunstblatt*, XIV, 1930

_____, "Betrachtungen über die abstrakte Kunst," in Max Bill, ed., *Kandinsky Essays über Kunst und Künstler*, Bern, Benteli Verlag, 1963. Originally published in *Cahiers d'Art*, no. 1, 1931

_____, "Mes gravures sur bois," *XXe Siècle*, no. 27, December 1966. Originally published in *XXe Siècle*, no. 3, 1938

_____, *Punkt und Linie zu Fläche, Beitrag zur Analyse der malerischen Elemente*, introduction by Max Bill, ed., Bern, Benteli Verlag, 1964. Originally published by Albert Langen, Munich, 1926

_____, "Der gelbe Klang," *Der Blaue Reiter*, new documentary edition by Klaus Lankheit, Munich, R. Piper & Co., 1965

_____, *Über das Geistige in der Kunst*, eighth edition [sic], Bern, Benteli Verlag, 1965. Originally published by R. Piper & Co., Munich, 1912

_____, "Über die Formfrage," *Der Blaue Reiter*, Klaus Lankheit edition, Munich, R. Piper & Co., 1965

_____, *Klänge*, Munich, R. Piper & Co., 1913. English translation by Elizabeth R. Napier: *Sounds*, New Haven and London, Yale University Press, 1981

Kandinsky and Franz Marc, eds., *Der Blaue Reiter*, Klaus Lankheit edition, Munich, R. Piper & Co., 1965. Originally published in 1912

Edward J. Kimball, unpublished pictorial analysis in eleven drawings of *In the Black Square*, New York, Columbia University, 1975

Paul Klee, *The Diaries of Paul Klee, 1898–1918*, introduction by Felix Klee, ed., Berkeley, University of California Press, 1968. Originally published by DuMont Schauberg, Cologne, 1957

Alfred Koeppen, *Die moderne Malerei in Deutschland*, Bielefeld and Leipzig, Verlag von Velhagen, 1902

Alfred Kubin, *Die andere Seite*, Munich, Nymphenburger Verlagshandlung, 1968

Ernst Kühnel, "Die Ausstellung Mohammedanischer Kunst München 1910," *Münchner Jahrbuch der bildenden Kunst*, 1910

Johannes Langner, "Impression V: Observations sur un thème chez Kandinsky," *Revue de l'art*, vol. 45, 1979

Klaus Lankheit, "Die Frühromantik und die Grundlagen der gegenstandslosen Malerei," *Neue Heidelberger Jahrbücher*, Neue Folge, 1951

_____, *Franz Marc: Katalog der Werke*, Cologne, DuMont Schauberg, 1970

_____, *Franz Marc Schriften*, Cologne, DuMont Buchverlag, 1978

Kenneth C. Lindsay, "The Genesis and Meaning of the Cover Design for the First *Blaue Reiter* Catalog," *Art Bulletin*, vol. XXXV, March 1953

_____, "Kandinsky in 1914 in New York: Solving a Riddle," *Art News*, vol. 55, May 1956

Kenneth C. Lindsay and Peter Vergo, eds., *Kandinsky: Complete Writings on Art*, Boston, G. K. Hall, 1982

Rose-Carol Washton Long, *Kandinsky: The Development of an Abstract Style*, Oxford, Clarendon Press, 1980

Wolfgang Macke, ed., *August Macke, Franz Marc: Briefwechsel*, Cologne, DuMont Schauberg, 1964

Thomas Mann, "On the Spirit of Medicine," quoted in Joseph Campbell, *The Masks of God: Creative Mythology*, New York, Penguin Books, 1968

Wilhelm Michel, "Kandinsky, W. Ueber das Geistige in der Kunst," *Die Kunst für Alle*, September 15, 1912

Ann Mochon, *Gabriele Münter: Between Munich and Murnau*, exh. cat., Busch-Reisinger Museum, Harvard University, 1980

"München um 1910," *Du*, vol. 29, July 1969 (special issue), Manuel Gasser, Peter Killen, Klara Obermüller, eds., Zürich

Münchner Malerei 1892–1914 von der Sezession zum Blauen Reiter, exh. cat., Museum for Modern Art, Hokkaido, Japan, 1977

Erdmann Neumeister, *Thomas Manns frühe Erzählungen: Der Jugendstil als Kunstform im frühen Werk*, third edition, Bonn, Bouvier Verlag, Herbert Grundmann, 1977

Reinhard Piper, *Briefwechsel mit Autoren und Künstlern 1903–1954*, Munich. R. Piper & Co., 1979

Post-Impressionism Cross-Currents in European Painting, Royal Academy exh. cat., New York, 1979

W. H. Roscher, *Ausführliches Lexikon Griechischen und Römischen Mythologie*, Leipzig, Verlag B. G. Teubner, 1884–86

Hans Konrad Röthel, *Kandinsky: Das graphische Werk*, Cologne, DuMont Schauberg, 1970

Hans Konrad Röthel and Jean Benjamin, *Kandinsky*, New York, Hudson Hills Press, 1979

Angelica Rudenstine, *The Guggenheim Museum Collection: Paintings 1885–1945*, vol. I, New York, The Solomon R. Guggenheim Foundation, 1976

Eberhard Ruhmer, ed., *Die Münchner Schule 1850–1914*, exh. cat., Bayerische Staatsgemäldesammlungen and Haus der Kunst, Munich, F. Bruckman, 1979

Sigrid Russ, ed., *Marianne Werefkin: Gemälde und Skizzen,* exh. cat., Museum Wiesbaden, 1980

Salme Sarajas-Korte, *Suomen varhaissymbolismi ja sen lähteet,* Helsinki, Otava, 1966

_____, "Kandinsky et la Finlande I, 1906–1914," *Ateneumin Taidemuseo Museojulkaisu,* 15 Vuosikerta, 1970

Peter Selz, *German Expressionist Painting,* Berkeley and Los Angeles, University of California Press, 1957

Susan Stein, "The Ultimate Synthesis: An Intepretation of the Meaning and Significance of Wassily Kandinsky's *The Yellow Sound,*" Master's thesis, State University of New York at Binghamton, 1980

Otto Stelzer, *Die Vorgeschichte der Abstrakten Kunst, Denkmodelle und Vor-Bilder,* Munich, R. Piper & Co., 1964

Ernest Stern, *My Life, My Stage,* London, Victor Gollancz Ltd., 1951

Wolfgang Venzmer, ed., *Adolf Hölzel, sein Weg zur Abstraktion: Ausstellung 1972,* with introduction by Wolfgang Venzmer, Dachau, Staat Dachau, 1972

_____, *Adolf Hölzel: Werk-Katalog,* Stuttgart, Deutsche Verlagsanstalt, 1982

Rose-Carol Washton, *Vasily Kandinsky, 1909–1913: Painting and Theory,* Ph.D. dissertation, Yale University, 1968

Peg Weiss, "The Graphic Art of Kandinsky," *Art News,* vol. 73, March 1974, pp. 42–44

_____, "Kandinsky and the 'Jugendstil' Arts and Crafts Movement," *The Burlington Magazine,* vol. CXVII, May 1975, pp. 270–279

_____, "Kandinsky and the Munich Academy," paper presented at the Annual Meeting, College Art Association of America, January 1974

_____, *Kandinsky in Munich: The Formative Jugendstil Years,* Princeton, Princeton University Press, 1979

_____, "Kandinsky: Symbolist Poetics and Theater in Munich," *Pantheon,* vol. XXXV, July-August-September 1977, pp. 209–218

_____, "Kandinsky, Wolfskehl und Stefan George," *Castrum Peregrini,* CXXXVIII, 1979, pp. 26–51

_____, "Wassily Kandinsky, the Utopian Focus: Jugendstil, Art Deco, and the Centre Pompidou," *Arts Magazine,* vol. 51, April 1977, pp. 102–107

Siegfried Wichmann, *Jugendstil Art Nouveau,* Munich, Schuler Verlagsgesellschaft, 1977

Siegfried Wichmann, ed., *München 1869–1958 Aufbruch zur modernen Kunst,* exh. cat., Munich, Haus der Kunst, 1958

Daniel Wildenstein, *Claude Monet: Biographie et catalogue raisonné, Tome III: 1887–1898 Peintures,* Lausanne-Paris, La Bibliothèque des Arts, 1979

Clara B. Wilpert, *Schattentheater,* Hamburg, Hamburgisches Museum für Völkerkunde, 1973

INDEX OF ARTISTS IN THE CATALOGUE

PHOTOGRAPHIC CREDITS

Color

Courtesy Bayerische Staatsgemäldesammlungen, Graphische Sammlung: cat. no. 63

Mary Donlon: cat. no. 332

Courtesy Mr. and Mrs. Benjamin Fortson, Fort Worth: cat. no. 265

Courtesy Aivi Gallen-Kallela-Siren: cat. no. 57

S. R. Gnamm, Munich; courtesy Siegfried Wichmann: cat. no. 21

Robert E. Mates: cat. nos. 219, 284, 285

Robert E. Mates and Susan Lazarus: cat. no. 323

Courtesy Münchner Stadtmuseum, Munich: cat. nos. 96a-g, 98, 201

Courtesy Museum Boymans-van Beuningen, Rotterdam: cat. no. 267

Courtesy Narodna Galerija, Ljubljana: cat. no. 75

Courtesy Neue Pinakothek, Munich: cat. no. 54

Courtesy Pelikan Kunstsammlung, Hannover: cat. no. 262

Courtesy Städtische Galerie im Lenbachhaus, Munich: cat. nos. 38, 139, 214, 215, 258, 261, 299, 315, 318, 320, 322, 326

Herbert H. G. Wolf, Wetzlar; courtesy Wächtersbacher Keramik, Brachttal, Germany: cat. no. 111

Black and White

Jörg P. Anders, Berlin; courtesy Staatliche Museen Preussicher Kulturbesitz, Nationalgalerie, Berlin: fig. 1; cat. no. 140

Courtesy Architektursammlung der Technische Universität München: cat. no. 24

Courtesy The Art Museum of the Ateneum, Helsinki: figs. 18, 19; cat. nos. 179, 180

Courtesy Badisches Landesmuseum, Karlsruhe: cat. nos. 123, 197, 200

Courtesy Bayerische Staatsgemäldesammlungen, Munich: figs. 13, 42; cat. nos. 291, 297

Courtesy Museum Boymans-van Beuningen, Rotterdam: cat. no. 195

Courtesy The Brooklyn Museum: cat. no. 343

Courtesy Bührle Collection, Zürich: fig. 31

Courtesy Deutsches Theatermuseum, Munich: cat. nos. 226–228

Courtesy Everson Museum of Art, Syracuse, New York: cat. no. 97

Courtesy Galerie Gunzenhauser, Munich: cat. nos. 178, 286

Courtesy Gallen-Kallela Museum, Espoo, Finland: cat. nos. 181–183

S. R. Gnamm, Munich: cat. no. 19

S. R. Gnamm, Munich; courtesy Siegfried Wichmann: cat. nos. 23, 28a-b, 29, 56, 128, 129, 131, 132

Courtesy Graphische Sammlung, Staatsgalerie Stuttgart: cat. no. 142

Courtesy Library of Congress, Washington, D.C.: cat. no. 340

Courtesy Harry Hess: cat. no. 288

Courtesy Hessisches Landesmuseum, Darmstadt: fig. 15

Courtesy The Houghton Library, Harvard University, Cambridge, Massachusetts: fig. 23

Courtesy Institute für Kunstgeschichte der Universität, Karlsruhe: cat. nos. 257, 271, 280–282

Dorothee Jordens; courtesy Münchner Stadtmuseum, Munich: cat. nos. 22, 87

Courtesy Felix Klee, Bern: fig. 14; cat. nos. 204–207, 236, 256

Courtesy Kunstbibliothek Staatliche Museen Preussicher Kulturbesitz, Berlin: cat. nos. 1, 13, 108, 141

Courtesy Kunsthalle Bremen: cat. no. 95

Courtesy Kunsthaus Zürich: fig. 9

Courtesy Paul Klee-Stiftung, Kunstmuseum Bern: cat. no. 171

Courtesy Kupferstichkabinett, Kunstmuseum Basel: cat. nos. 335, 336

Courtesy Delvard Nachlass, Münchner Stadtmuseum, Munich: cat. no. 105

Courtesy Narodna Galerija, Ljubljana: cat. nos. 72–74

Courtesy Heirs of Dr. W. Macke, Bonn: cat. nos. 41, 150, 162–164, 246, 247

Robert E. Mates: figs. 3, 16, 43, 44; cat. nos. 39, 43, 44, 80, 94, 212, 260, 269, 285, 296, 303, 321

Robert E. Mates and Mary Donlon: fig. 20; cat. nos. 192, 216

Courtesy Mittelrheinisches Landesmuseum, Mainz: fig. 22

Courtesy Münchner Stadtmuseum, Munich: cat. nos. 2–4, 14, 20, 26, 50, 52, 53, 93, 99, 104, 165–170, 191, 202, 224, 225, 289

Courtesy Gabriele Münter-Johannes Eichner Stiftung, Munich: cat. nos. 30, 32, 33, 35–37, 158, 160a-d, 302, 341

Courtesy Musée du Louvre, Paris: fig. 35

Courtesy Musée National d'Art Moderne, Paris: cat. nos. 325, 333

Courtesy Museum Bellerive, Zürich: cat. nos. 18, 68–71

Courtesy Museum für Kunst und Gewerbe, Hamburg: cat. no. 27

Courtesy The Museum of Modern Art, New York: cat. nos. 45, 46, 55, 126, 130, 210

Courtesy Narodna Galerija, Ljubljana: figs. 10, 11

Courtesy National Gallery of Art, Washington, D.C.: figs. 5, 28

Rosmarie Nohr, Munich: fig. 36

Courtesy Pelikan Kunstsammlung, Hannover: cat. nos. 241, 242, 244, 248–253, 264

Gerd Remmer, Flensburg, Germany; courtesy Städtische Museum Flensburg: cat. nos. 114, 121, 125, 133–136, 138

Courtesy J. A. Schmoll-Eisenwerth, Munich: cat. no. 85

Courtesy Schönberg Estate, Los Angeles: cat. no. 342

Courtesy Schiller-Nationalmuseum, Munich: cat. no. 221

Courtesy Schiller-Nationalmuseum/ Deutsches Literaturarchiv, Marbach: cat. no. 223

Carsten Seltrecht; courtesy Kunstmuseum St. Gallen: cat. no. 259

Courtesy David Lee Sherman: cat. no. 106

Courtesy Staatliche Graphische Sammlung, Munich: cat. nos. 11, 12, 58–62, 64, 66, 67

Courtesy Staatliches Museum für Völkerkunde, Munich: cat. nos. 304–310

Courtesy Stadtbibliothek mit Handschriftensammlung, Munich: cat. nos. 100–102, 229

Courtesy Städtische Galerie im Lenbachhaus, Munich: figs. 21, 32, 38, 41; cat. nos. 5, 25, 34, 42, 47–49, 76–79, 81–84, 86, 90–92, 109, 110, 113, 118, 137, 145–149, 155–157, 159, 161, 172–174, 176, 177, 184, 185, 187, 193, 194, 196, 199, 203, 209, 213, 217, 220, 230–232, 238–240, 243, 245, 254, 255, 266, 270, 272–275, 283, 290, 292–295, 298, 301, 311–314, 316, 317, 319, 324, 327–330, 334, 339

Courtesy Stuck-Jugendstil-Verein, Munich: cat. nos. 51, 234, 235, 237

Courtesy Gerhard Weiss, Munich: cat. no. 88

Courtesy Peg Weiss: figs. 2, 17, 40; cat. nos. 15–17

Liselotte Witzel, Essen; courtesy Museum Folkwang, Essen: cat. no. 331

Herbert H. G. Wolf, Wetzlar; courtesy Wächtersbacher Keramik, Brachttal, Germany: cat. nos. 112, 115–117, 120, 122

Courtesy Württembergisches Landesmuseum, Stuttgart: cat. nos. 119, 124, 222

Exhibition 82/1

10,000 copies of this catalogue, designed by Malcolm Grear Designers, typeset by Dumar Typesetting, Inc., have been printed by Eastern Press in January 1982 for the Trustees of The Solomon R. Guggenheim Foundation on the occasion of the exhibition *Kandinsky in Munich: 1896-1914.*